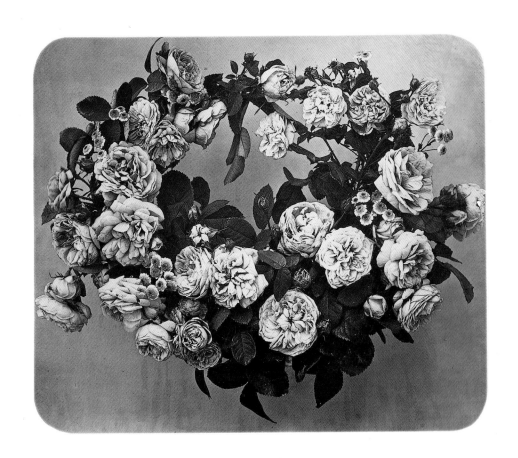

Image and Enterprise

THE PHOTOGRAPHS OF ADOLPHE BRAUN

Image and Enterprise

THE PHOTOGRAPHS OF ADOLPHE BRAUN

General Editors

MAUREEN C. O'BRIEN

MARY BERGSTEIN

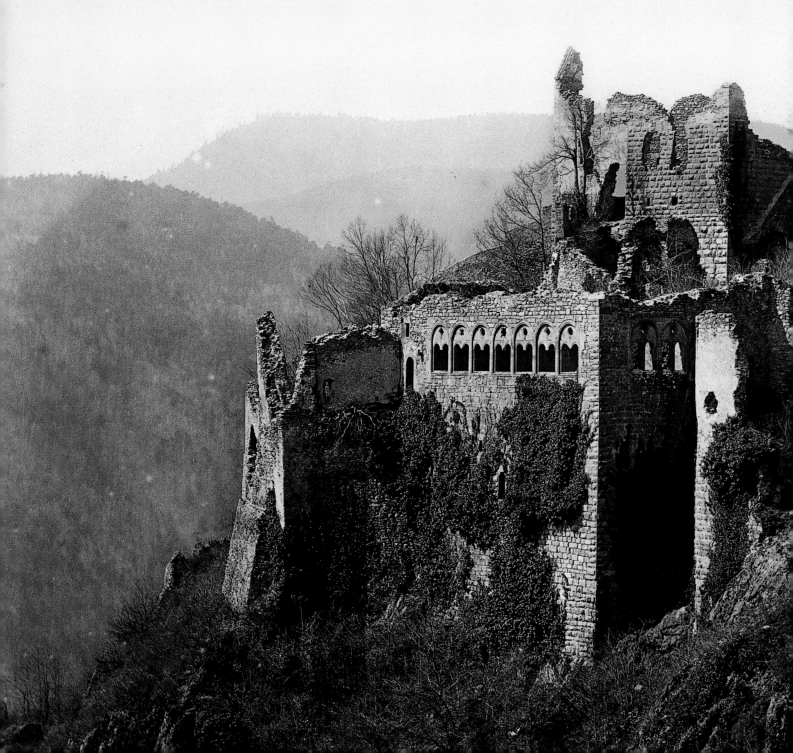

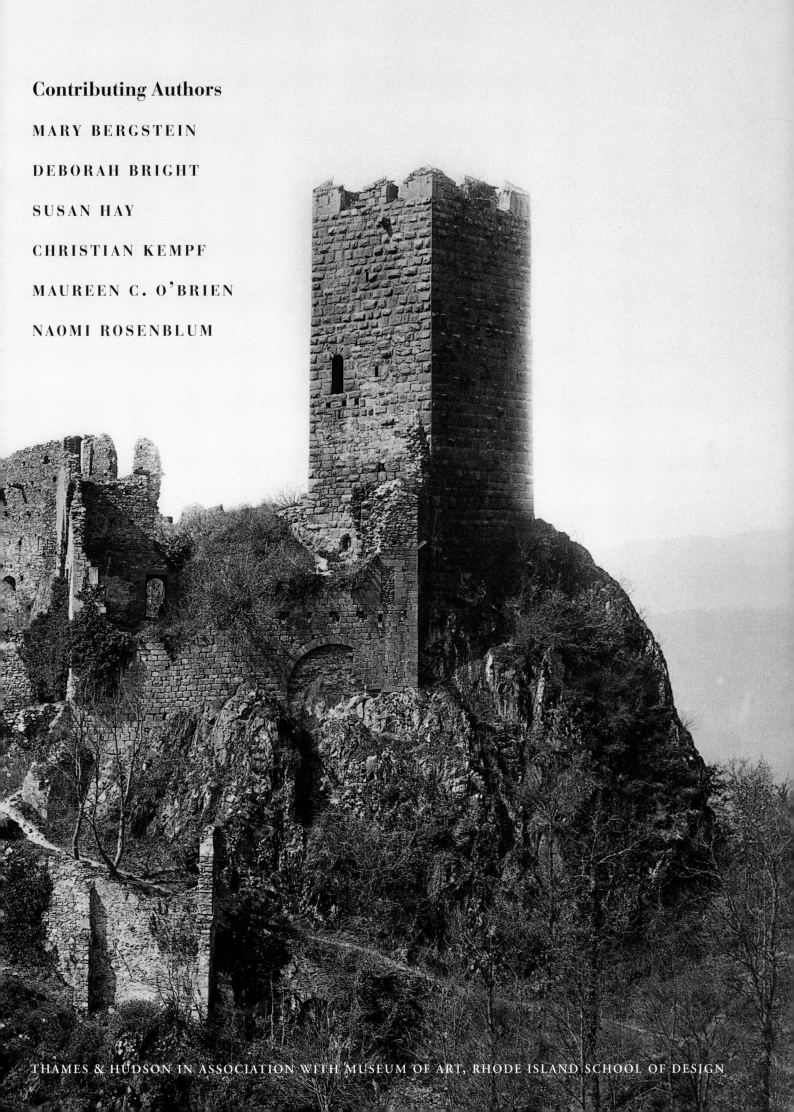

Contributing Authors

MARY BERGSTEIN

DEBORAH BRIGHT

SUSAN HAY

CHRISTIAN KEMPF

MAUREEN C. O'BRIEN

NAOMI ROSENBLUM

THAMES & HUDSON IN ASSOCIATION WITH MUSEUM OF ART, RHODE ISLAND SCHOOL OF DESIGN

First published on the occasion of the exhibition
"Image and Enterprise: The Photographs of Adolphe Braun."

Museum of Art, Rhode Island School of Design, Providence
4th February–22nd April 2000

The Cleveland Museum of Art, Cleveland
18th June–27th August 2000

*This project was made possible in part by generous funding from:
the National Endowment for the Humanities, dedicated to expanding
American understanding of history and culture; and with support
from the RISD Museum Associates; Olympus America Inc.; the
Florence Gould Foundation; the Robert Mapplethorpe Foundation;
Mr. and Mrs. V. Duncan Johnson; and anonymous donors.*

Edited by Judith A. Singsen
Editorial Consultant: Julia Ballerini

© Museum of Art, Rhode Island School of Design, Providence,
and Thames & Hudson Ltd, London

Library of Congress Catalog Card Number 99-072807
ISBN 0-911517-66-9

Printed in Hong Kong

Half-title page: *Fleurs photographiées. Couronne de roses, dahlias et
nasturtiums*
Photographs of Flowers. Wreath of Roses, Dahlias, and Nasturtiums
Albumen silver print
ca. 1854–1856
Musée de l'Impression sur Étoffes, Mulhouse

Title page: *Album de l'Alsace. Château de Saint-Ulrich*
Album of Alsace. Château of Saint-Ulrich
Albumen silver print
1859
Bibliothèque de la Ville de Colmar

Opposite: *Suisse. No. 3301. Oberland Bernois, Sauvetage du guide
Jean-Michel, tombé dans une crevasse du glacier inférieur de
Grindelwald*
Switzerland. No. 3301. Bernese Oberland. Rescue of the Guide,
Jean-Michel, who had Fallen into a Crevasse on the Lower Glacier
at Grindelwald
Albumen silver prints on sterescopic mount
ca. 1863–1864
The J. Paul Getty Museum, Los Angeles

A checklist of works by Adolphe Braun featured in the exhibition can be
found on pp. 141–152.
All photographs are attributed to Adolphe Braun or to members of his
company, unless otherwise stated in the captions.
Where the original titles used by Braun and his company are known,
they are given in French, with English translations. Otherwise, we have
adopted the descriptive title used by the current owner of the work.

Contents

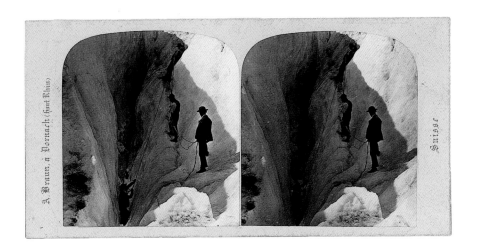

Foreword

ADOLPHE BRAUN's photographic enterprise offers a compelling model for the concept of artist as entrepreneur. In the middle of the nineteenth century, when national well-being was measured by industrial advancement, intellectual and business leaders encouraged links between the fine arts and industry. The discovery of a new technology for producing images sent a wave of excitement through the world of art and design. Refinements to the infant medium of photography made clear that its uses would be limited only by the imagination and ambitions of its practitioners.

In 1854, the challenge of making and marketing photographs was embraced by Adolphe Braun, a French textile designer who launched an ambitious and unprecedented venture: an album containing three hundred photographic images of flowers. Attuned to the needs of the manufacturers of deluxe goods, Braun intended these photographs to be used as sources for textile, wallpaper, and porcelain designs. To his gratification, French critics quickly acknowledged their intrinsic beauty and their appeal to a wider audience.

Today, we can also discover in the many products of his enterprise a record of nineteenth-century concepts of national patrimony; attitudes toward nature; the Grand Tour; and the history of both art and technology.

Over the next two decades, outstanding quality and diversity became the hallmarks of the Braun enterprise. His team of photographers recorded views of the monuments of Egypt, Rome, and Alsace, the breathtaking scenery of the Alps, the construction of railways, and great works of art in museum collections. These campaigns aimed to make Braun's photographs available to tourists, armchair travelers, interested amateurs, students of history and art, and professional artists. Their distribution was international: at the Rhode Island School of Design, in Providence, Braun's photographs of Old Master drawings were available to students when the institution's doors first opened in 1878. In the final analysis, however, Braun's images remind us that photography is indeed a transformative medium—a medium that, at its best, is profoundly geared to the pleasure of seeing and to the power of imagination.

This effort to place Braun's photographs in a broad social context was conceived and implemented by art historians Maureen C. O'Brien and Mary Bergstein at the Rhode Island School of Design. Outstanding contributions to the project were made by photographer and Braun scholar Christian Kempf, and by photography historian Sylvain Morand, Musée d'Art Moderne et Contemporain, Strasbourg. We are particularly grateful to former RISD Museum Director Doreen Bolger; to contributing authors Deborah Bright, Susan Hay, and Naomi Rosenblum; to Thames & Hudson, London; to editorial advisors Julia Ballerini and Judith Singsen; to Linda Catano, Tara Emsley, Melody Ennis, Erik Gould, Del Bogart, Susanne Cloeren Schulman, Laurel Barker, Joseph Leduc, Ann LaVigne, Nicole Saul Kogut, Nora Farrell, Glenn Stinson, Judy Amaral, Raquel Benros, and Richard Benefield at the RISD Museum; and to Norberto Massi for providing historical perspective.

Generous assistance was given by Carol W. Campbell, Bryn Mawr College; Richard Wendorf, Sally Pierce, Catharina Slautterback, Boston Athenaeum; Clifford Ackley, Anne Havinga, Museum of Fine Arts, Boston; Robert Bergman, Tom Hinson, Cleveland Museum of Art; Weston Naef, Judith Keller, Julian Cox, Kate Ware, Mikka Gee, Annie Lyden, Jacklyn Burns, J. Paul Getty Museum; Anne W. Tucker, Mary Morton, Roberto Prcela, Museum of Fine Arts, Houston; Ellen Handy, International Center for Photography; Therese Mulligan, International Museum of Photography and Film, George Eastman House; Maria Morris Hambourg, Malcolm Daniel, Metropolitan Museum of Art; Susan Kismaric, Museum of Modern Art, New York; Clay Lewis, National Endowment for the Humanities; Julia Van Haaften, Paula Baxter, New York Public Library; and Michael Gray, Fox Talbot Museum, Wiltshire, England.

In France we are indebted to Jean-Luc Eichenlaub; Archives départementales du Haut-Rhin, Colmar; Sylvie Aubenas; Bernard Marbot; Jean-Claude Lemagny, Marie Odile Roy, Bibliothèque Nationale de France; Francis Gueth, Bibliothèque de la Ville de Colmar; Dominique Brachlianoff, Muriel Le Payen, Musée des Beaux-Arts de Lyon; Françoise Reynaud, Musée Carnavalet, Paris; Sylvie Lecoq-Ramond, Catherine Leroy, Musée d'Unterlinden, Colmar; Henri Loyrette, Françoise Heilbrun, Musée d'Orsay; Jacqueline Jacqué, Musée de l'Impression sur Étoffes, Mulhouse; Michel Poivert, Katia Busch, Société Française de Photographie; François Cheval, Musée Nicéphore Niépce; Albert Raber, Société Schongauer, Colmar; and to Brigitte Kempf, Kik Williams, Jan-Claire Stevens, Pierre-Yves Mahé, and John Monahan.

We gratefully acknowledge the early and sustained support of the Rhode Island School of Design Museum Associates; Olympus America Inc.; the Florence Gould Foundation; the Robert Mapplethorpe Foundation; Mr. and Mrs. V. Duncan Johnson; and anonymous donors.

And finally we wish to thank the National Endowment for the Humanities for their major support which has made this project possible.

Phillip M. Johnston, Director
Museum of Art
Rhode Island School of Design

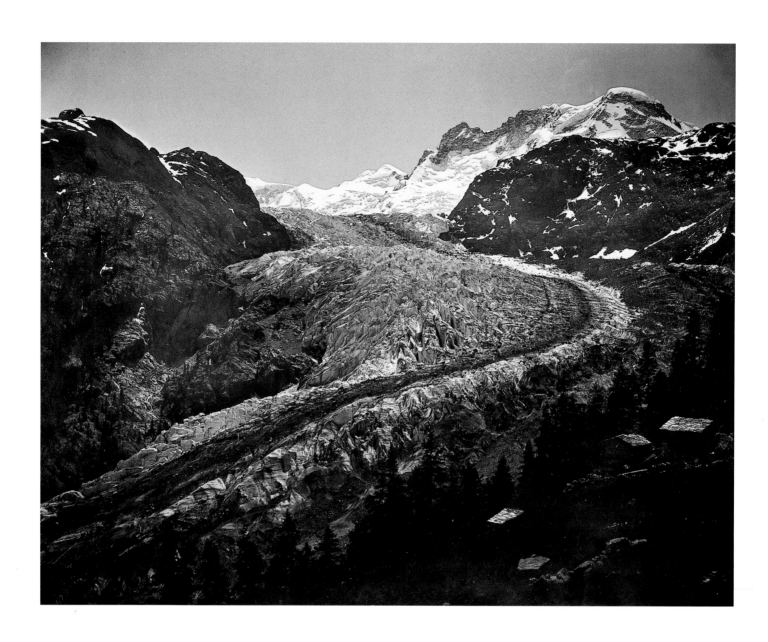

Suisse. Environs de Zermatt-Schwarzee. Glacier du Gorner et Breithorn
Switzerland. Zermatt-Schwarzee Region. Gorner and Breithorn Glacier
Carbon print
ca. 1863 (printed later)

Adolphe Braun's Photographic Enterprise

CHRISTIAN KEMPF

EAN ADOLPHE BRAUN came into the world at eleven-thirty on the night of June 13, 1812. He was the first son of Samuel Braun, a mounted police officer stationed in Besançon. When Samuel was discharged from the police force in 1822 as a result of changes in the political climate, he and his wife and children (Charles Nicolas Braun was born in 1815 and Marie Barbe Madeleine in 1823) returned to the family's home town of more than a century, Mulhouse. Adolphe met his future business contacts on the benches of the city's elementary and secondary schools.

A major industrial center in southern Alsace, very near the Swiss and German borders, Mulhouse specialized in the printing of fabrics and wallpaper. Its printed cottons, known by the French as *indiennes*, were particularly renowned. The old city center was governed by a few important manufacturing families, primarily Protestant, who were open to socially progressive ideas. They worked toward the funding of health care, the construction of housing, and the creation of vocational schools for their workers. In the training projects, the emphasis was on design,

chemistry, and mechanics, all of which were directly applicable to the printing industry. Adolphe Braun attended the *école industrielle*, but missed the opening of the Mulhouse design school. He was a talented draftsman, and whenever he had a free moment, he strolled through the nearby countryside, capturing plants and flowers in precise pencil drawings. It was by choice that he pursued his artistic training and developed his gift. At the end of 1828, Braun went to Paris to complete his education, one which had already been targeted to the needs of the industries producing decorative luxury goods. This trip to Paris was crucial: Paris was where fashion was made and good taste determined and Adolphe remained in the capital to forward his career. His family joined him there in 1830, after his father had been instated in the Parisian Municipal Guard.

While the specifics of Adolphe's childhood remain a bit hazy, the beginnings of his business and industrial activities are clearer. In 1834, he (accompanied by his younger brother Charles) opened a design studio in partnership with Charles Cantigny. Initially located

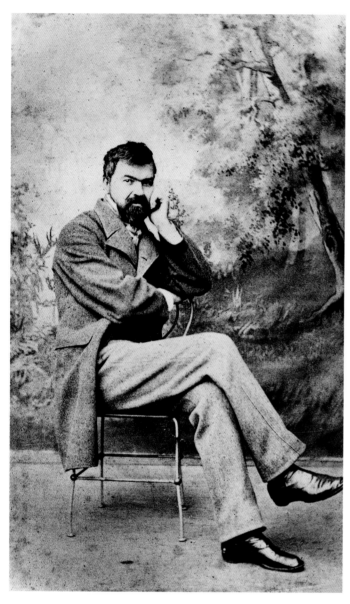

Unknown photographer
Portrait of Adolphe Braun
Reproduction after a *carte de visite*
ca. 1860

In these first efforts, one of Adolphe's most important qualities became evident: his strength in the face of adversity, his will to follow his own path with tenacity and confidence. He learned important lessons from his failures, which allowed him to develop business skills later recognized by all. Described as a man with an exceptional disposition, endowed with a tremendous capacity for work, Adolphe did not allow himself to be embittered by these difficult first years. Handsome, tall, with brown hair, gray eyes, and eyebrows high and thick, he had a sincere, peaceful, and reflective personality and was considered friendly and honest even under the most troublesome of circumstances.

In 1840 his hard work paid off. A new design studio at 20, Rue Saint-Fiacre was so successful that several additional designers were hired. Orders were continually increasing, and one would assume that Braun was on a familiar footing with his clients among the Mulhouse manufacturers, since the title of a book of drawings, published as lithographs in 1842, includes a dedication to one of them: *Recueil de dessins servant de matériaux, destinés à l'usage des fabriques d'étoffes, porcelaines, papiers peints &.&. Dédiés à Mr. Daniel Dollfus, par son Ami A. Braun* (Collection of Designs Offering Materials Intended for Use by Manufacturers of Textiles, Porcelains, Wallpapers, etc. Dedicated to Mr. Daniel Dollfus, by his Friend A. Braun). Consisting of thirty plates of "*Matériaux*" and "*Types*," some with color, the work presents floral and abstract motifs. The similarity between the abstract drawings and a photographic vision, particularly in the reversal of tonalities, is fortuitous. This type of drawing, employed in fabric or wallpaper patterns, was commonly used before the advent of photography.

at 9, Rue Mandar, it soon was moved to 27, Rue Paradis-Poissonnière. The endeavor was brief, but Braun was not discouraged. After two more attempts, Braun entered a partnership with Auguste Levasseur in 1838 at 34, Rue Neuve Sainte-Eustache, where it appears that Adolphe created designs for printed fabric. This venture proved to be another failure, but he and Levasseur came to an agreement with their creditors and successfully settled their debts.

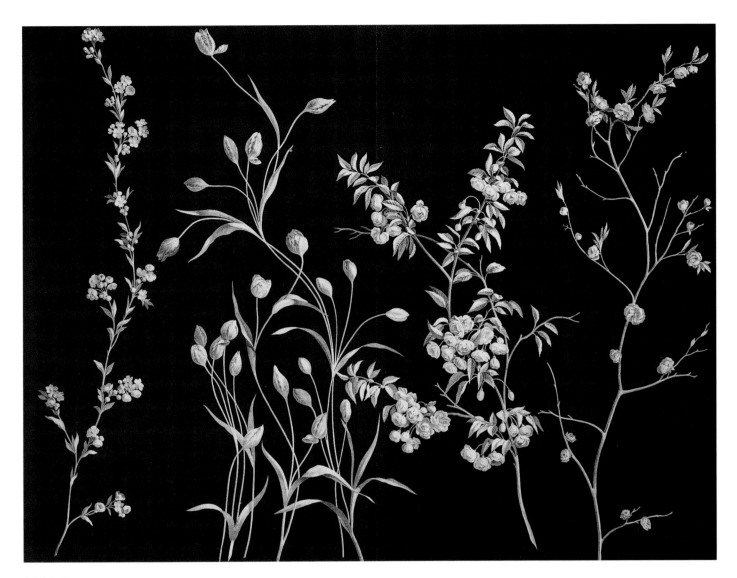

Adolphe Braun
Recueil de dessins (Pl. 25: "Matériaux")
Collection of Designs (Pl. 25: "Materials")
Lithograph
1842

Adolphe Braun was at the beginning of a brilliant and promising career with the necessary means to support his family. In 1834, he had married Louise Marie Danet, the daughter of the former secretary-general of the state's stables. Their marriage produced three children—Marie, Henri, and Louise—however, the premature death of his wife in 1843 brought Braun's well-mapped plans to an abrupt halt. This time, Adolphe's misfortune affected him deeply, and he decided to abandon his life in Paris. Dollfus-Ausset,

the manufacturer from Mulhouse, suggested that Braun take over as chief designer in his studios. Widowed and with three young children, Adolphe accepted the offer, sold his holdings in Paris, and returned to Alsace. How this connection with Dollfus-Ausset was formed is unknown, but it certainly redirected Adolphe Braun's destiny. All evidence suggests that this influential manufacturer's passion for photography was a determining factor in Adolphe's future career, which would take more than ten years to develop.

Adolphe reconstructed his family, his business, and his name. At the end of 1843, he married Pauline Baumann, the daughter of a well-known Alsatian horticulturist. Together they had two children, Gaston and Marguerite. Adolphe Braun soon strove to become better acquainted with Mulhouse's industrial leaders. Even though his father was Protestant, Adolphe had been raised a Catholic by his mother. As a result, many doors were closed to him in this highly compartmentalized community. Although he was easily admitted to the Société Industrielle de Mulhouse in 1843, it took him three more years to be introduced into the Loge Maçonnique de la "Parfaite Harmonie" (Masonic Lodge of Perfect Harmony). In the spring of 1847 he purchased a home and land in Dornach, a suburb of Mulhouse, and set up yet another design studio. It was not long before his excellent reputation allowed him to expand his client base, which came to include the noteworthy British companies of Butterworth and Brooks and of James Black, both in the Manchester area, and Montieth in Glasgow. Braun's father, Samuel, worked in the business, as did his brother Charles. Charles, like Adolphe, had developed his drawing skills, and his work was honored with a bronze medal at the 1849 Exposition des Produits de l'Industrie Nationale.

A confidential report of 1855 from the mayor of Dornach to the region's prefect sheds light on the studio's prestige: "Mr. Braun's reputation is so great that he must employ no less than forty designers, year-round, in order to fill the orders that he receives from all the countries of Europe." With so much success, why did Adolphe decide to venture into photography? Most likely he understood that it was going to be inextricably tied to the future of his own profession and that he was better off mastering it. He held several important

trumps: a knowledge of chemistry that was much more advanced than that of many of photography's pioneers; a strong artistic background; and a history in Mulhouse, a provincial town which from the very beginning played a role in the development of photography.

When Daguerre unveiled his daguerreotype process in August 1839, the manufacturers of Mulhouse immediately had several plates depicting Parisian monuments delivered from the capital. During the following months, the members of the Société Industrielle de Mulhouse acquired the equipment to produce daguerreotypes. Since they specialized in printing, it was of utmost importance for them to examine the possible applications of this new process to their own industry. A book of samples from the Société Industrielle de Mulhouse, preserved at the Musée de l'Impression sur Étoffes, displays direct photographic printing in several colors on fabric, showing the industry's early interest in a technique that has become common today. Finally, although this may not be directly related to Adolphe Braun's decision to branch into photography, several of the very first daguerreotype portraits, taken with Voigtländer's Petzval lens at the beginning of 1841, were executed in Mulhouse.

The deciding factor for Braun may have been his relationship with Dollfus-Ausset, a great photography enthusiast. By 1842, Adolphe Braun already considered him a friend and had been his employee for nearly five years. This important industrial personality from Mulhouse dedicated the bulk of his time and money to his two great passions: glaciology and photography. For his studies on the Aar glacier in Switzerland, he had had a small shelter built, where several scientists and friends gathered each summer in the 1840s. He brought along two daguerreotype photographers—Gustave Dardel

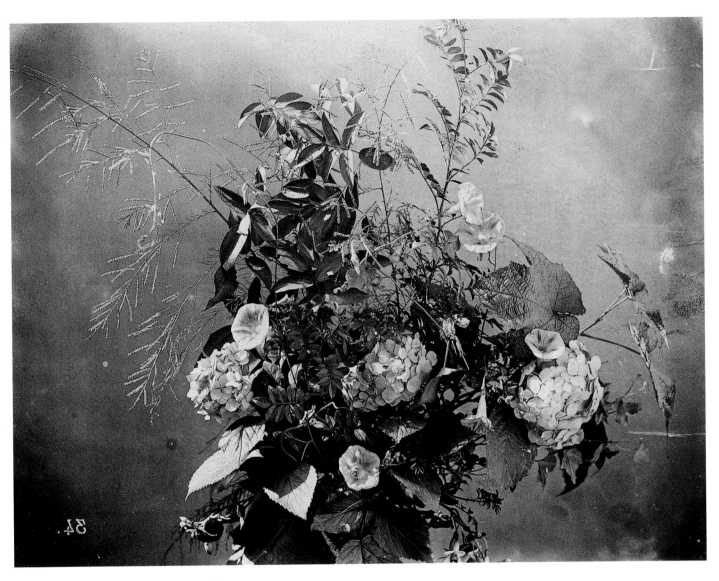

Fleurs photographiées (Fleurs et graminées)
Photographs of Flowers (Flowers and Grasses)
Albumen silver print
ca. 1855–1857 (printed later)

of Mulhouse in 1849, then Camille Bernabé, a photographer from Lyon, in 1850.[1] Their images are most likely the oldest known and accurately dated daguerreotypes taken on a mountain summit. Later, Dollfus-Ausset's obsession with photography led him to finance the Bisson brothers' (Auguste and Louis) business in Paris, and, in the 1850s, at his behest, the Bisson brothers made several expeditions in the Alps. Additionally, Dollfus-Ausset was a savvy collector of photographs, who was interested as much in the

photographers as he was in the works he purchased. In his time he was considered one of the great patrons of photography.

Given all this, how could Adolphe Braun resist trying the process himself? He was living in Paris when the discovery of the daguerreotype was announced, and he was aware of the media attention that followed. Out of either simple curiosity or professional anxiety, he had most likely been interested from the very beginning. A few family portraits remain as proof of Braun's

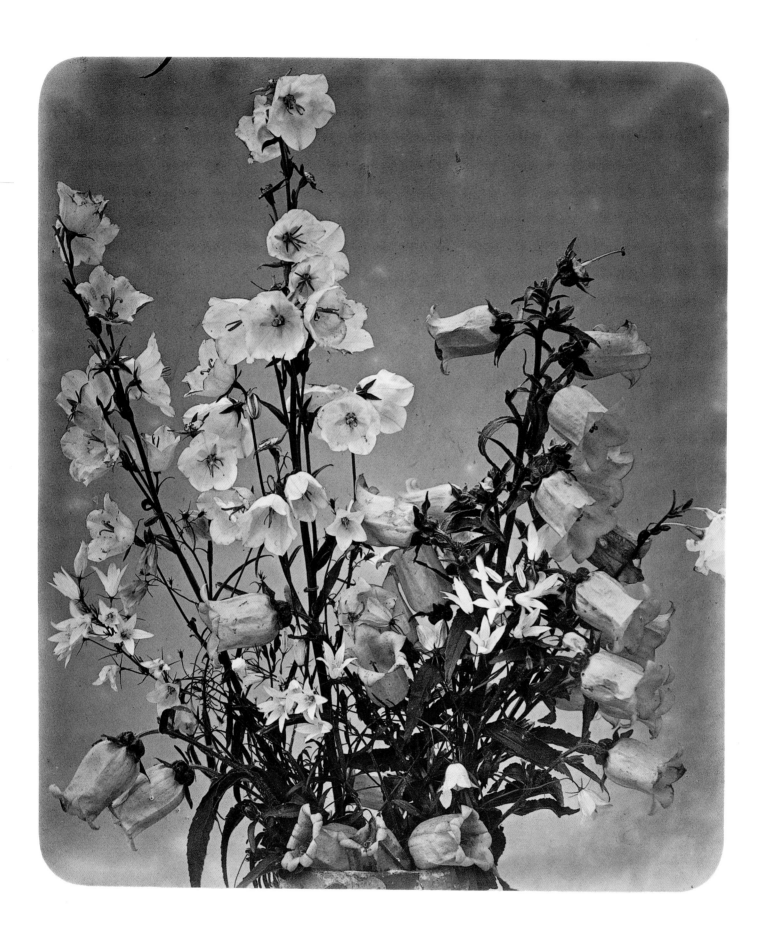

awareness of the daguerreotype, but nothing indicates that Braun was the artist, or that he himself ever executed a daguerreotype. His first photographs were devoted to flowers. Portraiture was not among his artistic interests then, and it only interested him later in an occasional way. Furthermore, daguerreotypes could not be duplicated, and duplication was necessary to Braun's intention, which from the beginning was to use his photographic work commercially. This is why he favored the collodion process, which was perfected late in 1851. From a glass-plate negative he could develop multiple positive prints on thin papers coated with albumen.

It was his flower images that brought Adolphe Braun into the top rank of photographers. The subject could not have been more appropriate for him, as flowers were the most important theme in the printing factories' design studios. On the outskirts of Mulhouse, the famous manufacturers of the Zuber wallpapers maintained their own greenhouses, in which were grown all kinds of flowers, from the mundane to the most exotic, to be used as guides for their artists. There is good reason to believe that Adolphe Braun and his designers profited from a similar set-up. After all, hadn't Braun married the daughter of the horticulturist who had supplied plants for the pasha of Egypt's gardens? Adolphe Braun disliked the distorted, repetitive, and conventional floral compositions of the schools and design studios. His stated goal for his *Fleurs photographiées* was to allow designers to work from natural models. During the months in which Adolphe was promoting his flower photographs, the Société

Fleurs photographiées (Campanules)
Photographs of Flowers (Campanula)
Albumen silver print
ca. 1854–1855

d'Horticulture was founded in Mulhouse by, among others, himself and several members of his family. Ornamental and decorative plants were in style and the society's intention was "to promote the love of flowers."

On November 6, 1854, to the surprise of the photographic community, Adolphe Braun presented a book of three hundred plates to the Académie des Sciences in Paris. Cut flowers, shrubs, various arrangements, wreaths, fruits, herbs, and grasses, all presented thoughtfully and artistically, made up the most complete and marvelous herbarium imaginable. Particular care had been taken to ensure that the plants were seen distinctly, their silhouettes clearly shown against a neutral background. The bouquets were often displayed on the same visual plane, so that each component could be more easily read. According to their creator, these photographs were to be the first series of a *Histoire naturelle des fleurs* (Natural History of Flowers), which he never realized despite additions to the collection of several hundred supplementary views (the formats range from stereoscopic to 16 x 20 in. [40 x 50 cm.]) over the next two to three years.

On November 11, 1854, Alexis Gaudin's photography magazine, *La Lumière*, praised highly this "useful application of photography to the fine arts and industry." The December 7 issue of the *Journal des débats* rightly noted that although these flower photographs were intended for designers and artists, they were "likely to tempt all people of good taste." The suggestion was important, and it was later reiterated and acted upon by the well-known photography critic Ernest Lacan, when he attempted to widen the distribution of Adolphe Braun's work to the public in 1858. In so doing, Lacan gave the photographs validity as autonomous works of art, not just as useful

aids to fine art. A small brochure, published by Adolphe Braun in February 1855 and later translated into English, restated the main points of the articles and reviews that had been written on his volume of *Fleurs photographiées* to that time.[2] The Exposition Universelle of 1855 was about to open in Paris; Adolphe managed to take part and exhibit a second series of prints to advantage.

It was here that Braun reaffirmed his initial success. From a mere designer, he had suddenly become one of the day's premier photographers. Into the 1860s, a variety of laudatory articles came out all across Europe praising this body of work.[3] Along with the Bisson brothers, Braun shared "the privilege of drawing eyes, captivating attention, of producing a unanimous feeling among the populace that only occurs in the presence of beauty!" Furthermore, exclaimed Lacan, "Never before has photography achieved this level of perfection."[4] The famous critic would ensure that Braun's products were regularly promoted in *La Lumière*. Gaudin himself was also interested in the commercialization of Braun's work, and it was perhaps at his prodding that Adolphe Braun went into stereoscopy in 1857.

With the collodion process, Adolphe Braun was able to reproduce his flower wreaths and arrangements with perfect subtlety and finesse. His surprising and quick mastery of this technique allowed him to minimize or correct early photography's more critical problems, like the process's insufficient sensitivity to light and the inaccurate reduction of color to a black-and-white continuum. With the collodion process, Adolphe achieved the first, and not the least, of his accomplishments. It is likely that he was working during the summer and autumn of 1854, and he is said to have ruined hundreds of plates before reaching his goal. The new plates, shown in late November 1854 to the committee of the Société Industrielle de Mulhouse and at the Exposition Universelle in early 1855, must have been shot during the previous summer, for only in summer was the daylight sufficiently bright to expose the negatives. It is certain that during 1854 Braun created dozens of glass plates, which he had no time to develop until the following winter. The positive prints on albumenized paper were admired for their great depth, their warm tone, and their tremendous impact. The flower series remained in the Braun catalogs until the end of the 1880s. These images compose one of the major works of art produced in this period, known as "the golden age of photography."

Adolphe Braun was by now considered on a par with the greatest artists working in photography, such as Édouard Baldus, Henri Le Secq, and the Bisson brothers, who were all admired for their architectural and landscape images. Encouraged by his initial success, Braun also decided to explore these diverse subjects. The preservation of architectural tradition was one of the French state's major concerns. Serious steps were being taken to record and/or preserve the country's most beautiful landmarks and monuments. It was in this environment that the famous 1851 Mission Héliographique was conceived, launched at great expense, and finally completed without its results being published.[5] Since the presentation of William Henry Fox Talbot's *Pencil of Nature* (1844), many photographers had grown interested in the idea of books illustrated with photos. Louis Blanquart-Évrard's photographic printshop had tried but had recently run into financial difficulties. Adolphe in turn made

Album de l'Alsace: Ramstein (l'Ortenbourg)
Album of Alsace: Ramstein (Ortenbourg)
Albumen silver print
1859

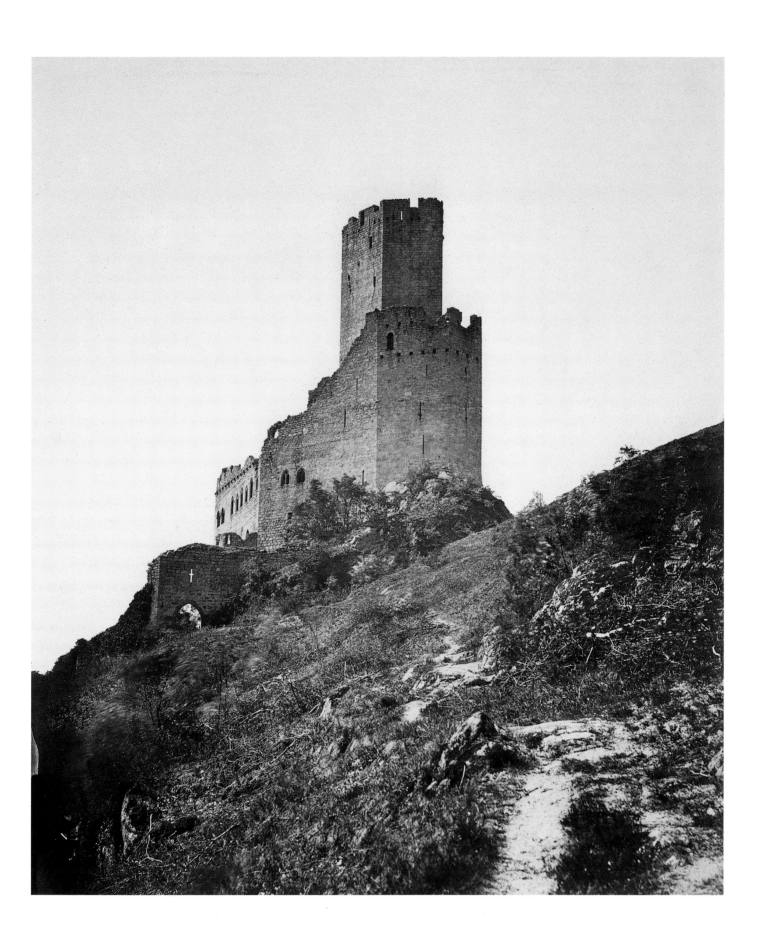

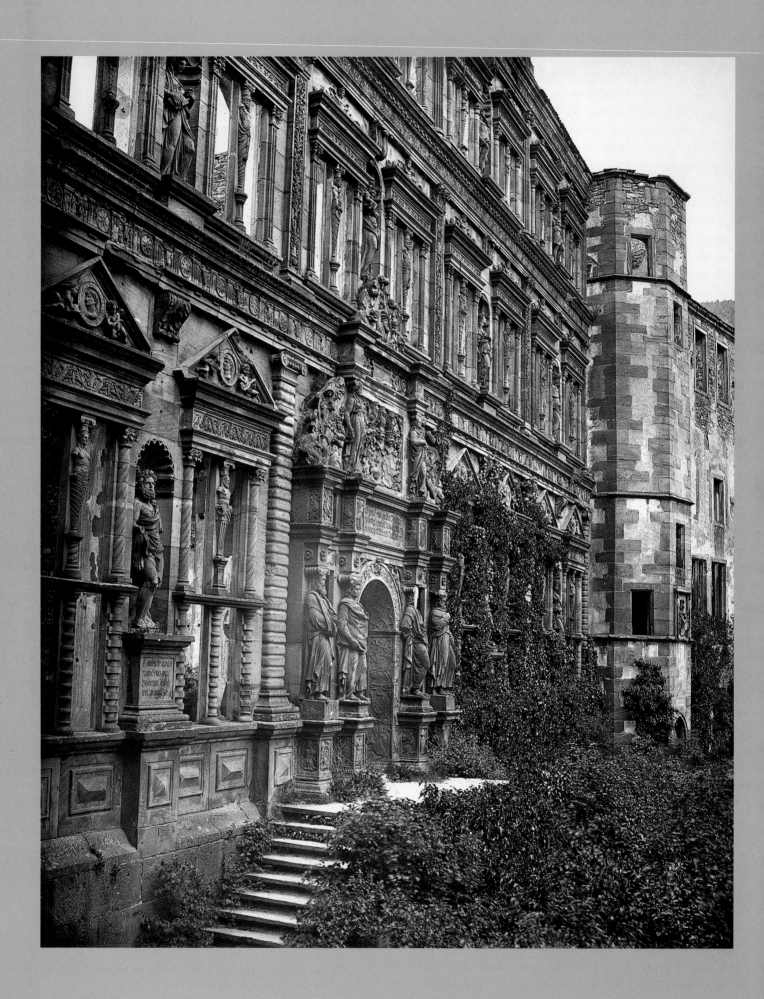

an attempt with what seemed to him to be a more promising subject, as the Société pour la Conservation des Monuments Historiques d'Alsace had just been created in Strasbourg.

During the summer of 1857, Braun came up with an ambitious plan to publish an album, containing a large-format photographic inventory (about 20 x 20 in. [50 x 50 cm.]), of the most well-known sites, works, and buildings in Alsace (see p. 17). Before doing this, he wanted to secure the moral support and financial backing of the appropriate official bodies. For funding, he could only rely upon general good will, most notably the promise of support from Napoleon III. From the start, Braun had to resolve a number of practical problems. Shooting outside his studio took extra time, as well as necessitating a traveling laboratory. Due to an insufficient number of subscriptions, the project ran into serious trouble. Braun showed an initial series of about fifty plates, devoted solely to the Département du Haut-Rhin (the Upper Rhine), in December 1858. He anticipated making an additional seventy-five plates, of which about thirty would be devoted to the Département du Bas-Rhin (the Lower Rhine), including Strasbourg and its cathedral. Despite all difficulties, Adolphe Braun was committed to the completion of his project; much more so after he was strongly encouraged by the departmental prefect, who personally took it upon himself to ask the Emperor for support. *L'Album de l'Alsace*, with 120 plates, was finally completed in December 1859.[6] "It is somewhat out of patriotism that I publish a work of such importance at a reasonably low price," he explained to the prefect. Despite the project's

lack of funding, Adolphe Braun was content to have received for his work an award that he had been after for some time: the Legion of Honor. Napoleon III presented it to him at Christmas and shortly after bestowed upon Braun the title of Photographer of His Majesty the Emperor.

L'Album de l'Alsace recorded Alsatian imagery in a meaningful way and was often drawn upon as a source book. One of the most famous works on Alsace from the end of the nineteenth century, created by Charles Grad, contains engravings directly inspired by *L'Album de l'Alsace*.[7] Adolphe Braun himself didn't shy away from direct borrowing, in shape or spirit, from previous works illustrated with lithographs by Godefroy Engelmann or Jacques Rothmuller. Without looking to be innovative, Braun selected equally from among medieval châteaux, Roman ruins, Gothic religious structures, and civic buildings from the medieval or Renaissance periods; however, despite the reality of the photograph, he could not avoid duplicating the romantic effect of the lithographs, particularly when he included people in the frame.

From the universal appeal of flowers, Braun had moved to a very regional subject, dealt with in a documentary fashion. His descent in popularity was as sudden as his rise had been. Praise came less frequently, and Adolphe's project even received certain slightly unfavorable reviews, although the general body of his work was of excellent quality and included some beautiful shots. The series allowed him to perfect his technique and he later found that the grandiose landscapes in Switzerland and the French Alps were more in line with his photographic vision.

Likely on advice from Alexis Gaudin, Adolphe Braun moved into another type of photography: stereoscopy. More financially feasible, stereoscopy charmed a public

Allemagne. Château de Heidelberg, le Palais d'Othon-Henri
Germany. Château of Heidelberg. Palace of Othon-Henri
Carbon print
1864 (printed ca. 1880)

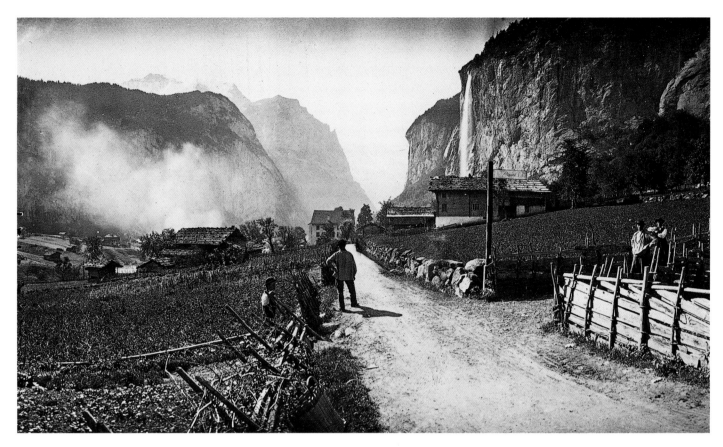

Suisse. Panorama de Lauterbrunnen et vue du Staubbach
Switzerland. Panorama of Lauterbrunnen and View of Staubbach
Albumen silver print
1866

excited by the illusion of three dimensions. On his travels while shooting the Alsace album, Adolphe had sometimes doubled his large views with stereoscopic photographs. Back in the summer of 1857, he had begun a series entitled *Paysages animés*, which Ernest Lacan raved about in *La Lumière*. It was based on small and rather naive field scenes in the Mulhouse area. In these small villages it was easy to find grape pickers, peasants, and bathers frolicking in a stream or people dressed in their Sunday best playing blind man's buff in the garden, but the scenes had to be posed for the camera in order to avoid the blurriness of action shots. This series seems to have had very little distribution.

The stereoscopic views, however, allowed Adolphe Braun another taste of success. It was from 1859 onward, after only a few trials, that Braun really began to produce landscape collections, focusing on the most fashionable tourist destinations in Germany and Switzerland. The wide distribution of these collections guaranteed a decent profit. Classic sites along a romantic route, notably the length of the Rhine valley, were a common subject in the first catalogs. Switzerland and Savoy with their Alpine and glacier views were later the subjects of his most significant projects, in terms of both quality and quantity. Filling out these collections were smaller series on the south of France, Paris and Versailles, and some one hundred plates of Belgium and Holland.

Within about ten years, Adolphe Braun had put together a catalog of more than six thousand

stereoscopic plates. The selection was so wide and the quality so high that a good many retailers wanted to deal only with Braun, a situation that often hurt local photographers. Braun's success grew after he began offering pictures in varying formats: 7½ x 8 in. (19 x 21 cm.) and particularly 16 x 20 in. (40 x 50 cm.) This last size was loved by all, as much by amateur photographers and tourists as by professional photographers. The aesthetic and technical quality of the larger formats was admirable, and this time great thought and planning had gone into the selection of sites in order to increase the profit margin. Germany was represented by a mere six plates, focusing on Heidelberg and its castle (see p. 18). All of the other plates were reserved for Switzerland and the Chamonix valley.[8] Later, in 1869, twenty-six views of Italy were

Savoie. Vallée de Chamonix. Station des Grands Mulets
Savoy. Chamonix Valley. Grands Mulets Station
Albumen silver print
1866

added, which had been shot during the course of early art-reproduction projects there.

In 1866 Adolphe added to his collections a panoramic format in several sizes, from 3 x 4½ in. (8 x 11 cm.) to the impressive 10½ x 20 in. (27 x 51 cm.) In an increasingly competitive landscape-view market, he once again produced innovative work, executing some of his most beautiful shots, which included as many in Switzerland as in Italy. For this purpose Braun had acquired the rights to the Pantascopic camera, conceived by Englishmen John R. Johnson and John A. Harrison and constructed by David Hunter Brandon. The camera lens rotated on a vertical axis while the collodion plate moved in its chassis along a rail to keep up with it. Brandon and Braun technicians collaborated successfully to improve the Pantascopic camera, making it as easy to use as a regular one.

From the start of his landscape series, Braun found it impossible to supervise all of the filming. He hired cameramen, mainly from his own family, who were

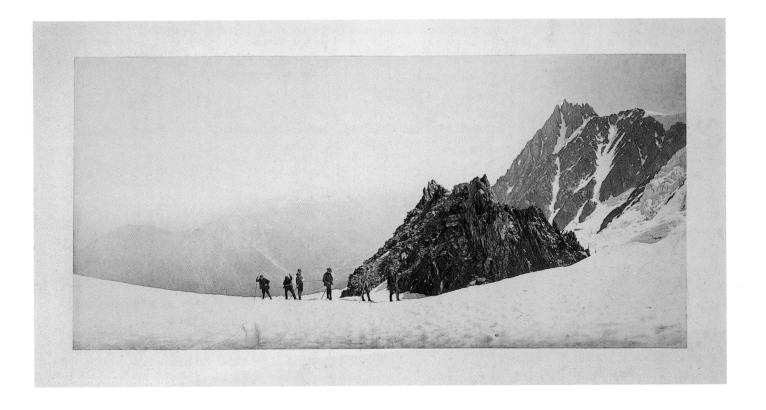

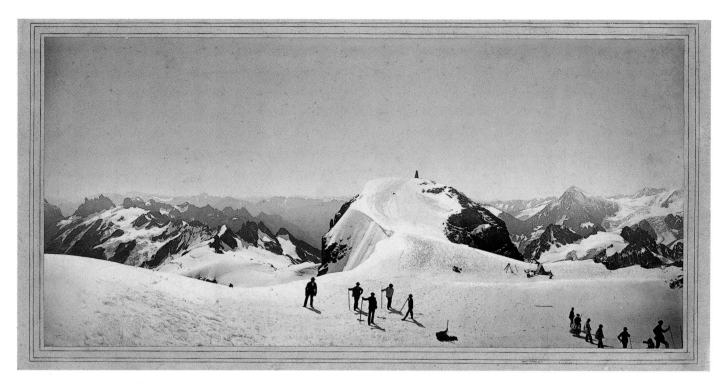

Suisse. Sommet du Mont Titlis
Switzerland. Summit of Mont Titlis
Carbon print
1866

committed to the project. Adolphe's brother Charles and his son Gaston took part in shooting the Alsace album. They soon were directing the various expeditions that left each spring for several months to record sites in neighboring countries. At the age of eighteen, Gaston traveled throughout Belgium and Holland, returning to France by way of Germany. Accompanied by Samuel, his elderly father, brother Charles was in Potsdam in May of 1862 for the king's general review of his troops. Adolphe also requested the services of a former cameraman from the Bisson brothers, whose firm specialized in mountain views. This cameraman, Jean-Claude Marmand, took part in the 1860 campaigns. Later, one of his cousins, who bore the same first and last name, joined the team, making authorship difficult to assign. Although the landscape views were executed under Adolphe's direction, it is virtually impossible to ascertain the extent of Adolphe's

actual participation in the projects or to assign him direct credit for them.

The Braun catalogs continued to burgeon with a variety of subjects, some of which are of great interest, even if their ultimate value was fleeting compared to Adolphe's more significant series. The first, and clearly the most puzzling, is entitled *Animaux de ferme*. With his finances now secure, Adolphe bought a variety of properties, particularly farms, in and around Dornach. Likely it was at one of these farms that he systematically photographed cows, calves, bulls, horses, and other animals, standing alone, in herds or harnessed, and often accompanied by farmhands. In a rather large format, about 12 x 16 in. (30 x 40 cm.), these views taken with a fairly fast shutter speed and a wide aperture—which created a peripheral distortion—stand out among the otherwise very careful and technically flawless work that characterized all

of Adolphe's productions to this point.[9] These rare images are often very beautiful in the brute simplicity of their composition, their lack of artifice, and the quality of their light. This series of more than two hundred plates is noted in an 1865 catalog and just once again in 1880, but there is no mention of them in exhibition reviews or in articles written about Braun in this period.

In 1867, animals once again became Braun's photographic subjects, but this time in a completely

different vein. Adolphe created six large compositions of still lifes entitled *Panoplies de gibier* or *Sujets de chasse* (Game Trophies, Hunt Subjects); two others were added later. Feathered and furred game, shown with all the appropriate hunter's gear, constituted a unique theme that required a feat of technical ability. Adolphe again proved his talent as a technician, as much through the unusual format of the shots (about 32 x 24 in. [80 x 60 cm.]), as by the use of the carbon printing process, recently adopted by Braun's business. Like each detail of the images, every composition in the series was rendered with great tactility and a wealth of tone. In contrast to his flowers, this time Adolphe

Animaux de ferme
Farm Animals (Cow Resting)
Albumen silver print
ca. 1862

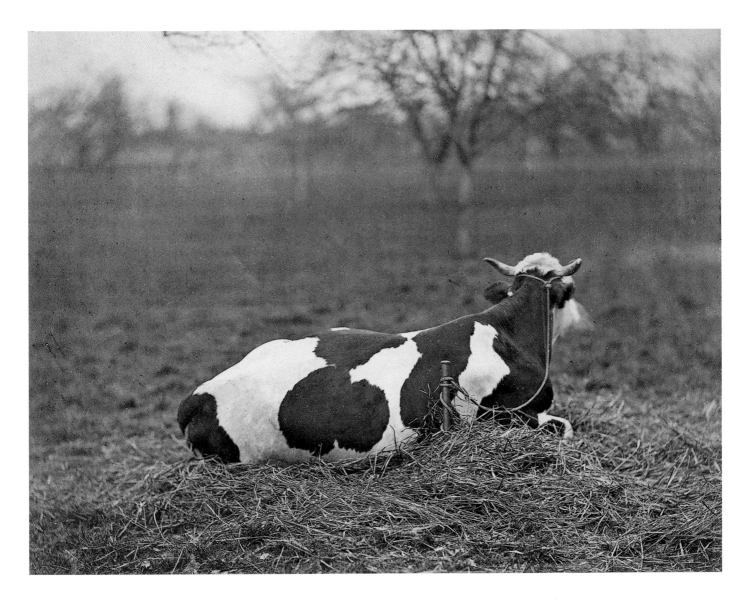

deliberately chose a decorative style. These photographs were relatively expensive, yet they could not compete with actual paintings of the same subject executed in the tradition of seventeenth-century Dutch masters; this may perhaps explain their limited distribution.

Braun created a small series called *Costumes de Suisse* in 1869, using models who posed in the courtyard of the Dornach studio in front of scenery that was either painted or constructed from grass and branches. Forty-six subjects— in 12 x 9½ in. (30 x 24 cm.), in album card format (6 x 4 in. [15 x 10 cm.]), and in stereoscopic views and *cartes de visite*—are mentioned in the *dépôt légal*.[10] All the different formats and variant poses of single subjects together amounted to hundreds of plates in terms of production. The novelty of these photographs was mainly due to their also being offered in color: watercolor paint was applied directly on to the albumen print. Adolphe Braun's first attempts with color were achieved in the same year that Charles Cros and Louis Ducos du Hauron announced their tri-chromatic processes.

In 1869, as a prelude to the inauguration of the Suez Canal, a group of foreign dignitaries were invited to take part in an expedition on the Nile to admire the ancient sites between Cairo and Aswan. If Adolphe Braun received the honor of being included on the official roster, it does not appear that he personally responded to the invitation. In his stead, Gaston reported to Marseille and embarked on the *Moeris*, bound for Alexandria, on October 9, 1869. He was accompanied by a Parisian representative from the family business, Amédée Mouilleron. They brought back from their trip about two or three hundred negatives in 8 x 10½ in. (20 x 27 cm.) and in stereoscopic formats of the great Pharaonic ruins and numerous monuments in Cairo.[11] It is unclear whether

or not they participated in the official festivities of the inauguration, since they did not return with a single view of it.

The Franco-Prussian War (1870–1871) was followed by the violence of the Paris Commune. Together they left many historical sites and buildings severely damaged, a situation that prompted professional photographers to create an irrefutable visual testimony of the destruction. Adolphe Braun's intention from the start of the war had really been to cover the fighting, but a lack of positive reaction to his proposition and the devastating course of events left him, as others, to focus on the war's aftermath. Destroyed and often deserted sites in Paris and the supposed peripheral strongholds that ensured its security; Strasbourg and its suburbs in ruin; and Belfort with its fort (see p. 26) and neighboring regions were the subjects of a catalog of more than one thousand photographs of all sizes. However, the disorganization of the Braun firm and its commercial network, tied to that of the entire country, precluded financial success. In Alsace, he came up against strong competition from Charles Winter, who had managed to corner the market with his views of Strasbourg.[12] Nonetheless, it is likely Adolphe Braun created the most important documentation of the war's ravages.

Adolphe Braun capitalized on the costume theme for a second time in 1871 after Germany had annexed Alsace and Lorraine. Due to this recent political change, a small series of photographs featuring a woman from Alsace and a woman from Lorraine had so much local success that it drew the attention of the new German authorities. A government media campaign attempted to negate the effect of these photographs by insinuating that Braun's "Alsatian" model was the fiancée of a German soldier, which then turned the subjects into

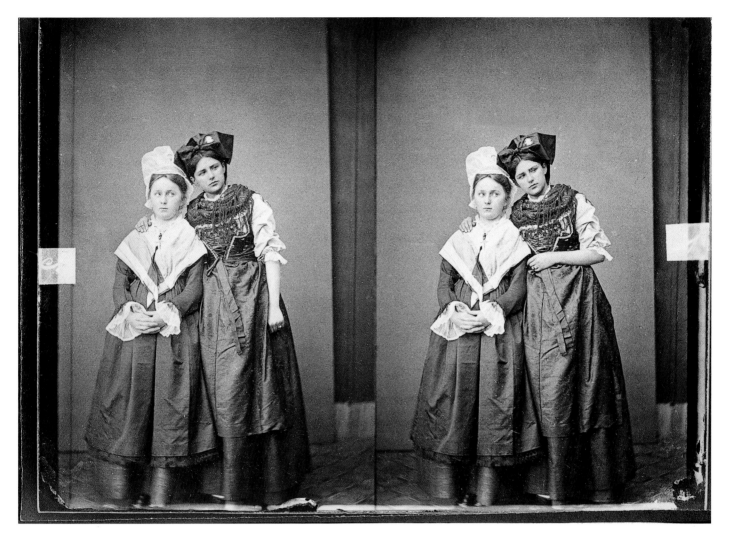

L'Alsace et la Lorraine
Alsace and Lorraine
Albumen silver print from uncut *carte de visite* negative
ca. 1871

truly regional icons. These images of lost provinces resurfaced in a variety of guises, including on postcards, engravings, and ceramic plate designs.

It is also necessary to mention the studio's other periodic projects. These were in response to local requests and do not show up in the catalogs: photographs for manufacturers, portraits, groups, and souvenir cards—the daily work of any local photographer. In this context, a more substantial reporting assignment was commissioned in 1861 by the chief engineer of Huningue's pisciculture, an experimental establishment for breeding and raising

fish, located near the Rhine on the outskirts of Mulhouse. In order to undertake the shoot, it was necessary to obtain preliminary consent from the Ministry of Agriculture, Commerce, and Public Works in accordance with regular administrative procedures. Attached to the report, published in 1862 by the establishment's director and conveyed to the regional authorities, was a book of photographs taken by Adolphe Braun. Unfortunately, neither the report nor the photographic material has survived; however, a work on Huningue's pisciculture was published in 1868. Laid out in atlas format, it contains various maps

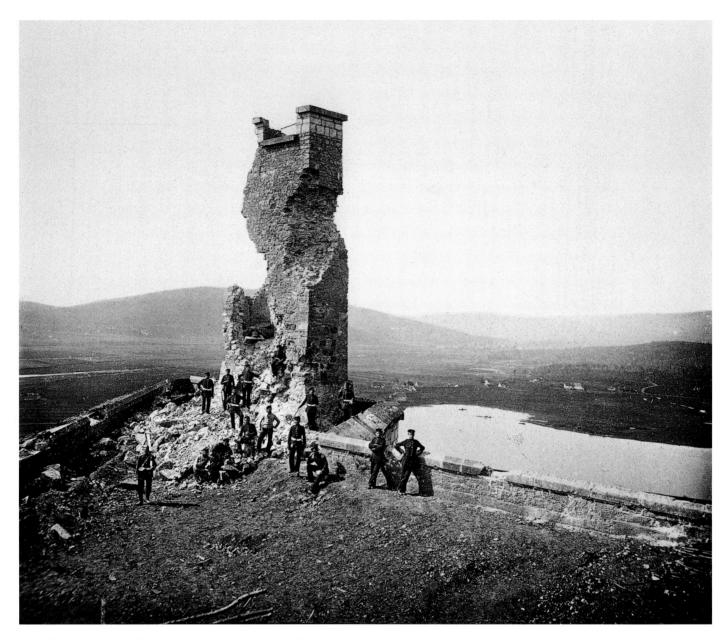

Le Théâtre de la guerre, 1870–1871: Belfort. La Tour de La Miotte
The Theatre of War, 1870–1871: Belfort. The Tower of La Miotte
Albumen silver print
1871

and twenty-four original photographs), without a single mention of their creator. In the absence of any other authorization requests, one must assume that these images were made some years earlier by Braun.[13]

Even as he was in the midst of launching his new panoramic format in 1866, Adolphe Braun was already interested in another project that was much more important to the future of his company: the reproduction of great artworks. In his eyes, this was going to be his personal masterpiece, the highest service he could render to Art. He wanted to bring drawings, paintings, and sculptures out from the confines of museums and private collections, by disseminating their likenesses to a larger public. This was not a new idea. From the beginning of photography, this potential had been foreseen, and a number of attempts, with

varying levels of success, had already been made. What made Adolphe Braun's proposition unique was the unequaled quality of his reproductions and the permanence that the carbon process gave his prints.

The high cost of photographic reproductions of artworks was discouraging to buyers because of the short life of prints produced with the unreliable silver process. To avoid this marketing problem, Braun tried several times to produce permanent prints using Émile Rousseau's iron-salt process. These attempts cost him a small fortune without usable results. He quickly replaced this technique with the double-transfer carbon process patented by the Englishman Joseph Wilson Swan, who started in business at Gateshead in Durham and later established an important workshop in Newcastle upon Tyne. The most significant advantage of the process was its use of permanent dye (lamp black at first, hence the name "carbon process"). In buying the French and Belgian rights to Swan's process early in 1866, Braun made a decisive choice that ensured the success of his project.

In spite of the relative complexity of the carbon developing process, Braun's results were clearly superior to those of competing companies. Soon after their release, it was no longer considered an option to obtain reproductions from anyone but Braun. While improving the process to produce varied hues and to make it workable on a large scale, he reorganized his studio and equipped it with a steam engine—an all-time first for a photography workshop—that generated the heat and energy required for production and treatment of several hundred prints a day. Adolphe quickly came to be considered the chief carbon-developing specialist. The reproductions of certain drawings, not just in blacks but also in sanguines, were said to be so perfect that they could fool an expert. From the first months

onward, Adolphe applied this technique with voracity to a feast of masterpieces. The first few series were put on the market in 1867: a selection of drawings and paintings from the Basel Kunstmuseum, the Louvre, the galleries of the grand duke and grand duchess of Saxe-Weimar-Eisenach, and the Albertina in Vienna. By the end of this first year, Braun and company had produced close to 2,500 negative plates!

The oldest of Adolphe's sons—Henri, who would eventually become a painter—decided to put his artistic

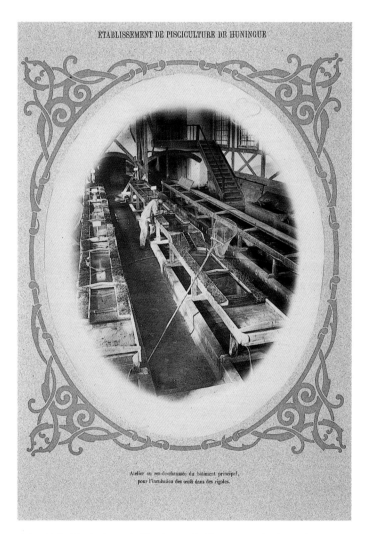

Atlas de la Pisciculture de Huningue. Atelier au rez-de-chaussée du bâtiment principal, pour l'incubation des œufs dans des rigoles
Atlas of Pisciculture at Huningue. Ground-Floor Workshop of the Main Building, Used for Incubating Eggs in Troughs
Albumen silver print
1868

27

knowledge to use and work for his father in the art-reproduction endeavor. He supervised and directed the trips, particularly to Italy, and was advised by Paul de Saint-Victor, a renowned art critic who volunteered his writing talents for such a worthy project. This support was greatly appreciated by Adolphe Braun, who, despite all his efforts and contrary to his hopes, had not received the kind of cooperation and backing he desired from the various bureaucracies involved. Braun would have preferred the art and design schools and museums to have made official systematic acquisitions. His reproductions—which increased with the hundreds and thousands of new subjects—made their mark mainly through the patronage of true connoisseurs and specialists. Braun's firm finally established dominance in this field through the signing of an exclusive thirty-year contract with the Louvre in 1883.[14] From that time, reproduction of artworks became their specialty, particularly since the landscape series, although in production to the century's end, no longer had the same appeal for a public that had discovered the postcard.

Adolphe Braun wanted to perfect his reproductions, particularly of paintings, by the use of full color, and he never stopped trying to do so. His painted photographs and his efforts at carbon developing with two hues in 1869 did not satisfy him. In 1872, he had confidentially unveiled to a few friends colored carbon prints developed by Gaston and called "Polychrome." They were simply imitations of oil paintings with colors applied directly to the back of the emulsion (gelatin layer) after it had been exposed and developed, but before it was transferred to the final sheet of photographic paper. It appears that this process was used for at least ten years, but only for portraits. A life-size colored likeness of Pope Pius IX in all his splendor

was presented to the Supreme Pontiff in 1875; others were shown at the Société Industrielle de Mulhouse exhibition the following year. Probable contacts with color photography pioneer Louis Ducos du Hauron were not followed up, nor was a joint research project, with the journalist and lawyer Paul Dalloz in 1875, on possible printing applications of Léon Vidal's *photochromie* process. Adolphe Braun's renowned enthusiasm and talent for technical innovation, experimentation, and development of new processes would have quickly discovered a solution to the question, if sudden death hadn't brought his research to a premature end.[15]

Braun's meteoric career was not without its problems. The profits from his success secured his social situation rather quickly at the start of the 1860s with the purchase of land, farms, and buildings; but as the progression of his work accelerated, it nearly brought about his downfall. The purchase of a variety of patents for the panoramic camera and for the processes of Rousseau and then of Swan in 1866; the relocation of his studio; the Franco-Prussian War; the varying profitability of different production runs all had damaging repercussions for his business at the beginning of the 1870s.

After Alsace was annexed by Germany, Gaston decided to remain a French national and settled down in Paris, where he married the daughter of Louis Pierson, a society portrait artist who worked on the Boulevard des Capucines. In 1872, Gaston formed a company, Pierson & Braun Fils, with his future father-in-law. Then Adolphe, even though he was heavily in debt, took over the Pierson studio in 1874, under the name of Ad. Braun & Fils, as it provided an invaluable and crucial commercial opening in Paris. In 1876 it was formed again as Adolphe Braun & Cie in order to bring

in new capital. This was accomplished without too many problems, thanks to Braun's excellent reputation. Adolphe died the following year, but the business endured. Due to Louis Pierson's personal investments and experience, and to the administrative abilities of one of his sons-in-law, Léon Clément, the business recovered and took the name Braun, Clément & Cie in 1889, then Braun & Cie in 1910. As political and economic uncertainties leveled out, the family firm expanded to form a worldwide network with several branches abroad, one being the Helman Taylor Company, which opened on New York's Fifth Avenue in 1895.

On December 31, 1877, surrounded by family members who had gathered in Dornach to celebrate the seasonal festivities, Adolphe Braun died a sudden death. With him perished the bright flame of innovation that had fueled the company and raised it to such heights. As a designer confronted with the advent of photography, he had successfully melded his artistic and commercial concerns. Few of his peers had succeeded in translating their skills with such talent. As an astute businessman, he had always known when to act, moving into fields his predecessors had lacked the courage to enter. Adolphe Braun was one of the first great photographic industrialists of the mid-nineteenth century.

1 For a more detailed account, see Sylvain Morand, "Les premières expositions de photographies en Alsace," *Cahiers alsaciens d'archéologie, d'art et d'histoire*, vol. XXXI (1988), pp. 205–12; and R. M. Lagoltière, "Mulhouse et la conquête photographique des Alpes et du Mont-Blanc," *Annuaire historique de la ville de Mulhouse*, vol. II (1980), pp. 39–63. See also Sylvain Morand and Christian Kempf, *Le temps suspendu: le daguerréotype en Alsace au XIXème siècle*. Strasbourg: 1989.

2 The brochure was entitled *Photographies de fleurs, à l'usage des fabriques de toiles peintes, papiers peints, soieries, porcelaines, etc., par M. AD. BRAUN, à Dornach, près Mulhouse (Haut-Rhin)* or *Photographic Flowers from Nature, by Ad. Braun, Dornach, near Mulhouse (Haut-Rhin)*. It was printed by P. Baret in 1855 at Mulhouse.

3 After the silver medal from the Société Industrielle de Mulhouse, Braun received the silver medal of the first order at the Paris Exposition Universelle in 1855; a gold medal granted by Empress Eugénie that same year; the medal of honor of the first order in gold conferred by the Académie Nationale Agricole et Commerciale (National Agricultural and Commercial Academy) in 1856; a snuff box presented by the Prussian King Wilhelm IV in 1856; a gold medal given by the Queen of England in 1857; and a medal from the London Universal Exposition in 1862.

4 Ernest Lacan, *Le Moniteur universel*, 7 March 1856.

5 The Mission Héliographique of the Commission des Monuments Historiques assigned the recording of French architectural patrimony to photographers Baldus, Hippolyte Bayard, Le Secq, Gustave Le Gray, and O. Mestral in 1851. The third project, given to Le Secq, covered Champagne, Lorraine, Alsace, and the department of Oise.

6 *L'Album de l'Alsace* consisted of seventy-six views (in seventy-three plates) for the Département du Haut-Rhin and forty-four views (in forty-three plates) for the Département du Bas-Rhin in its final version. Certain plates were panoramas consisting of two or three joined views. There are some additional views that are known to have been produced outside the edition.

7 Charles Grad, *L'Alsace, le pays et ses habitants*. Turckheim: 1843–1890. Grad was an engineer and Alsatian politician.

8 The series in 16 x 20 in. format came out in 1859; the Heidelberg views probably not until 1864.

9 There was also a stereoscopic series of *Animaux de ferme*.

10 It was a legal obligation to place on deposit with the office of the Ministry of the Interior an example of all printed material and of all works (literary, musical, etc.) intended to be reproduced in quantity or for sale. These examples were supplied for what was known as the *dépôt légal*. This stipulation also applied to photography, but had not yet been heeded by Adolphe Braun. This time he gave in under pressure from the authorities, who had been accused of negligence by the press.

11 Several authors who went on the trip told of Gaston's untiring energy, running to each stage to set up his tripod in order to attain the best plates. The catalog of Egyptian views, which came out in 1870, inventoried eighty images in a normal format and sixty in stereoscopy.

12 For more information, see Sylvain Morand, *Charles Winter, photographe: un pionnier strasbourgeois 1821–1904*. Strasbourg: 1985.

13 The 1862 report was published by Éditions Berger-Levrault in Strasbourg: *Notice historique sur l'établissement de pisciculture de Huningue* (Historical Account on the Establishment of the Huningue Pisciculture). At the end of June 1862, two copies and an attached album of photographs taken by Braun were submitted to the prefect of the Haut-Rhin. The *Établissement de pisciculture de Huningue, atlas des bâtiments et appareils, ponts et chaussées* (Establishment of the Huningue Pisciculture, Atlas of the Buildings, Machinery and Civil Engineering Works) of 1868 consists of eight double plates of maps and fifteen plates containing twenty-four oval photographs.

14 This contract, which made many envious, proved rather troublesome. More specifically, the firm had to reproduce seven thousand works, fourteen hundred of which were chosen by the museum, and had to supply the curators with all necessary prints at no cost.

15 I am much obliged to Naomi Rosenblum, an eminent historian of photography, for having generously provided her fascinating personal archives on Adolphe, Gaston, and Henri Braun from the time of their first art reproduction projects.

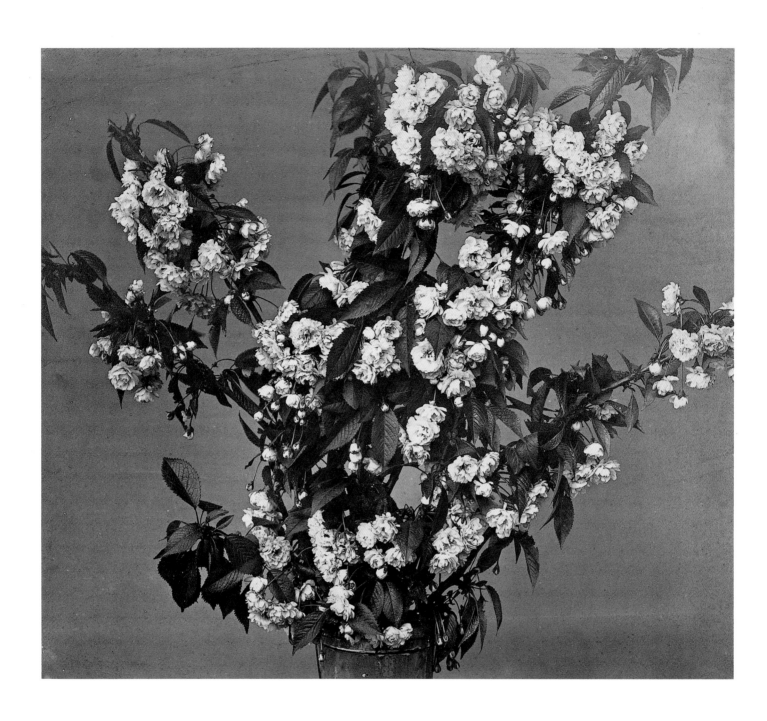

Fleurs photographiées (Fruit Tree Blossoms)
Photographs of Flowers
Albumen silver print
ca. 1854–1856

Reproducing Visual Images

NAOMI ROSENBLUM

THROUGHOUT THE ENTIRE nineteenth century, competing methods of reproduction vied with each other to meet the growing demand for visual illustration—whether the reproduction of existing works or the production of new images. Older processes were improved and new ones discovered or invented, among them photography, as artists and scientists sought ways to reproduce visual images quickly and inexpensively without losing the characteristics of the original work. In that Adolphe Braun and the company he founded were involved with many of these techniques, his career serves to illuminate the close relationship between photographic and photomechanical printing techniques that occupied so many minds of the time.

At the beginning of the century there were three types of printing surfaces in use, both for creating original works and for duplicating images wrought by others. The older intaglio and relief processes— wood and metal engraving, mezzotint, etching—had been joined shortly before the turn of the nineteenth century by the new medium of lithography, which added a technique of greater versatility.[1] Intaglio and relief methods of printing could be artful in themselves, but because these techniques required considerable skill and time on the part of the individual engraver, they duplicated original paintings and drawings with only varying degrees of accuracy and were also expensive. Lithography, while both less expensive and less time-consuming, also required a skillful artist to copy the design on to stone. So a search began for a means of reproducing in large numbers images drawn by others. In the 1830s, this search led to photography.

These were the methods of reproduction available during the years when Adolphe Braun's commercial enterprise was taking shape. As a designer of fabrics in Paris and Mulhouse, in an era of expanding industrial opportunities, his first foray into this arena was a collection of lithographed and engraved drawings meant to be useful to designers, *Recueil de dessins servant de matériaux, destinés à l'usage des fabriques d'étoffes, porcelaines, papiers peints &.&. Dédiés à Mr. Daniel Dollfus, par son Ami A. Braun*, published in Paris in 1842. The thirty plates represented botanical matter, either in black on white backgrounds or in reverse.[2] Shortly after the appearance of this collection,

Braun returned to his Alsatian homeland in Mulhouse, took a position as designer with Dollfus-Mieg—offered by the recipient of the dedication, Daniel Dollfus-Ausset—and eventually opened his own design studio.

By then, photography had been available for over three years, but its early processes were unsuitable for Braun's purposes. Although the Niépce brothers—mainly Joseph Nicéphore—working in France in the late 1820s and early 1830s, had experimented with light-sensitive varnishes and later with light-resistant bitumen, their attempts to transfer line engravings, made translucent by waxing, first to glass and then to metal plates were only marginally successful. Having been altered by Louis Jacques Mandé Daguerre and announced to the world on August 19, 1839, as the daguerreotype, the process could produce a unique image of actuality, captured by the action of light on a silvered surface sensitized with iodine. Despite efforts to etch daguerreotype plates and produce multiple impressions in ink, the finely detailed photographic image on the metal plate became valued for itself rather than as a means of replication.

In England, a similar desire to obtain copies of engravings (among other objects) prompted William Henry Fox Talbot's efforts. Talbot used sensitized paper as a negative and obtained positive prints by exposing another sheet of sensitized paper to light in contact with the first (see p. 35). Talbot had envisaged reproducing works of art by photography because, in theory, the paper negative could provide innumerable positive silver prints.[3] However, in the years immediately after the discovery of negative/positive photography, silver was expensive and the processing beset by problems. Paper grain was visible and prints faded or discolored when not washed properly or when glued with and to certain substances,

François Lemaître
Paper Proof from Original Heliograph of Cardinal d'Amboise
1827

making large-scale printing unfeasible. Talbot continued his researches and came up with an intaglio etching system—a forerunner of the photogravure method invented in Vienna in 1879 by Karl Klic.

This aspect of Talbot's research was based on the light-sensitive properties of potassium bichromate—now called dichromate—which hardens when exposed to light. This discovery, which had been announced by amateur Scottish scientist Mungo Ponton in the same year as the photographic processes of Daguerre and Talbot, was later advanced by French physicist Edmond Becquerel, who succeeded in increasing the sensitivity of the dichromate. Its importance for those interested in photographic reproduction centered on the characteristics of the hardened gelatin: when exposed to

Joseph Nicéphore Niépce
Cardinal d'Amboise
Heliograph on a pewter plaque
1826

light than either the daguerreotype or the paper negative and without the latter's visible extraneous textures. After exposure (while still damp) in a camera and then immediate developing, the negative could in theory be endlessly printed (see p. 34). Most commonly, this was done by contact on paper coated with a mixture of albumen and sodium chloride, which was then bathed in a silver-nitrate solution. The emulsion was slightly lustrous, and the tonality of the resulting print might be pale or rich, and the print itself lasting or ephemeral, depending on the chemical baths used and whether the print was toned in gold chloride. The photographer's care in washing; the character of the water; and the kind of mounting boards and glues used also affected the look and stability of albumen prints. Collodion glass-plate negatives were frequently treated by pouring varnish over them and tilting the plate, in order to make them less susceptible to atmospheric deterioration.

This collodion/albumen process, notice of which appeared in a news article in Alsace in October 1851, undoubtedly intrigued Braun, who embarked on a project to produce a set of three hundred large-plate photographic prints of flowers—life-size and some actually larger. Initiated around 1853 and presented to the Académie des Sciences in 1854, the six volumes of *Fleurs photographiées* were intended for use by "designers of fabric, wallpapers, porcelains, etc." It also was recognized at the time that these elegant flower images transcended mere usefulness.[4]

The production of these images was beset by problems. The flowers had to be arranged and photographed in daylight bright enough to expose the negative, which meant working during the warmer months when the flowers had a tendency to wilt in the heat. To make the exposure required that the operator first compose the image on the ground glass of a very

light, it cracks or reticulates into a network of unusually fine lines, precluding the need for a screen interposed between negative and print to break the tonal areas into discrete elements.

It was, however, the revolutionary changes in silver-process technology that first prompted Braun's involvement with photography. It was found that a mixture of collodion (a dissolved form of gun cotton in ether) and soluble iodide and bromide could be used to adhere a solution of silver nitrate to a glass plate, producing a negative base that was more sensitive to

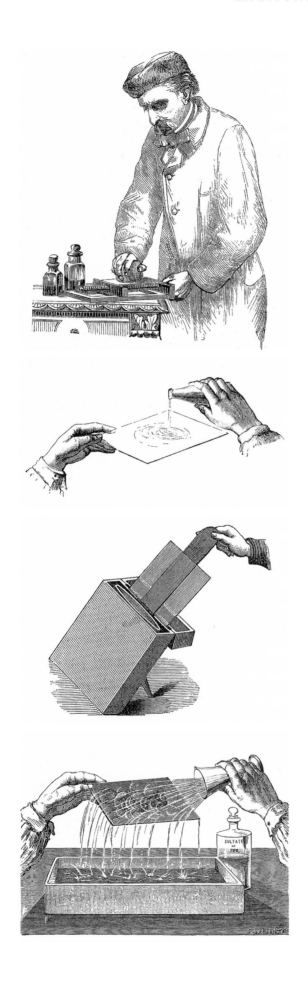

large camera, then retire to the darkroom to flow the collodion mixture, followed by a bath of silver-nitrate solution, on to the glass plate, and, finally, while still damp, insert it into the camera. Exposure time might be as long as half an hour with the lens closed down, in order to assure sharpness and because the collodion solution was not equally sensitive to all colors of the spectrum. The exposed plate was removed from the camera to the darkroom and processed immediately, usually in pyrogallic acid. Printing was done in daylight on paper recently coated with sensitized albumen and mounted in frames. Since the first set of flower images measured about 16 x 20 in. (40 x 50 cm.), handling the glass plates was in itself a feat.

When shown at the 1855 Exposition Universelle in Paris (and again at the London Universal Exposition of 1862), the large-format albumen flower prints were greatly admired, but proved too costly—at 1,200 francs for the album—for textile artists and art students. Braun therefore reduced the size and the price. Between 1856 and 1858, large prints sold for ten francs each, while the smaller format could be bought for six francs.[5] The production of so many glass plates—some five hundred over time[6]—and the making and mounting of several editions of albumen prints obviously required a workforce, which consisted initially of several members of the Braun family and eventually of two outside photographers. Undoubtedly, experience with this workforce along with the accolades that greeted the flower images convinced Braun that photographic

Artist unknown
Engravings from Various Photography Manuals,
Showing the Polishing, Coating, Sensitizing
and Developing of a Collodion Glass Plate

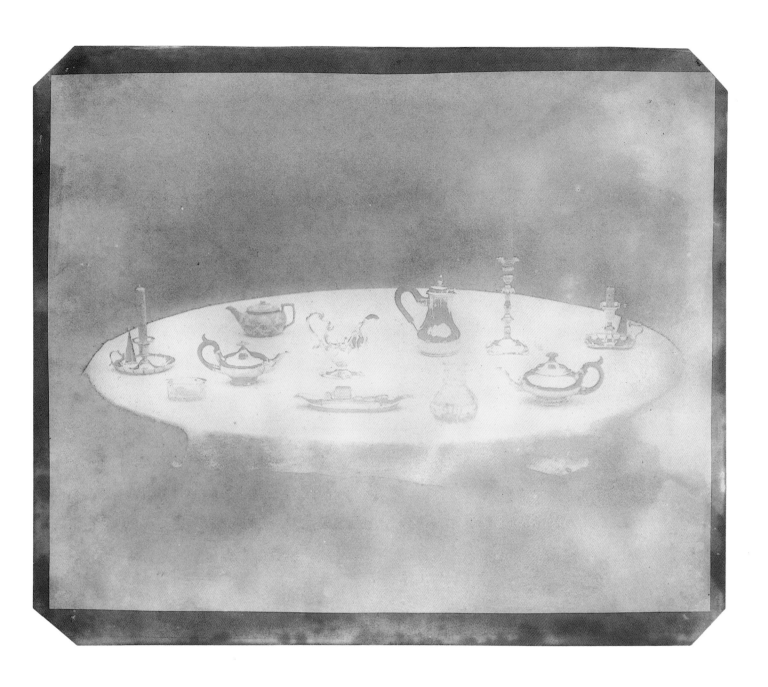

William Henry Fox Talbot
The Breakfast Table
Potassium-iodine stabilized salt paper
print from camera paper negative
1840

printing could become commercially viable and prompted him to turn his attention from designs for fabrics to other photographic formats and themes.

Photographers—Braun included—were aware during the late 1850s and throughout the 1860s that the high cost of large collodion/albumen photographs limited sales, so they searched for less expensive formats. The calling-card portrait was one response, and the stereographic view was another: both used collodion for the negative and albumen for the print. The *carte de visite* image, measuring approximately 3 x 2½ in. (7.5 x 6.5 cm.) but attached to a larger cardboard mount, had been popularized by André-Adolphe-Eugène Disdéri in 1854. This method of making a number of portraits—usually eight—in a variety of poses on the same plate, using a camera that incorporated dividing septa and a means of advancing the plate laterally, substantially reduced costs; the multiple images were printed on a single sheet of albumen paper, cut apart, and then glued to small mounts. Furthermore, the portraits were too small to require expensive retouching by hand.

Stereography is based on the capacity of eye and mind to see an image in three dimensions. When two photographs of the same subject, taken from two slightly different lateral positions (corresponding to the position of the human eyes), are placed in a special viewer, the illusion of three dimensionality is created whether the images are glass positives, daguerreotypes, or prints on paper. This optical property had been discovered long before the advent of photography, but in 1838 in England Charles Wheatstone demonstrated a device called a "reflecting stereoscope," whereby two separate drawings of geometric shapes, superimposed by projection with the aid of mirrors, appeared to converge into one three-dimensional object. Over

the next thirty years, the Scottish scientist David Brewster perfected a viewing apparatus or "refracting stereoscope" in which two images, taken by two lenses placed about 3½ in. (9 cm.) apart (initially with two cameras, eventually with a single camera with a septum and two lenses [see p. 39]) and mounted side by side on a rectangle of cardboard, could be made to seem three-dimensional.

For producing stereographs, as the doubled images were called, the collodion/albumen process promised to be less tenuous than for larger works. As with the *cartes de visite*, the small size—2¼ x 3¾ in. (6 x 9.5 cm.)—required less exposure time, and the kind of care and retouching needed for larger-format prints was unnecessary. While still not entirely factory-produced, they were generated in their hundreds of thousands, because by 1857 the stereograph had taken hold of the public imagination. The necessary viewing apparatus, the stereoscope, was manufactured in a variety of sizes, shapes, and models, the most popular being a hand-held device with two eyepieces and a movable holder into which the stereograph card could be slipped. By the 1860s, this photographic format had become a means of both household entertainment and education for the middle classes, in part through the publicity accorded it in photographic journals, such as the *Atlantic Monthly* in the United States.[7]

Publishing firms and dealers in England, France, the German-speaking nations, and the United States, which circulated such prints in their millions, either hired photographers themselves or bought stereograph images from photographic outfits. Braun's first efforts with stereography were marketed initially by Alexis Gaudin's firm in Paris and publicized in the journal *La Lumière*. The first subjects were flowers, followed by a series called *Paysages animés* (Animated Landscapes).

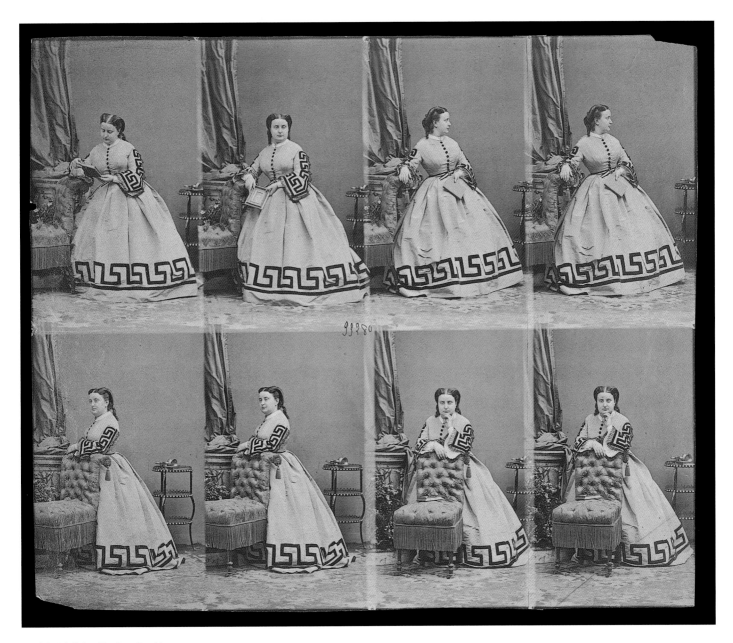

André-Adolphe-Eugène Disdéri
Princess Buonaparte Gabrielli
Albumen silver print from an uncut *carte de visite* negative
ca. 1862

These images were unusual in that they showed groups of country people—peasants, fishermen, hunters, etc.—disposed in a typical landscape or positioned around an edifice. Taking advantage of the short focal length of the stereograph lens, which usually allowed movement to be arrested without blurring, Braun's operators captured more animated and lifelike scenes than were possible on larger negatives. Braun's views

of Paris streets and boulevards, with their swiftly moving figures only occasionally out of focus, forcefully suggested the vivacity of city life. Shortly after these subjects appeared, the Braun firm began to issue touristic stereograph views of the regions of Europe that were becoming popular among rail travelers.

As individuals began to travel for pleasure during the mid-nineteenth century, photographers recognized

the commercial value of providing them with visual souvenirs, and especially with inexpensively priced stereograph views that seemed to bring back the actual experience. Braun was quick to appreciate the business possibilities of documenting scenery in this format. In 1860 he sent his operators to the Rhine valley, and in the following years, they covered the Alps in Switzerland and Savoy, the German countryside, the south of France, Paris and its environs, Belgium, and Holland. Views were printed on both albumen and carbon papers in several formats and sizes.

Alsace figured prominently in both Braun's stereograph and large-format views. His pride in a region that had accrued to France (and would soon be detached and returned to Germany), derived from patriotic feelings and from his desire to gain acceptance in the court of Napoleon III. When the albums, with their depictions of an area near Konstanz where the Emperor had spent part of his childhood, were sent him, they elicited a decoration, a gift, and the right to use the title Photographer of His Majesty the Emperor.[8] Other themes, issued as albumen prints in a variety of formats, included costume pieces—usually a young woman wearing the distinctive regional attire of a Swiss canton—and farm animals. A later series of costume images of Alsace and Lorraine, made in 1871 or 1872 after the two regions had been ceded to Germany as a result of the Franco-Prussian War, reflected the loss felt by Braun, a dedicated Francophile.

All of Braun's views made during the 1850s and much of his work from the 1860s were produced by the collodion/albumen process. This required that the operators, whether in the Alps or on the Rhine, carry with them portable darkrooms as well as cameras and glass plates of different sizes. Although bearers were available for portage, the processing still had to be done in less than ideal circumstances. In addition, once the glass-plate negatives had been returned to Mulhouse, a workforce was needed at the printing shop to prepare the images for sale. It is estimated that the firm published almost seven thousand stereograph views between 1858 and 1873, as well as large numbers of works in other sizes and formats.[9]

One of the cameras taken along on these photography expeditions produced panoramas—views that embraced an angle greater than ninety degrees. Undoubtedly inspired by the popularity during the early nineteenth century of painted panoramas, such expansive views were achieved, at first, by joining together a series of contiguous photographs and, later, by using a specially constructed camera. The Pantascope used by Braun's operators was built in Paris in 1862 by David Hunter Brandon, from plans patented in England by John R. Johnson and John A. Harrison. It was demonstrated in 1865 to members of the Société Française de Photographie.[10] The glass plate moved slowly on a lateral course by means of a carrier equipped with rails, while the lens, governed by clockwork, turned in an arc of about 120 degrees. This device made panoramas in two sizes, the larger produced by a camera that was greater in size than its British progenitor. Braun's interest in the panorama format began in the mid-1860s, at a time when stereographic views were flooding the market and a photographic novelty may have been seen as necessary for his firm's continued economic well-being. The panoramic views of the Alpine region of Savoy, recently ceded to France, captured the vast snowy expanses in a suitably novel format.

Braun (and his contemporaries) had embraced the collodion/albumen process because they believed that it would provide an inexpensive means of replication,

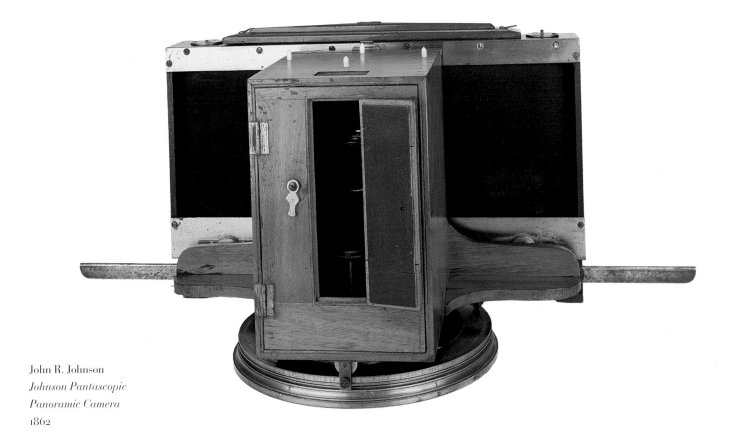

John R. Johnson
Johnson Pantascopic
Panoramic Camera
1862

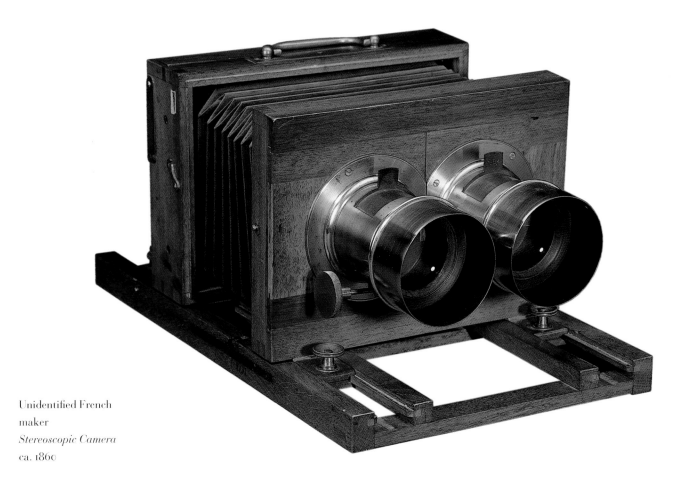

Unidentified French
maker
Stereoscopic Camera
ca. 1860

perhaps even taking the place of engraving and lithography. However, the fact that albumen prints faded or became spotted in a variety of circumstances soon became evident. In addition, weather conditions could make the processing slow and costly, prompting photographic firms that produced large editions to seek non-silver processes that would result in *inaltérable* (stable) prints at lower cost. This became possible with the improvement of processes based on gelatin and dichromate. French civil engineer Alphonse Louis Poitevin added carbon-black coloring matter to the mixture in 1855, resulting in the so-called *procédé au charbon* (carbon process), even though pigments of different origins and colors were eventually used. At first, this stable, non-silver process did not reproduce the full tonalities of the negative—the lighter ranges were lost—so throughout the late 1850s and into the next decade, individuals experimented with these materials, coming up with a number of different recipes for working with carbon, dichromate, and colloidal substances. Eventually, the problem with the lighter tones was solved by exposing the negative against the uncoated side of the prepared paper, which resulted in a reversed image, which was then transferred to yet another sheet of paper, thereby giving this method the name of the carbon transfer process. Although introduced in France in 1860 and in England in 1861, the process became more feasible in 1864 when a method of making carbon tissues was patented by Joseph Wilson Swan in England. Braun worked for a short period with Émile Rousseau to improve Poitevin's carbon process, employing this method for some of the earliest reproductions of drawings in the Basel Kunstmuseum.[11] but in 1866 he purchased a franchise from the Swan Company for carbon printing in Belgium and France.

In what was one of the most difficult parts of the procedure, long sheets of paper for transferring the image from the negative—the carbon tissue—were lightly and evenly coated by machine with a mixture of dichromated gelatin and coloring material. After exposure to daylight against the glass-plate collodion negative, during which the gelatin hardened in proportion to how much light passed through, the carbon tissue was placed gelatin side down under pressure against a sheet of transfer paper, coated with plain gelatin. Placed in a bath of warm water, the paper backing of the carbon tissue was removed and the pigmented gelatin remained attached to the transfer paper. A second bath washed away unexposed, and thus unhardened, gelatin, leaving a positive image.

Carbon printing became Braun and company's preferred process for reproductions of artworks, except for a period shortly after the end of the Franco-Prussian War, when the firm employed *photoglyptie* (the Woodburytype) for creating large numbers of small-format reproductions. This exceptionally faithful method of reproducing camera images, which had been invented by Walter B. Woodbury, a British photographer who took out a patent in 1864, was similar to carbon printing, except that clear gelatin was used and part of the process was mechanized. A relief matrix was made by exposing a negative against a sheet of colorless dichromated gelatin, which became harder and thicker in the areas where more light passed through, and remained less so in the areas that received less light. To obtain prints, the gelatin relief was forced under pressure into a lead sheet, creating a mold into which colored gelatin (or ink) was poured. After pressure was exerted to transfer the coloring matter from mold to paper, the positive image was soaked in a hardening solution and trimmed.

Produced without screens or particulate matter, the Woodburytype, like the carbon print, made exceptionally accurate reproduction possible, with the added quality of stability. Between 1868 and 1880, the process was used extensively for reproductions in publications, one of the best-known examples being the more than three hundred editions of portraits of French worthies known as the *Galerie contemporaine*, published by Goupil & Co. Its disadvantage was the need to trim the print before mounting it, in order to cut away the excess gelatin or ink pressed out around the edges, but its demise was also hastened by competition from various collotype processes and by the discovery of a method of continuous tone reproduction of image and text on the same page. After several years, Braun's firm appears to have abandoned the Woodburytype in favor of carbon printing for all its products.

The collotype, also invented by Poitevin, was a planographic method that made possible a photographic reproduction based on the principles of lithography. It, too, employed the effects of light on dichromated gelatin, which reticulated to form the code of minuscule dots needed to break up the continuous tones of the photograph for printing. Greasy ink was applied to the stone (later to a metal plate) and the image was transferred to paper. The process was known as the Albertype in Germany and the United States after improvements were made by Joseph Albert of Munich; as the Autotype in Great Britain; and as the Phototype in France. It was deemed more practicable than the Woodburytype because the image could be printed with a border and did not require trimming, although it, too, could not be printed at the same time as the text.

In purchasing the carbon franchise and then perfecting its industrial use, Braun's firm was in a position to out-perform other photographic enterprises

GALERIE CONTEMPORAINE

GEORGES SAND
Née à Paris, le 5 ,uillet 1804, morte à Nohant, le 8 Juin 1876.

Gaspard-Félix Tournachon (Nadar)
Georges Sand [*sic*]
Woodburytype
ca. 1860 (printed ca. 1877)

in terms of the number and quality of reproductions, first of drawings and then of paintings and sculptures. The introduction of steam machinery into the Braun factory at about the same time as the purchase of the carbon franchise enabled the firm to mechanize carbon and Woodburytype printing. The establishment at Dornach was considered impressive for its time; except for paper, everything needed to make the prints was produced on the premises. One signal advance was the use of steam power to grind the coloring pigments to an exceptional fineness; another was the introduction of colors other than black, namely sepia and a reddish purple, and later sanguine, green, and blue. The hues

chosen for the carbon prints related to the master drawings being reproduced. By 1869, Braun was able to combine two differently colored tissues. The photographs appeared to render the coloring of the originals so accurately that the term "facsimile" was used by critics referring to these prints.[12]

For his first art-reproduction campaign in 1866, Braun photographed some three hundred drawings in the Musée du Louvre and some 140 in the Basel Kunstmuseum. Between that time and 1869, the Braun group—among them his sons Gaston and Henri—worked in museums in Vienna, Florence, and Venice, and in the Sistine Chapel and Palazzo Farnese in Rome, photographing frescoes as well as works in monochrome. Interrupted by the Franco-Prussian War, the reproduction business commenced again in the fall of 1871, this time with the objective of portraying sculpture and major paintings in museum collections. The campaign started at the Louvre and moved on to include museums in Dresden, Holland, and Luxembourg. The firm also made reproductions of modern paintings by Théodore Rousseau and Jean-François Millet, and in the early 1870s sent operators to London to photograph in the British Museum, the National Gallery, and the Museum of South Kensington (now the Victoria and Albert Museum). After Adolphe Braun's death at the end of 1877, his son Gaston continued the campaigns, becoming in the process an expert in color chemistry.

Efforts to photograph works of art were greatly aided by the activities of Paul de Saint-Victor, art critic first for *La Presse* and after 1868 for *La Liberté*. He suggested works of significance, facilitated entry to museums, and publicized the results.[13] Among the problems faced in various museums were insufficient light and, in the Vatican especially, locations requiring

substantial scaffolding to obtain access for the cameras, innumerable festival days that interrupted the work, and unusually large crowds of people that got in the way. In photographing the sculpture at the Louvre in 1871—for which Saint-Victor's intervention had been propitious—operators working in natural light could not always select the best angle; Braun considered the resulting photographs to be less than satisfactory.[14]

A series of some six carbon still lifes made by Braun in 1867 merit discussion because they offer insight into Braun's thinking about the service photography could render to art and culture.[15] Of exceptionally large format (32 x 24 in. [80 x 60 cm.]), the images are of dead game—stags, rabbits, ducks—arranged with articles of the hunt—pouches, nets, etc. They appear to have been an attempt to capitalize on the traditional taste in the northern regions of Europe for paintings with "after the hunt" subjects to be hung in dining rooms. Expensive by photographic standards at the time, but low in cost compared to paintings, these images reflected the belief embraced by Braun (and others) that photography held the key to democratizing art, by providing not only models from which artists might work, but photographic substitutes for paintings and drawings as well.

Undoubtedly, the most significant contribution to this idea were the photographs of great works of art. Introducing the middle classes to masterpieces was seen by bureaucrats and industrialists as a means of upgrading the taste of people who only recently had been peasants and tradespeople. By 1859, a number of photographers throughout Europe were already engaged in this pursuit.[16] Because they were accurate and relatively inexpensive, photographic art reproductions were initially conceived as a means of improving the training of young artists, which was

important to the French nation's continued primacy as the purveyor of luxury decorative goods. Sales of reproductions could be made not only to individuals, but also, and more importantly, to art schools, libraries, and museums in France and elsewhere.

The reproductions could be considered inexpensive when compared with the prices of the original works of art. Produced in a variety of sizes, ranging from 5 x 7 in. (13 x 18 cm.) to 26 x 32 in. (65 x 80 cm.), they were marketed both individually (priced between two and nine francs each, according to size) and by subscription (priced between 88 and 8,005 francs, depending on size and number of prints from a particular museum).[17] Nevertheless, despite critical recognition of their excellence, support from the French government did not materialize. To market its products commercially, Braun's firm had to sell them abroad, mainly through dealers, to art schools, libraries, and individuals in England, Germany, Russia, and the United States, rather than in France.

One may refer to the art reproductions as "products" because in effect Adolphe Braun had transformed himself from artist/craftsman into industrialist and the photographic print from handmade artifact into mass-produced object. This object, however, could never be as cheaply produced photographically as printed photomechanically, and, despite Braun's belief that he could bring to fruition his early dreams of finding in photography a substitute for ink printing, photomechanical methods took over. After Braun's death, the firm remained steadfast in its commitment to reproducing works of art, eventually switching from carbon printing to the gravure process.

[1] Luis Nadeau. *Encyclopedia of Printing, Photographic, and Photomechanical Processes*. Fredericton (New Brunswick): 1994. p. 155. Thanks are due to Nadeau for the descriptions of the processes with which this article is concerned.

[2] Pierre Tyl. *Adolphe Braun: photographe mulhousien, 1812–1877*. Dissertation, University of Strasbourg. 1982. p. 14. Besides the inscription "Braun del." the plates bear the names of various engravers, lithographers, and printers; all appear to be printed by a combined lithographic and engraving process.

[3] The last publication of Talbot's printing establishment in Reading was *Annals of the Artists of Spain*, 1847, for which Nicholas Hennemann had made sixty-six reproductions of paintings, etchings, and drawings by Spanish artists. See, H. J. P. Arnold. *William Henry Fox Talbot: Pioneer of Photography and Man of Science*. London: 1977. p. 158.

[4] D. Koechlin-Ziegler. "Rapport sur les photographies de M. A. Braun." *Bulletin de la Société Industrielle de Mulhouse*, vol. XXVII (January 31, 1855). p. 5.

[5] The flower pictures were listed in Braun and company's catalog until 1887. Tyl, op. cit., p. 43.

[6] Today, only forty-three plates and some sixty prints remain: ibid., p. 30.

[7] Oliver Wendell Holmes. "The Stereoscope and The Stereograph." *Atlantic Monthly*, vol. VIII (June 1859), pp. 738–48; this article was one of the fullest treatments of stereography, but other articles appeared in major photographic publications in Europe.

[8] An intaglio print bearing the text, "Photographe de Sa Majesté, l'Empéreur," was given the author by Pierre and Audrée Braun, descendants of Adolphe, when she visited them in Toulon in 1973.

[9] For a breakdown of views published in various formats between the years 1858 and 1866, see Tyl, op. cit., pp. 57–69.

[10] *Bulletin de la Société Française de Photographie*. Paris: 1865. p. 6. My thanks to Fred Spira for information on the Pantascopic camera.

[11] A reproduction of a Holbein painting in the Basel Kunstmuseum, now in the collection of the George Eastman House, Rochester (New York), bears the stamp "procédé Poitevin-Swan" and the address "14, Rue Cadet," Braun's early Paris address.

[12] On several occasions in 1869, Braun presented the Société Française de Photographie with examples of the reproductions. The colors used were black for the shadow areas and sepia for the other tonalities. See *Bulletin de la Société Française de Photographie*. Paris: 1867. p.15; 1869, pp. 9 and 184.

[13] A series of thirty-eight letters from Adolphe, Gaston, and Henri Braun to Paul de Saint-Victor in the author's possession testify to this intervention.

[14] Adolphe Braun to Paul de Saint-Victor, 1871; collection, the author.

[15] These images were called *Panoplies de gibier* or *Sujets de chasse*. Six were announced in the Braun and company catalog of 1867, eight in a catalog of 1887, and seven in 1912; see Christian Kempf, *Adolphe Braun et la photographie*. Strasbourg: 1994. p. 45. The exact number of works in existence is unknown. See Laure Boyer, *Adolphe Braun et la reproduction photographique des œuvres d'art*. Dissertation. University of Strasbourg. 1998, p. 16.

[16] Braun was not the first to reproduce works of art. Writing in 1859, Philippe Burty noted the great interest that year "in photographs of paintings and drawings." The article mentions the work of Robert Jefferson Bingham, Caldesi & Montecchi, Sacchi, and the Alinari brothers (Leopoldo and Giuseppe). In addition, the Bisson brothers and Charles Marville had photographed works of art: "Exposition de la Société Française de Photographie," *Gazette des beaux-arts*, vol. II (May 1859), p. 218.

[17] Tyl includes a list of the prices of individual reproductions in various sizes, as well as the price of subscriptions to the albums of prints from various museums: op. cit., pp. 122–24.

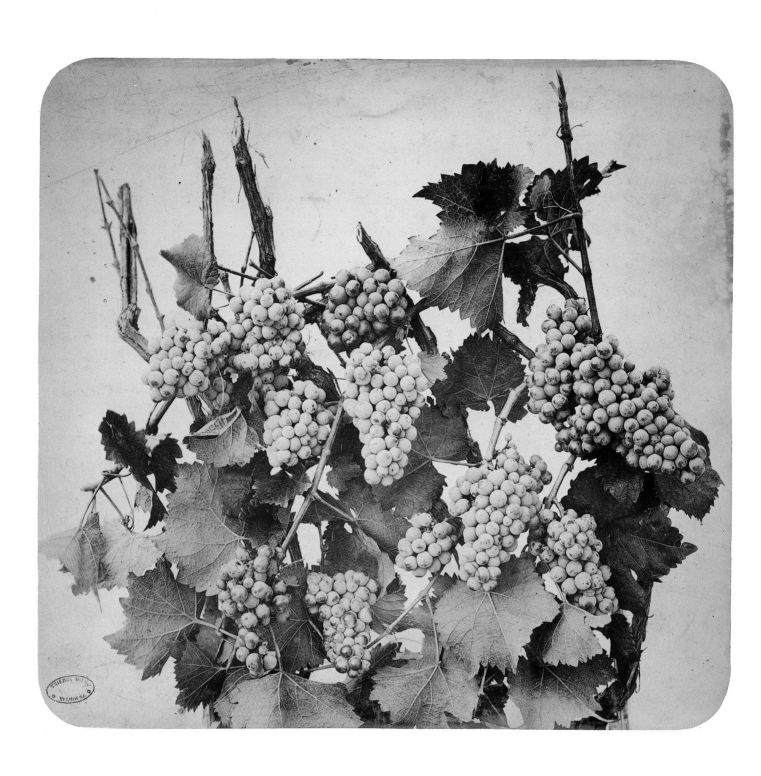

Fleurs photographiées (Grappes de raisin)
Photographs of Flowers (Grapes)
Albumen silver print
ca. 1854–1856

Adolphe Braun and Textile Design

SUSAN HAY

Although Adolphe Braun is best known as a photographer, it would be equally appropriate to call him a textile designer. He began his working life in Paris in the 1830s as a designer of printed textiles; this career earnt him a comfortable living, which later afforded him the time and the capital to undertake his photographic experiments. The textile design firm he founded in 1847 in Dornach, near Mulhouse (Alsace), was an instant success and continued to operate until 1872, concurrently with his photographic business.

The two careers of Adolphe Braun were, in fact, closely related, and Braun's interest in both was a result of the interdependence of industry, art, and science in mid-nineteenth-century France. Born into a Mulhouse family, he was surrounded by uncles and cousins who were dyers, colorists, printers, and designers in the textile industry there, the structure of which brought all these men into close contact with the oligarchy of factory owners. The latter recognized the importance of art and science for their industry, were concerned with the education of their workers, and took an active part in the scientific experimentation in mechanics and chemistry that could be applied to the betterment of textile manufacturing. To this end the businessmen of Mulhouse brought together representatives of both science and the arts in their Société Industrielle de Mulhouse, founded in 1826. Chemists, industrialists, economists, and designers were all recognized as belonging to the same intellectual milieu.

It was this combination of designers, scientists, and industrialists that ensured the primacy of Mulhouse as the chief producer of well-designed, beautifully printed cottons that were expensive, but appealed to the transnational European market. The same group of men educated their sons by sending them to Paris to finish their training in chemistry (Daniel Koechlin), physics and mechanics (Daniel Dollfus-Ausset), or design (Adolphe Braun).[1] These Parisian connections were not only profitable to the textile industry, but also meant that the men of Mulhouse knew the principal national players and could share in technical advances being made in Paris in medicine, microscopy, and, eventually, photography. Adolphe Braun was well placed to use these innovations not only in his textile-design career, but also as a base from which to launch his second career, photography.

In 1878 Braun's family gave ninety-four volumes of designs and textile samples owned by Adolphe Braun to the Musée de l'Impression sur Étoffes at the Société Industrielle de Mulhouse. Thanks to this gift, Braun's textile career—his design processes and his use of images taken in the 1840s from medicine and microscopy and in the 1850s from photographs, a first in textile history—may be followed up to 1854, when he published his initial series of flower photographs (*Fleurs photographiées)*, intended to aid designers. Volumes of other manufacturers' textile samples from Mulhouse and elsewhere attest that these photographs were indeed put to use at a time when Mulhouse was the primary location for French textile printing.

It may be difficult to comprehend, in an era of cheap, machine-printed cottons with production runs of thousands of yards, how rare and coveted printed textiles were in eighteenth- and nineteenth-century Europe. Previously, India had monopolized both the trade in cotton and the secret and time-consuming method of creating patterns in fast colors with stamped or painted dyes. In the seventeenth century, however, East India companies in Europe began importing Indian painted textiles of the highest quality, as cargo on their return voyages, together with spices and tea from Asian regions farther east. These chintzes (from the Hindu *chint* meaning spotted or variegated) were patterned with delicately detailed floral patterns that to Westerners appeared exotic and fantastic. Their popularity was instant.

Chintz was brought to Paris in about 1658, and after 1664 the French East India Company imported thousands of pieces per year. Manufacturing concerns had been founded in the south of France by at least 1648, and the dyeing process was described in a 1693 publication by the Dutch official Daniel Havart. By 1686 the silk and linen weavers of France were so alarmed by the competition that they demanded protection. Royal edicts of 1686 and 1689 prohibited the import, manufacture, and wearing of chintz.

European consumers of printed textiles were so taken by the colorful and practical lightweight cottons with their fast dyes that they continued to buy smuggled Indian cottons. The French East India Company itself ignored the laws.[2] Parisians from the Marquise de Nesle to Madame de Pompadour openly wore chintz, and the latter decorated a complete apartment at Bellevue with chintz hangings. By the 1750s it was evident that the prohibitions would never achieve their goal and moreover prevented France from developing a profitable industry. Repeal of the proscription in 1759 allowed the manufacture of chintz in France, while the ban on the import of Indian cottons was kept in effect until 1774.

From the beginning, good design was recognized as key to the success of a printing business. At the first prosperous French manufactory of printed textiles, located in the Cour des Princes, in the Arsenal district of Paris near the Bastille, Swiss workers had a contract "to engrave and design all the patterns that might be ordered...on the condition that the company will pay eighteen livres weekly, plus lodging."[3] By 1759 the designers had forced several local factories to compete for their services, increasing their already elevated salaries to twenty-four livres weekly. As additional factories began operating, designers and engravers continued their dominance; in 1789, at the great Jouy factory outside Paris, they received daily wages of three times those paid to the average worker. The factory owner, Christophe Philippe Oberkampf, acknowledged that "the design is the most essential thing in facilitating the sales on which the prosperity of the

factory depends," and hired as his chief designer the court painter Jean-Baptiste Huet, who is associated with many of the most beautiful designs that were printed at Jouy with a refined technique using large copper plates.[4] European engravers further improved the Indian processes, but each blockprinted design, still used for printing dress fabrics, required the exact cutting of up to fifty different woodblocks.

In the 1770s, British printers began to use mechanical presses with engraved copper rollers, a faster but still labor-intensive process that enabled the country, with its already large trade in imported white woven cottons that were then printed in Britain, to seize the lead in the international export market. By the 1820s the British industry was centered in the Midlands, where large runs of low-cost textiles were produced both for the British middle classes and for export.

The growth of competition with Great Britain further emphasized the designer's role in production. After the Revolution, Napoleon took the lead in patronizing and reviving the decorative arts to encourage industry. Throughout the nineteenth century, government support helped the French to reconstruct the luxury market among society's new bourgeois leaders. By the time of Adolphe Braun's birth in 1812, the luxury trades were well established. While Great Britain was ahead of France in terms of the mechanization of production, both sides recognized that French design was artistically superior. Unfortunately, elegant French handmade or hand-finished porcelains, silks, and furnishings were too expensive for all but a small section of the market. In the face of British competition, then, excellence of design was of the utmost importance. The question being asked in the 1830s, therefore, was *how* could French designers maintain their artistic superiority?

On the British side, there were calls to introduce the fine arts into industry through improved design models and through improved education for designers. The Select Committee on Arts and Manufactures, formed in England in 1835, found that the French "seem to have an art of design in employment, perfectly in union with their manufacture; in fact, art dwells with manufacture more in France than in England." The remedy required governmental action.[5] The Government School of Design was founded in London in 1837, closely followed by institutions to promote better design among students preparing for careers in architecture, crafts, and design in Manchester and in other industrial centers.

In France similar solutions were offered. The members of the Société Industrielle de Mulhouse were among the first to recognize the importance of encouraging good design, particularly in the field of printed textiles, where low-cost English products threatened to push out the better-designed, carefully printed, but more expensive French products that were better suited to the top end of the market. In founding the first design school in Mulhouse in 1829, the society was motivated by "the necessity of staying ahead of everyone else in the perfection of the work...with such a superiority in execution and good taste" that Mulhouse printed goods would still be sought despite their relatively high price.[6]

Adolphe Braun's education reflected the growing fear of English competition in Mulhouse. Although it was completed before the founding of the design school, he did attend the *école industrielle*, the special secondary school for industrial design. Thanks to the particular interests of Mulhouse industrialists, emphasis was given to science and mechanics as well as to calligraphy and design, a concept that was still foreign in English schools. Under an 1831 curriculum, these

subjects consumed nineteen out of twenty-nine or thirty hours weekly.[7] At age sixteen, Adolphe Braun was ready to apply his training in both science and art to his design career, and set off for Paris to complete his education with an apprenticeship in the capital.

As the court at Versailles had been before it, Paris was the center of fashion in France throughout the nineteenth century. The most elegant designs, the most harmonious color combinations, the latest fashions in silks, embroideries, shawls, and other elements of feminine toilette were reputed to be found in the capital.[8] Designers there were often patronized by manufacturers whose factories were located far away. Because of the connections of the Mulhouse industrialists with the intellectual community in Paris, the young apprentice designer had the opportunity to come into contact with artists, designers, chemists, and physicists who were developing new processes. Thanks to his Mulhousian education, Braun could comprehend and adapt their discoveries.

Adolphe Braun apprenticed in several studios in Paris before opening his own at 9, Rue Mandar. He later formed the company of Braun et Cantigny at 27, Rue Paradis-Poissonnière in 1834, the year of his marriage. After only a few months, this partnership dissolved, leaving Braun to carry out his design work from several further addresses in the same neighborhood. In 1838 he began a new and short-lived career in the company called Auguste Levasseur and Adolphe Braun, listed variously in the Almanach-Bottin du Commerce as "textile printers," "manufacturers of novelties," and "merchants of novelties," selling goods that were bleached and printed by contract. This business also failed rapidly and was liquidated in 1840.

After these ill-fated ventures, Braun returned to his original plan and opened a new studio on the fourth floor of a six-room apartment at 20, Rue Saint-Fiacre. The workroom was furnished—with two painted tables, seven small desks and an oak desk, seven copper lamps, eight chairs, and an armchair—for six designers and Braun himself. The rest of the apartment was occupied by Braun and his young wife, Louise, and their children.[9]

Here the process of producing printed textiles began, with an order from a factory owner or with simply a design drawn on speculation, which was then developed for block or roller printing. Braun's design notebooks show that he usually completed a pen or pencil sketch first, before carrying out the design in gouache, which he then delivered to the customer. A notebook dated 1838 contains records of designs sold to more than twenty different customers, who unfortunately cannot be identified with printing factories as a result of lack of documentation. The profusion of Germanic names suggests that Braun was selling to Alsatian, German, and/or Swiss concerns as well as to those nearer Paris. The designs are all small patterns suitable for dress prints, geometrics or florals, and Braun's notes indicate which patterns were destined for woodblocks (*en bois poirier*) and which for machine blockprinting (*pérotine*). Other notebooks show how Braun developed a design, and how he looked at each one and criticized it before it left the workroom. Book S1430 has small abstract patterns, similar to those in S1449, annotated with penciled calls for "originality" and "more movement" in the margins, or with "roller" or "woodblock" to specify the printing process.

For three years Braun occupied this studio. It was here that he assembled and published his first collection of designs, *Recueil de dessins servant de matériaux, destinés à l'usage des fabriques d'étoffes, porcelaines, papiers peints &.&. Dédiés à Mr. Daniel Dollfus, par*

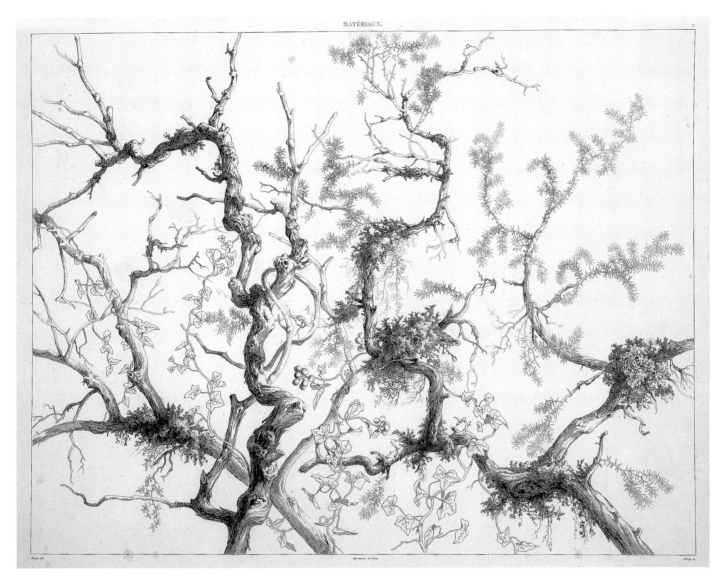

MATÉRIAUX.

Adolphe Braun
Recueil de dessins (Pl. 12: "Matériaux")
Collection of Designs (Pl. 12: "Materials")
Lithograph
1842

son Ami A. Braun (Collection of Designs Offering Materials Intended for Use by Manufacturers of Textiles, Porcelains, Wallpapers, etc. Dedicated to Mr. Daniel Dollfus, by his Friend A. Braun), in 1842. Braun's *Recueil de dessins* is a series of lithographed plates, published by a number of different printers in Paris, including Kaeppelin et Cie, P. Dien, and Henry Berthoud. The engravers included Eugène Bléry, Napoléon Sauvage, Mercier, A. H. Boullet, and others. Most of the pages are what Braun called *"Matériaux,"* flowers drawn from nature and engraved as separate stems or as bouquets or wreaths for artists to use as design models for textiles, porcelains, wallpapers, etc. These engravings of roses, morning glories, wheat, strawberries, zinnias, mistletoe, and tree trunks reveal that Braun already had a photographer's eye for detail and contrast, to be seen especially in plate 12 with its extremely detailed drawing

of branching tree trunks with lichen, mistletoe, and ivy.

This publication should be viewed within the tradition of the many engraved series created over the years by architects, interior designers, and others, for use by fellow professionals. These include the seventeenth-century publication of Charles Le Brun's designs for Versailles and books by architects Philibert de L'Orme and Jean Marot, who also designed specifically for textiles. In the eighteenth century, Charles Delafosse's *Nouvelle iconologie historique* (1771), books of trophies by Pierre Ranson, and Jean Pillement's engravings of chinoiseries were among the popular sources for designers of architectural ornament and decorative arts, including textiles. Until the late eighteenth century, however, French designs for floral ornament were largely decorative rather than naturalistic.

In England, artists like George Ehret were producing botanically correct illustrations for scientific use, that were also regularly borrowed by designers. As early as 1778, motifs on English textiles printed with copper plates were based on illustrations in William Curtis's *Flora Londinensis*, an encyclopedic work for botanists that attempted to depict every type of plant that grew within seven miles (eleven kilometers) of London. At the same time, designers of porcelain were using the botanical encyclopedia *Flora Danica* as a source of images for dinner services, and London textile printer William Kilburn was producing woodblock-printed cotton textiles patterned with drawings of minute coral structures in a profusion of naturalistic colors.

In France, the floral designs of Gerard van Spaendonck, whose decorative paintings of flowers looked back to the Dutch seventeenth-century tradition, were used as sources of inspiration by porcelain and textile designers in the late eighteenth century. However, the first real attempt in France to create a botanical encyclopedia with accurate illustrations was Jean Lamarck's *Encyclopédie méthodique botanique*, published in Paris between 1782 and 1823. By 1790, Jouy's director Christophe Philippe Oberkampf was using this publication as a source for some of his most elegant textile designs, basing them directly on many of the 6,439 plates of engravings by Pierre Joseph Redouté, Jean Baptiste Audebert, Jacques Eustache de Sève, and others. The encyclopedia included newly discovered plants such as the tigridia from Mexico; the banksia, found on Captain James Cook's expedition to the South Seas in 1768 and 1769; and the magnolia, introduced into Europe from America in 1734.[10]

With the advent of Redouté and other followers of van Spaendonck, French floral design became truly naturalistic for the first time. By 1829, designs from Redouté's publications had been used over and over again as models for printed textiles. "For forty years the designs of [Joseph-Laurent] Malaine and Redouté have served as models in our design studios, and I dare say...that our best designers are those who have been able to study these clever masters," remarked Mulhouse textile printer Edward Koechlin after the establishment of the design school.[11]

Redouté himself was a conscious instigator of the trend toward increasingly accurate representations of nature in the decorative arts and in industrial products, which continued throughout the nineteenth century. "Botanical iconography, or the art of painting plants...serves usefulness as well as beauty. For while to the nature lover it presents paintings of great charm,... it is also of value to manufacturers who borrow these designs to decorate their wares; to heads of academies

Christophe Philippe Oberkampf
Fruits exotiques (detail)
Exotic Fruits
Cotton
ca. 1792

wishing to further the progress of their pupils; and even to the professors themselves, who, dedicated to the tuition of flower painting, will find these models a great help in their work. Iconography, once essential to botanical study only, now graces the choicest products of industry....To me,....it has become obvious that new models are required."[12] By "new models," Redouté meant strictly naturalistic engravings based on drawings from life. John James Audubon visited Redouté in 1828 and recounted just how important this principle of naturalism was for the famous flower painter: "Old Redouté dislikes all that is not nature alone. He cannot bear the drawings of either stuffed birds or quadrupeds [that were Audubon's models for some of the engravings in his *Birds of America*]."[13] Redouté's naturalistically drawn roses became the most popular models of the first half of the nineteenth century.

Following in Redouté's footsteps, the Société Industrielle de Mulhouse aimed, in founding its design

Adolphe Braun
Recueil de dessins (Pl. 8: "Types")
Collection of Designs (Pl. 8: "Types")
Lithograph
1842

school in 1829, to make "good models" available to students, to develop their taste and to enable them to distinguish "the beautiful, and the true, from the bad." It also called for the "long and sustained study" of flowers drawn from nature.[14] The principle of naturalism in design became one of Braun's chief concerns. In the *Recueil de dessins*, however, Braun did not limit himself to the accurate drawing of flowers from nature. The most unusual aspect of the *Recueil* is its inclusion of a completely new category of designs to be applied to the decorative arts: images drawn from the microscopic examination of nature. Thirteen pages are devoted to lithographs of such images, with nine pictures to a page. On two of these pages, the nine

images are themselves divided into four sections, based on entirely different microimages, giving a total of thirty-six small illustrations per page. In all, Braun's *Recueil de dessins* has 171 microscopic images, more than any publication, scientific or otherwise, at that time.

Braun's images show the structure of wood; the microscopic appearance of bark; many vascular structures of plants; unnucleated blood cells of mammals; and nucleated blood cells of avian or reptilian forms. Based on their format and their gradations of gray to black, it has been suggested that these images may have been taken from microdaguerreotypes.[15] It was exactly these sorts of images that physician Alfred Donné and his assistant Léon Foucault were examining in their *Cours de microscopie* of 1844, the first publication to reproduce images taken from microdaguerreotypes. No direct sources for Adolphe Braun's images have been located, and no evidence, apart from their appearance, indicates that they were taken from photographic material; indeed, timing suggests otherwise. After Donné and Foucault unveiled the first microdaguerreotype in February of 1840, it took them four years to assemble the eighty images they published in their 1844 atlas of plates. The sheer number of Braun's images makes it difficult to imagine how he could have had access to so many microdaguerreotypes by 1842.

Evidence from ten pages of painstakingly hand-colored lithographs in the Mulhouse copy of the *Recueil de dessins* bolsters the theory that he was using another method. These images—of algae, molds, and other plant forms (see p. 54), with their closely observed detail, three dimensionality, and naturalistic coloring—suggest that the artist may have been using a camera lucida.[16] The camera lucida is a simple tube with a lens and mirror attached to the microscope between the

Alfred Donné and Léon Foucault
Cours de microscopie. Atlas (Pl. 6)
Course in Microscopy. Volume of Plates (Pl. 6)
1844

stage and the oculars. It was an important means of reproducing microimages before the invention of the daguerreotype and is still in use today. It provides a simple, inexpensive way to trace images seen with the microscope by giving a direct view of both the object displayed on the microscope stage and the image being traced by pencil or brush on to a sheet of paper just next to the microscope.

Just before 1840, it had become possible for a young designer like Braun to own or borrow a microscope and camera lucida. In his *Cours de microscopie*, Alfred Donné recommends to students an inexpensive compound microscope with a short focal length, made by Charles Chevalier in Paris. It sold for only one hundred francs, which was considerably cheaper than the earlier thousand-franc price of an imported model. It was this microscope that Donné and Foucault

Adolphe Braun
Recueil de dessins (Pl. 10: "Types")
Collection of Designs (Pl. 10: "Types")
Lithograph
1842

adapted for microphotography, devising a method of lighting the field and attaching the camera so that an adequate daguerreotype could be taken. Alfred Donné also recommended a camera lucida as an indispensable tool for students of microscopy and used one in his own laboratory.

Braun's microimages were remarkable for their time, despite the explosion of microscopic work on tissues from 1800 to the 1830s. Braun's detailed representations that record the whole field of vision were a step forward in the graphic depiction of microscopic phenomena, an endeavor that had originated with Anthony van Leuwenhoek, the great Dutch microscopist, at the end of the sixteenth century. Further advances were made in early nineteenth-century France by Donné and Foucault, as well

Adolphe Braun
Recueil de dessins (Pl. 7: "Types")
Collection of Designs (Pl. 7: "Types")
Lithograph
1842

as by the botanical illustrator Pierre Jean François Turpin, who published numerous volumes between the early years of the century and his death in 1840. Turpin published hand-colored line engravings, in conventional botanical format, isolating species and showing diagrams of the important structures of the plants he had examined. However, he did not include illustrations of the whole field of view shown by the lens, which would have also featured adjacent and over- or underlying structures. Donné and Foucault edited the views in their *Cours de microscopie* by removing what Donné saw as "distracting" background structures.

Braun's tracings, on the other hand, reproduce what he actually saw in its entirety: structures superimposed on one another and out-of-focus backgrounds. He was

interested purely in the visual decorative impact of all that he was seeing through the lens, rather than in structures artificially isolated for scientific purposes. However, his *Recueil de dessins*, with its large number of completely naturalistic images, was an important step scientifically as well as artistically.

Whether or not Braun's images were taken from direct observation or from microphotographs, his use of them was decisive and creative. His design notebooks overflow with image after image, sketched first as cellular forms in black, gray, and white gouache, then in polychrome. The profusion of drawings shows how he transformed images of vascular tissue or wood fibers, first into billowing grasses and curvilinear leaf forms and, finally, into sinuous floral patterns or exotic Paisleys, while retaining the overall shape of the original. Each initial tracing resulted in fifteen or twenty different designs over several pages.

Little is known about the publication of the *Recueil de dessins* itself. Only a few copies of it survive. In addition to the copy presented to Daniel Dollfus-Ausset (whom Braun calls simply Mr. Daniel Dollfus in the dedication), Braun gave one to the Société Industrielle de Mulhouse, which acknowledged it as a valuable source for the industry and for study in design schools such as its own. The book includes designs lithographed by many studios in Paris, suggesting that they were completed at different times and that the designs were assembled over several years prior to their publication. His gift of the volume to Dollfus-Ausset and its warm dedication to him also documents the fact that, from his Paris studio, Adolphe Braun had maintained his professional contacts in Mulhouse. An 1850 volume of printed textile samples from Dollfus-Mieg in Mulhouse shows that Dollfus-Ausset responded positively and eventually printed

several textiles based upon Braun's microimages. Given his continuing connections with Mulhouse, it is not surprising that when Braun's Parisian wife died suddenly in 1843, he chose to return to this city in Alsace where the textile industry was booming. He was thirty-one years old.

The center of the French cotton-printing industry, Mulhouse was an unlikely industrial capital because of its situation far from its source of supply—in France, principally the port of Le Havre— and from the bulk of its market in Paris. Its physical and political proximity to Switzerland, however, gave it advantages that no other French locality possessed. Mulhouse had been an independent republic allied with the Swiss confederation until it voted to annex itself to France in 1798. Knowledge of Switzerland's flourishing textile

Adolphe Braun
Design Book
Book 81464, detail of page 15
Gouache

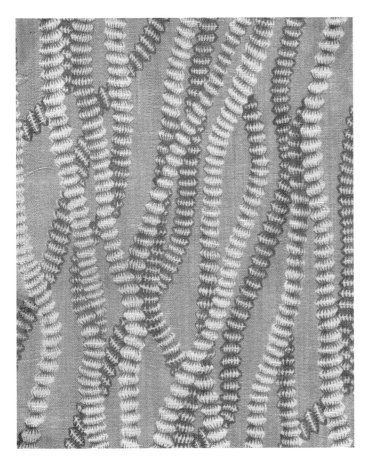

Dollfus-Mieg
Textile Sample (detail)
Book S18, page 49
Cotton
ca. 1850

importation from abroad of white cotton goods for printing, nor had it been subject to the sumptuary laws that prohibited production of printed cotton in France. Although these laws were widely violated by importers and consumers in France, the regulations were effective in forestalling French development of the cotton-printing industry until their repeal in 1759. Moreover, situated near the Rhine River and almost on the borders with Switzerland and the German states, Mulhouse was located at the center of European commerce. Its businessmen could import cotton from abroad, then print, and re-export it without paying customs duties, which they did until the French border closed completely in 1798. This act brought instant panic to the cotton printers of Mulhouse and was the chief motive for the annexation vote the same year.

Of equal importance, Mulhouse possessed a Protestant oligarchy with a strong work ethic, an interest in science and technology, and close family alliances that contributed to solidarity and the ability to call upon financial help in times of need. Extended families with large numbers of children provided the human resources for expanded commercial ventures. The Société Industrielle de Mulhouse strengthened and widened these bonds by including representatives of the arts, science, and technology in their intellectual circle.

Daniel Dollfus-Ausset, to whom Braun had dedicated his *Recueil de dessins*, was a member of this oligarchy, and it was he who came to Braun's rescue when personal tragedy struck. Dollfus-Ausset, son of the founder of Dollfus-Mieg et Compagnie, was trained in physics and chemistry and was interested in scientific experimentation that might yield new processes for the improvement of textile printing. He no doubt responded to Braun's use of the new science of microscopy, and, in 1843, he offered Braun the means to return to Mulhouse

industry—with its expertise in the spinning, weaving, and printing of cotton—was available in Mulhouse, which sits about twenty miles (thirty-two kilometers) north of the Swiss city of Basel. Most importantly, Switzerland had the capital to lend to fledgling cotton-printing establishments in Alsace, at a time when the industry required expensive factories with many large worktables; printing and calendering equipment; chemicals for dyeing; adjacent meadowlands for bleaching; and also vast quantities of water for its operations.

Politically too, Alsace was well situated. An independent republic in the eighteenth century, it had not been subject to French customs laws preventing the

as the chief designer at Dollfus-Mieg, a position that Braun held for four years before once again founding his own design studio. On returning to Mulhouse, Braun was quick to join the Société Industrielle de Mulhouse, as a professional designer on an equal basis with the industrial oligarchy.

At Dollfus-Mieg, Braun worked in a studio with Charles-Henri Grosrenaud, a talented designer in his own right, who was celebrated for the "good taste and delicacy" of his work.[17] A design notebook in the library of the Musée de l'Impression sur Étoffes, given by Dollfus-Mieg, provides an indication of their production during these years. It includes many small geometric and floral designs by Grosrenaud intended for dresses. Bound in the same volume are four pages of Braun's lithographed designs of cellular forms, taken from the *Recueil de dessins.*

The designs that emerged from the studio were put to use by the largest and most famous textile printer in France. In 1813, only thirteen years after it was founded, Dollfus-Mieg was among the top three printers, producing 35,000 pieces—each sixteen *aunes* or ells (approximately twenty meters) long—totaling 435 miles (seven hundred kilometers), as yard goods and shawls.[18] Spinning operations had begun in 1812 with a steam-powered mule jenny, the first in Alsace, and in 1832 a mechanical loom was installed, which, together with the hand-loom operations at various sites in Alsace, enabled the company to produce most of its own cottons for printing. In 1839, Dollfus-Mieg had 945 workers in its printing establishments, with 150 tables for blockprinting, 17 roller-printing machines that could accommodate four colors, and a newly purchased eight-color machine.[19] By 1866, the company was printing 7,800 miles (12,600 kilometers), the equivalent of the total production of all Alsatian manufacturers in 1839.[20] Renowned for its designs, it had won gold medals in 1834 and 1839 at the Exposition des Produits de l'Industrie Nationale in Paris.

As Dollfus-Mieg boomed, Braun saw renewed opportunity for himself as a designer. In 1847 he purchased a property near the company's office in Dornach, a suburb of Mulhouse, to which he moved his family: his new wife, Pauline Baumann—daughter of horticulturalist Charles A. Baumann from nearby Bollwiller, a camellia specialist who himself had published a book of engravings of that flower—and their son Gaston. This house, with a court, gardens, and a meadow, also became the location of his studio, one of nine in Mulhouse listed in the 1848 Almanach-Bottin du Commerce. He sold designs in Switzerland, Prussia, Germany, and in Eastern Europe, and won a bronze medal at the Exposition des Produits de l'Industrie Nationale in Paris in 1849.[21] By 1855, the Braun studio, with more than forty designers, was one of the most substantial in Mulhouse.

In the early 1850s Braun apparently became associated with firms in England and Scotland, working for Butterworth and Brooks, a printer of dress fabrics, at their Sunnyside Printworks in Rawtenstall (near Manchester).[22] John Brooks, of Butterworth and Brooks, testified in 1849 that he openly pirated patterns from London firms, sending "a drawer...to go from the City to the west-end to look through the windows and to imitate patterns; to take a little bit from one and another, and make it into a pattern; and then I, as a calico printer, will say that that is a new pattern."[23] It would be interesting to know what Adolphe Braun's designs for Brooks looked like and what became of them when used in actual textiles; unfortunately there is no evidence on the subject.

Subsequently, Butterworth and Brooks gave up altogether on good design, turning instead to mass production of the cheapest designs for home and overseas markets.

Also among Braun's clients was Henry Montieth of Bogle and Company, founded in Dalmarnock (Scotland) in 1805. The most important printer of Turkey-red designs in Glasgow in the 1820s, Montieth was used to looking to France for innovation: he had used Mulhousian Daniel Koechlin's discharge process to bleach patterns on Turkey-red handkerchiefs, boasting in 1823 that his factory machine-produced 224 handkerchiefs every ten minutes.[24] Braun provided Montieth with fifty thousand francs worth of designs in 1854, according to Scottish printer Walter Crum.[25]

The enthusiastic hiring of Braun by these British firms shows how little effect the Art in Industry movement was having on textile design in Britain, even after the founding of design schools. Manufacturers had not changed their practices, common since the 1840s, of looking to French design to improve their "national inferiority of taste and fancy," as Yorkshire manufacturer James Thomson disgustedly called it in an 1840 attempt to obtain a copyright law that would prevent the pirating of designs. Recent studies have shown that even when English manufacturers employed design-school graduates, they refused to recognize the talents of these men and continued to treat them as "mere mechanics on weekly wages."[26] This is in contrast to Adolphe Braun's experience in France, where he was paid twice what he would have been in England and was welcomed into the organizations of the mill owners themselves and treated as one of them.

Meanwhile, Adolphe Braun had discovered photography. His next effort from the point of view of Art in Industry was the publication of a volume of even more realistic flower subjects, photographed from life using the new collodion process, which allowed multiple prints from a single negative and greater detail than earlier positive/negative processes. For his *Fleurs photographiées*, Braun employed his own garden and courtyard, choosing for his ravishing flower photographs branches of magnolia or pear, bunches of oak and grape leaves, and bouquets of home-grown flowers. Whether he arranged them in wreath forms or simply placed them informally in buckets or vases, his aim was to photograph them before they wilted or dried out, so that artists and designers would have models that would be as close to nature as possible.

Although one version of the title page of the album of photographs reads only "Fleurs Photographiées, de Adolphe Braun à Dornach (Ht-Rhin)," Braun's intended audience of designers is clearly stated in the brochure he published around 1855 (P. Baret, Mulhouse) to promote the sale of the photographs, *Photographies de fleurs, à l'usage des fabriques de toiles peintes, papiers peints, soieries, porcelaines, etc., par M. AD. BRAUN, à Dornach, près Mulhouse (Haut-Rhin)*. The booklet included an extract from the minutes of the Académie des Sciences, to which Braun's work was presented on November 6, 1854, by Victor Regnault, vice-president of the Académie and president of the Société Française de Photographie. Regnault praised him both for the "harmony and finesse" of the photographs and the fact that he had "tried to group the flowers and the branches in order to produce the most interesting effects from the point of view of art." The images were a complete success, he declared. Like Braun's 1842 publication, the flower photographs had two aims: to advance the naturalism of available models for artists and designers and to make art, in the arrangement of the bouquets and branches, of service

to industry. When *Fleurs photographiées* was reviewed in *La Lumière* on November 11, 1854, the author of the article praised this explicitly. After Braun gave a copy to the Société Industrielle de Mulhouse, it was recognized as a work destined to "fill the void" of "careful studies from nature that designers seldom had the time to make; thus they often simply repeated the same flowers over and over again."

The publication of these flower photographs had a real impact on industrial design and was recognized as influential by critics. Philippe Burty, art critic of the *Gazette des beaux-arts* and former painter of flowers and ornaments for the Gobelins tapestry workshop, wrote in 1860 that the volumes had been "received with favor by industrial artists.…The groups of flowers, branches, leaves, and even fruits have been composed by a man expert in this material, and industrial art can draw from them immense services." Another member of the Société Française de Photographie, Eugène Durieu, took note of the "extremely remarkable photographic specimens," and enthused, "Art disputes the primacy of industry in them."[27] The flower photographs were certainly used by textile designers; an incomplete copy of the publication exists in the library of the Musée de l'Impression sur Étoffes, the gift of Thierry-Mieg et Compagnie of Mulhouse, which used them for designs in the 1850s, among them large-scale furnishing textiles with very detailed flowers that were inspired by Braun's photographs (see p. 62). A portfolio of photographs belonging to the Mulhouse designer Jacques Schaub in the Musée de l'Impression sur Étoffes contains a few dog-eared individual flower plates by Braun. Schaub's textile designs are also in the museum, a few of which show close resemblance to Braun's models.

Braun's own notebooks show how the photographs were used: Book S1380 contains enormous pencil tracings on paper from life-sized photographs of flowers. These would then have been transferred to other sheets of paper and carried out in gouache like his earlier designs (see p. 62). Neither the textiles nor the tracings can be matched up with actual photographs that still exist in various collections. If photographs were used in textile design studios in the same way as gouache designs, then they would have been tacked to the wall at the four corners and reused until they disintegrated; it would therefore be no surprise that only a small number of impressions survives. The evidence of the torn and damaged photographs from the Schaub studio suggests that this is the case.

After 1856, Braun's own hand can no longer be detected in the design of textiles,[28] but his name continued to be listed in the Almanach-Bottin de Commerce as a textile designer from 1850 to 1872. Only in 1861 did this publication also include his photographic work, citing his company as producing "all types of photography." Government statistical reports reveal that in 1858 Braun employed fourteen workers, in 1859, between fifteen and twenty-two, and by 1860, two years before the cotton famine caused by the American Civil War, he had forty employees. By 1863, the studio was clearly feeling the effects of the slowdown in cotton imports, and from 1863 to 1868 the number of workers was down to between sixteen and twenty-six, with the lower figures occurring in the winter months, in contrast to 1855, when the studio worked year-round.

By this time, of course, Braun's photographic business had increased greatly and had become his major interest. No textile design books from this period survive, and no later textiles from his studio have been identified. What then, was the legacy of Adolphe Braun to textile design, and to the ideas represented by the

expression, "the application of fine arts to industry," that had preoccupied him throughout his career? In general, Braun's work followed and reinforced the dicta of Redouté and of other artists of his generation like Turpin. Inspired by the needs of botanists for accurate information, they tried to be as naturalistic as possible in their depictions of nature for industrial artists, insisting on the reproduction of flowers as they appeared in life.

Although Braun was not the first to espouse these ideas, he carried them out in new ways. His 1842 publication of the *Recueil de dessins* included both flowers drawn from life, and new images drawn from the microscopic study of several different natural forms, building on the latest scientific efforts to depict images from nature. His *Fleurs photographiées* of twelve years later were still responding to the same themes. Braun's was not the first attempt to reproduce natural forms on paper by photographic techniques; William Henry Fox Talbot's Talbotype flower images were exhibited in England in 1839 (the same year that Daguerre discovered photographic processes independently in France), and could have been distributed as portfolio pages, but each page required a separate exposure. This was also true of the images in Anna Atkins's three-volume iconography of British seaweeds, photographed by cyanotype beginning in 1843; Atkins's work took eleven years to produce, and was never widely available. By 1854 publishers in Vienna were presenting a process called "nature-printing." An image of a leaf or flower was made directly on the engraving plate by pressing the plant straight into soft metal that was then hardened for printing, but this technique could only be employed for plants that were relatively flat. Braun's *Fleurs photographiées* was the first photographic publication that was widely

used in design studios, which would pin up the flower photographs individually, for study or copying.

As for "the application of fine arts to industry," Braun's career must have been a model for those who, like Napoleon III, believed that "improvements in industry are closely tied to those in fine arts," and that designers needed accurate models that could be supplied either in design books, through photography, or through the wide circulation of these models in exhibitions.[29] Until the 1851 Crystal Palace Great Exhibition in London, the first truly international exhibition that included both art and industry, France was sure of its artistic superiority. After that exhibition, although it was still evident that France was in the lead in terms of luxury goods, there were growing fears that its luxury market was too difficult to support and that French industry needed to challenge Great Britain in the production of inexpensive goods for the mass market. Adolphe Braun attempted, in his published works and in his designs for industry, to bring increased artistic merit to printed textiles designed for the mass-market manufacturer Dollfus-Mieg and for other companies in Mulhouse. In each of his published design books and in his textile designs, he strove to provide the most beautiful, naturalistic, and useful models possible.

Although his *Fleurs photographiées* enjoyed wide success and the praise of all those to whom he presented it, Braun never quite achieved the recognition he thought he deserved. When he submitted the *Fleurs photographiées* to the Empress Eugénie, who interested herself in the promotion of art in industry, he hoped for a decoration from the wife of the Emperor. Daniel Dollfus-Ausset suggested that he be recompensed with some object of art that would be of equal value to the 1,200 francs the publication sold for, which was one accepted method of governmental support for artists.

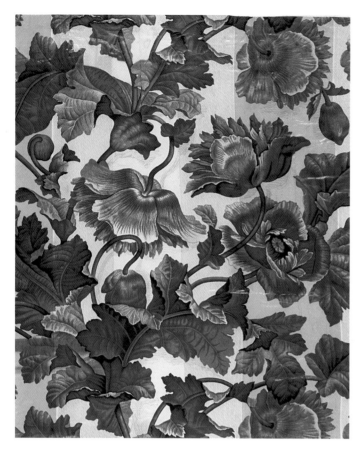

Thierry-Mieg
Printed Textile with Poppy Motif (detail)
Book s265, page 137
Cotton
1856

Adolphe Braun (attrib.)
Drawing of Poppies
Book s1380, no. 9768
Pencil on tracing paper
Possibly 1850s

She, however, sent him only a gold medal with a portrait of herself. Another disappointment to Braun was his receipt of a silver rather than a gold medal at the Paris Exposition Universelle of 1855. He had been informed that the gold medal was his, so it was particularly poignant when the committee later decided that the design section would be eligible only for the silver medal. He had to be content with this, but won from the textile manufacturers of Alsace a petition addressed to the Secretary of State recommending the flowers as models for the government manufactures at Sèvres, Gobelins, and Beauvais. Not put off by his rebuff at the exhibition, he sent the *Fleurs photographiées* to Queen Victoria of England, who

also sent him a portrait medal; other copies went to King Wilhelm IV of Prussia and to Baron Alexander von Humboldt.[30]

Braun's influence on textile design ultimately went further than the medals and words of congratulations offered him on the occasion of the publication of the *Fleurs photographiées*. Braun's idea of using photographs as design models outlived his own efforts by many years, inspiring new works by other photographers into the early twentieth century. These included nature studies by Alphonse Jeanrenaud and Testud de Beauregard presented at the 1859 Societé Française de Photographie exhibition, followed by A. Bolotte and Arthur Martin's submission of "flower

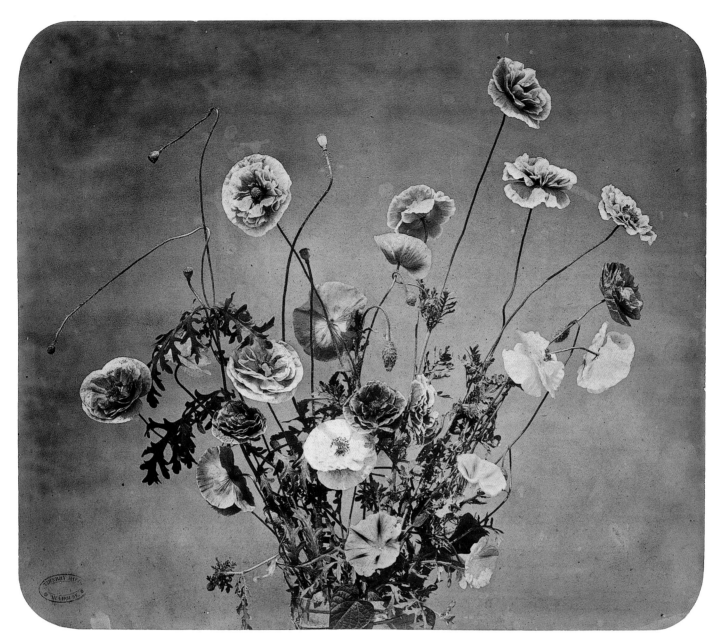

Fleurs photographiées (Pavots)
Photographs of Flowers (Poppies)
Albumen silver print
ca. 1854–1856

photographs from nature" at the Paris Exposition des Beaux-Arts Appliqués à l'Industrie in 1863.[31]

Between 1864 and 1869, in the midst of new praise for photography as a source for models in art and industry, the Parisian photographer Charles Aubry photographed his own arrangements of flowers, leaves, and fruits to serve as models for industrial design and for use by art students. Life-sized or nearly life-sized, they were arranged, like Braun's *Fleurs photographiées,* in portfolio style so that each plate could be used separately. Aubry's images were in general more static and less naturalistically composed than those of Braun, reflecting *japoniste* models and his technique of dipping leaves and flowers in plaster of Paris. Several

photographs stamped with Aubry's name and studio address appear in the portfolio of photographs belonging to the Jacques Schaub studio in Mulhouse, now in the library of the Musée de l'Impression sur Étoffes. Their damaged corners reveal that they were pinned to the wall as models in exactly the same way as Braun's flower plates had been.

Soon after it became practical in the 1880s to print photographs on ordinary paper through screens, the Viennese photographer and publisher Martin Gerlach issued a series of publications for designers, including photographic reproductions of plants, trees, and other natural forms. Later, also following in the footsteps of Adolphe Braun, he published books of photographs of folk jewelry, other folk arts, domestic and farm architecture, and of art and sculpture in Germany and Austria. His portfolios *Festons und decorative Gruppen*, issued in several editions before 1897, were meant to serve as models for "modern decorative arts." Like Braun, Gerlach emphasized that his photographs were taken "directly from nature." They included decorative groupings of fruits and flowers with fishing and hunting trophies, snakes, birds, bottles of wine, and even arrangements of foodstuffs, with appeals by the author of the Foreword, Dr. Richard Graul, for a new direction in art. He called for a "search for naturalism," through which "modern painters and designers [might] seek in the study of nature to free themselves from the weighty models and exhausted ideas of the past."[32]

In the meantime, however, political events put an end to the great explosion of textile printing that had taken place until 1870 in Alsace, and discouraged new developments in design. The Franco-Prussian War and Prussia's subsequent annexation of Alsace caused great upheavals in the textile industry, closing much of the French market to Alsace. A certain conservatism

of design and a desire to return to the past are evident in the prints that continued to be produced. Books of plates, like Braun's *Recueil de dessins* of 1842, and his photographs were still used as design sources, as realistic floral imagery retained its popularity. Floral patterns designed at Thierry-Mieg had a longevity of nearly twenty years, a lifespan typical of textiles of the time.[33] A list of fabrics produced by Mulhouse printers in the years between 1870 and 1900 reveals the taste of producers and consumers alike for revival styles: textiles "that were decorated with various floral designs…inspired by Watteau…or by Jouy (designs from the last century, etc.)…by Gobelins… by panel paintings, by scenes with figures, by delftware," and so on.[34] This was one of the characteristics that made them popular in America in the watering places of the new industrial aristocracies like Newport, Rhode Island.

It was only after the turn of the twentieth century that French textile design, inspired by painters like Raoul Dufy and by the couturier Paul Poiret, assimilated the taste for abstraction already prevalent in Britain, where designers had long disdained the close imitation of natural models. Under the influence of both Japanese and Chinese models as well as of the designers Augustus Welby Northmore Pugin, Owen Jones, and William Morris, increasingly flattened and decorative leaves and flowers in geometrical forms had appeared in designs for decorative arts of all kinds. Contemporaneously both English and French painters were espousing new and abstract ways of depicting nature. Botanical illustration had also joined the new mood for abstraction, preferring schematic line engravings or line-drawn lithographs that could combine elements of plants that appeared at different times of the year.

At the same time, records of French textile firms reveal a continuation of the taste for realistic floral patterns right through the twentieth century, so that Braun's new models for design never really became out-of-date. As his textile career became less a focus for his own involvement, and he became design director rather than chief designer, critical attention turned to his photographs not just as design models, but as works of art in their own right. He suddenly became one of the most famous practitioners of the new technique in France, a development he probably never intended. Once he realized his fame he was quick to take advantage of the opportunities photography offered as a career in itself. Yet again showing his eclectic background and broad training, he seized the opportunity and set off in the new direction.

1 Jacqueline Jacqué, *Andrinople, le rouge magnifique: de la teinture à l'impression, une cotonnade à la conquête du monde*. Paris and Mulhouse: 1995, p. 14.

2 Josette Brédif, *Printed French Fabrics: Toiles de Jouy*. New York: 1989, p. 18.

3 Serge Chassagne, *Oberkampf: un entrepreneur capitaliste au siècle des lumières*. Paris: 1980, p. 16.

4 Quoted in Henri d'Allemagne, *La Toile imprimée et les indiennes de traite*. Paris: 1942, p. 16.

5 Quoted in Toshio Kusamitsu, "British Industrialization and Design before the Great Exhibition," *Textile History*, vol. XII (1981), p. 78.

6 Société Industrielle de Mulhouse, *Histoire documentaire de l'industrie de Mulhouse et de ses environs au XIX siècle*. Mulhouse: 1902, p. 120.

7 Raymond Oberlé, *L'Enseignement à Mulhouse de 1798 à 1870*. Paris: 1961, p. 48.

8 Pierre Tyl, "Adolphe Braun: photographe mulhousien, 1812–1877." Dissertation, University of Strasbourg, 1982, p. 11, quoting Charles de la Boulaye, *Dictionnaire des arts et métiers*. 3rd edn. Paris: 1863.

9 Tyl, op. cit., pp. 12–13.

10 Susan Hay, "Printed Textiles and Botanical Illustration: Some Examples from Jouy," *Bulletin de Liaison, Lyon, Centre International des Études de Textiles Anciens*, vols. LXIII–LXIV (1985–1986), pp. 113–22.

11 Oberlé, op. cit., p. 220.

12 Pierre Joseph Redouté, *Fruits and Flowers Comprising Twenty-Four Plates Selected from "Choix des Plus Belles Fleurs et des Plus Beaux Fruits."* Translated by Eva Mannering. New York: 1956. Preface, p. vii.

13 Quoted in Peter and Frances Mallary, *A Redouté Treasury: 468 Watercolors from Les Liliacées*. New York: 1986, p. 22.

14 Oberlé, op. cit., p. 221.

15 Naomi Rosenblum, "Adolphe Braun: A Nineteenth-Century Career in Photography," *History of Photography*, vol. III, no. 4 (October 1979), p. 360.

16 I am indebted to Dr. Don Singer, Professor of Pathology, Brown University, Providence, for this insight and for information about the process.

17 Société Industrielle de Mulhouse, op. cit., p. 637.

18 Ibid., p. 1006.

19 Claude Fohlen, *L'Industrie textile au temps du Second Empire*. Paris: 1956, p. 219.

20 Robert Lévy, *Histoire économique de l'industrie cotonnière en Alsace*. Paris: 1912, p. 95.

21 Tyl, op. cit., p. 16.

22 Ibid., pp. 15–16; David Greysmith, "Patterns, Privacy and Protection in the Textile Printing Industry," *Textile History*, vol. XIV, no. 2 (1983), p. 168.

23 Kusamitsu, op. cit., p. 87.

24 Naomi E. Tarrant, "L'Industrie du rouge turc dans l'ouest de l'Écosse," in Jacqué, op. cit., 1995, pp. 62–69, esp. p. 63.

25 Tyl, op. cit., p. 16.

26 Greysmith, op. cit., pp. 173–74.

27 Quotations in the above three paragraphs have been translated from Tyl, op. cit., pp. 38–39.

28 The information in the following paragraph has been taken from Tyl, op. cit., pp. 129–31.

29 Quoted in Katherine B. Hiesinger and Joseph Rishel, "Art and Its Critics: A Crisis of Principle," in Philadelphia Museum of Art, *The Second Empire, 1852–1870: Art in France under Napoleon III*. Philadelphia: 1978, p. 30.

30 Tyl, op. cit., pp. 36–37.

31 Elizabeth Anne McCauley, *Industrial Madness: Commercial Photography in Paris, 1848–1871*. New Haven and London: 1994, p. 242.

32 Richard Graul, in Martin Gerlach, ed., *Festons und decorative Gruppen nebst einem Zieralphabete aus Pflanzen und Thieren: Jagd- Touristen- und anderen Geräthen...*, 3rd edn, vol. I. Vienna: 1897, p. 3.

33 Mary Schoeser and Kathleen Dejardin, *French Textiles from 1760 to the Present*. London: 1991, p. 136.

34 Société Industrielle de Mulhouse, op. cit., p. 401.

Costumes de Suisse: Canton de Bâle

Costumes of Switzerland: Canton of Basel

Albumen silver print

1869

The Influence of Contemporary French Painting

MAUREEN C. O'BRIEN

Adolphe Braun made his public debut as a photographer in 1854, when he introduced *Fleurs photographiées*, a collection of three hundred floral images, to the Académie des Sciences in Paris. The excitement and approval that surrounded this remarkable body of work heralded an enterprise that helped to define photography's response to nature and art. By the 1880s, the Braun company catalog presented a vast inventory of images that were useful to practicing artists and designers and that were available as visual resources to schools and libraries, where they were used to teach the history of art. Braun's photographs of works of art from Europe's finest collections helped to revitalize the classical tradition in painting, while his landscape photographs of Alsace and Switzerland and of the ancient monuments of Egypt and Rome upheld a lingering romantic tradition. Just as engravings had served artists in the past, these photographs were used as highly detailed aides-mémoires and as substitutes for sketches by those who lacked the time or resources to travel. They were consulted by collectors, tourists, and by both amateur and professional artists practicing a wide variety of styles.[1]

Braun's photographs of landscapes and works of art had long-standing prototypes in other print media, but as sources for artists they enjoyed the advantage of seeming to be objective likenesses of nature and culture. Their ability to document the photographer's proximity to the source, and their accuracy in recording it, linked them to the heightened public interest in naturalism, and to the realist concerns that pervaded the writings of French critics in the mid-nineteenth century. In the years leading up to the creation of his *Fleurs photographiées*, Braun would have been aware of significant changes in French painting and of the endless debates surrounding realist style and subject matter in contemporary Salon reviews. The shift away from both classicism and romanticism in French art had been predicted as early as 1833, when a Salon review by Gabriel Laviron declared that art should be available to all through realistic depictions of the visual world. Dismantling the hierarchy of subject matter that placed history painting at the head of the canon, and landscape, genre, and still-life painting at the bottom, he voiced support for a national art whose subjects were drawn from life.[2]

By mid-century, Laviron's wish had come to pass in a realist movement that would eventually revolutionize French painting. Its critical agenda acknowledged photography as a handmaiden to truth (if not its co-equal in art) and promoted new formats that were neither traditionally inspirational in subject matter nor grand in size. Easel paintings, which were scaled to bourgeois taste and accessibility, now found a place alongside great academic "machines," and the words "realist" and "naturalist" invaded fine-arts journals, alerting readers to an artistic point of view that had begun to change the face of public exhibitions. In Salon reviews, paintings like Gustave Courbet's *Young Ladies of the Village*, 1851 (Metropolitan Museum of Art, New York), were extolled for their rustic integrity and truthfulness to nature[3] and accorded the same level of critical analysis as Alexandre Cabanel's vision of *The Death of Moses*.[4] Competing with paintings of historical and allegorical themes at the Salons was a new category of small, dexterously executed compositions "to the success of which the subject counts for little."[5] By 1857, the vast majority of the paintings exhibited there were described by Jules-Antoine Castagnary as genre: a broad category that included portraits, interiors, landscapes, scenes of everyday life, and still lifes. For this champion of realist painting, they represented "the human side of art which is replacing the heroic and divine."[6]

If, at the beginning of the nineteenth century, still-life painting was considered an endeavor for decorative painters, by the 1850s it had acquired contemporary legitimacy through the revival of its Dutch and Spanish antecedents and through its appeal to bourgeois collectors. Critics like Théophile Thoré announced that the art of Rembrandt van Rijn, Frans Hals, and Jacob van Ruisdael provided models for all that was possible for French realist art in the nineteenth century. Seventeenth-century Dutch artists had documented contemporary life in its myriad forms and in their embrace of all citizens, customs, occupations, and landscapes had painted a broad portrait of humanity. To define them as "crude naturalists," wrote Thoré, was to place Rembrandt himself at the tail end of great European art.[7]

Examples from the golden age of still-life painting were also included in this wave of interest, although the genre's internal hierarchy was reassessed. Traditionally, still-life subjects with lavish tableware, exotic floral displays, or *trompe-l'œil* effects, and also those that made reference to antiquity, death or vanity ranked above modest interiors that included pots and pans and the more humble aspects of meal preparation. Ironically, it was this last aspect of traditional still-life painting that found the greatest currency among French realist painters in their attempt to achieve an art that celebrated nature and expunged artifice. Close models for these more modest qualities lay in earlier French painting, particularly in the interiors and still lifes of Jean-Baptiste-Siméon Chardin, whose work was vigorously reappraised in the mid-nineteenth century.[8]

Although specific references to Chardin in Braun's work emerged later—in the homely interiors of the *Costumes de Suisse* and in the still-life arrangements of the *Panoplies de gibier*—critical recognition of Chardin in the 1850s influenced the perception that Braun's floral photographs had artistic value as well as superior graphic and scientific properties. The worthiness of Chardin's paintings as prototypes for contemporary French still lifes reflected a growing appreciation of naturalist ideals and of qualities of depicted air and light. Particularly important to critics was Chardin's ability to convey a sense of air circulating around an

object in nature, a quality that could be successfully achieved in photography and was particularly noted in Braun's *Fleurs photographiées*. The simple visual language of Chardin was equivalent to Braun's frank, evenly lit images, and was adapted by artists such as Philippe Rousseau and Antoine Vollon, whose familiar domestic arrangements were favorably received at the Salon. The new French sensibility for still-life painting avoided the conceits that had been valued in the earlier hierarchy of subjects and embraced

Chardin's interest in exalting common objects. This restrained style in which details were simplified and objects placed against light backgrounds was said to represent a more delicate *nature française*.[9]

The images in Braun's *Fleurs photographiées* reflected the realist taste for simplified presentation and were thus intellectually accessible to both viewers and contemporary critics. To designers for industry, they were the next best thing to fresh materials, offering natural scale and appearance with precise detail and

Switzerland. The Castle of Chillon
Albumen silver print
ca. 1862

outline. To amateurs of horticulture, they provided accurate documentation of flower species and were as pleasurable for private viewing as they were useful for scientific study. To painters, Braun's photographs surpassed both drawings and engravings in their ability to serve as objective prototypes. Stripped of overt narrative or compositional content, they offered these audiences a new, visually pleasing, and potentially useful, way of seeing nature.

Even without being marketed as discrete art objects, the *Fleurs photographiées* could be consumed as such. Their impact on critics at the Exposition Universelle of 1855, where they appeared in the Design Applied to Industry section, was based on their technical brilliance and commercial application. By 1859, however, when they were shown at the spring exhibition of the Société Française de Photographie, now adjacent to the annual Salon, they were accorded a reception previously reserved for works of art. One writer described them as capturing the attention of the crowd by evoking a sentiment felt only in the presence of beauty.[10] In effect, they demonstrated that aspects of nature could be displayed without context and still be perceived as appropriate subjects for pictures.

To Gustave Courbet, who constructed his *Pavillon du réalisme* outside the official galleries of the 1855 Exposition Universelle, Braun's photographs must have had tremendous appeal. By 1853, Courbet was referencing photographic models in his large figural paintings[11] and had begun to have his work photographed for promotional and marketing purposes. Over the next twenty years, his paintings were shot by photographers Édouard Baldus, Charles Michelez, and Robert Jefferson Bingham. Sometimes the framed prints were shown at exhibitions of Courbet's work.[12] He also used portrait photographs as direct sources, referring to

one for his painting of the philosopher Pierre-Joseph Proudhon and his children.[13] Later in his career, he based his painting of the castle of Chillon on a photograph from Braun's popular views of Switzerland (see p. 69).[14]

Like Eugène Delacroix, whose commitment to understanding nature from close study was reconfirmed in the baskets of flowers and fruits he exhibited at the 1855 Exposition Universelle,[15] Courbet demonstrated a serious interest in flower painting. Formal affinities to Braun's photographs, including the life-size scale, rich tonal range, strong contrasts, and detached presentation of the subject, are evident in the still lifes of fruits and flowers that he began painting in the early 1860s. In addition to floral subjects with figural interest, such as *The Trellis (Woman Arranging Flowers)*, 1863 (Toledo Museum of Art), Courbet executed a number of smaller compositions of flowers in baskets or vases during the spring and summer of 1862, which he spent on the estate of amateur botanist Étienne Baudry.[16] These bouquets, like Braun's photographs, have a convincing physical presence and convey the sense of loosely arranged flowers fresh from the garden. Allegorical content, common in Courbet's subject paintings, is absent from the majority of his floral works. Although domestic interiors provide settings for pictures like *Magnolias*, 1863 (Kunsthalle, Bremen),[17] even these references disappear from later works, such as *Fleurs de cerisier*.

Henri Fantin-Latour may also have seen Braun's floral images in Paris in the late 1850s. Beginning around 1860, Fantin-Latour painted hundreds of flower compositions from life, showing a preference for small, springtime garden bouquets, and old-fashioned roses in vases or glass containers.[18] They recall the simple domesticity of both Chardin's and Delacroix's studies

Gustave Courbet
Fleurs de cerisier
Cherry Blossoms
Oil on canvas
1872

from nature. Throughout his career, Fantin-Latour preferred a flat gray or gray/brown background for these compositions, similar to the neutral setting used by Braun for his *Fleurs photographiées*. However, his closest compositional parallels to Braun's floral photographs did not appear until the 1870s, in paintings like *White Roses* (see p. 72) and *September Bouquet*, 1872 (City Art Galleries, Manchester). In these and in later depictions of lilies, nasturtiums, and cropped cherry branches, his specimens were composed like those in the *Fleurs photographiées*: eccentrically arranged and without visible containers.[19] Their flattened pictorial spaces and close-up views show striking formal affinities to Braun's undomesticated floral images and suggest a way of seeing that resembles the non-selective vision of the camera lens.

Similarly, in the late still lifes of Narcisse Diaz or in certain floral subjects of the 1860s by Frédéric Bazille,

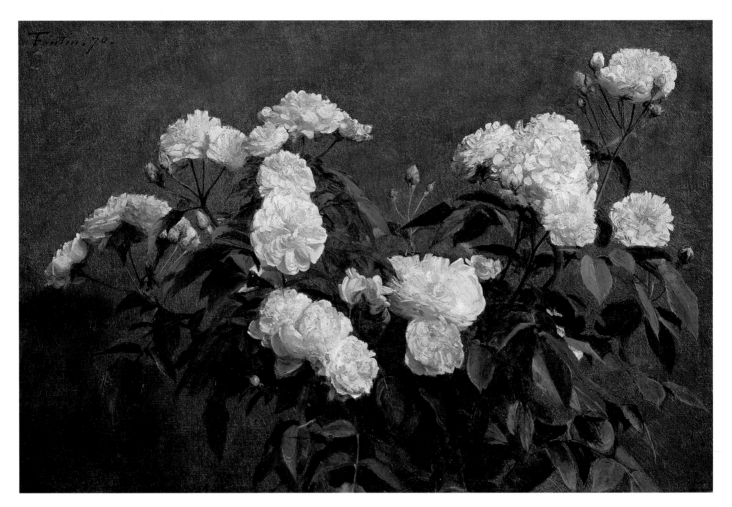

Henri Fantin-Latour
White Roses
Oil on canvas
1870

Auguste Renoir, Gustave Caillebotte, and Claude Monet, flowers copied from nature are loosely arranged against a flat background with minimal attention to context or support. These were idiosyncratic responses to the general appreciation of floral imagery advanced by the *Fleurs photographiées*. Ernest Lacan had predicted that Braun's "gracious photographic basket of fresh flowers" would be found in the boudoirs, studios, and salons of elegant women, artists, and poets.[20] When drawn upon by painters, Braun's photographs had the potential to accustom viewers to a concept of art in which nature was, if not randomly selected, then, at least, abstracted from familiar artistic and cultural contexts.

Although vaunted by critics as sources for painters, the images of the *Fleurs photographiées* were conceived by Braun as a design resource for the French luxury industries. The project represents an important milestone in a career that began with his training as a textile designer in the Alsatian city of Mulhouse in the early 1820s, when Braun studied classics, drawing, physics, and chemistry, while developing an extensive knowledge of technical processes. He was also exposed to engravings and drawings that were included in sourcebooks for designers, and to examples of fine and decorative arts that were the historic prototypes for luxury goods. During the early years of his training he

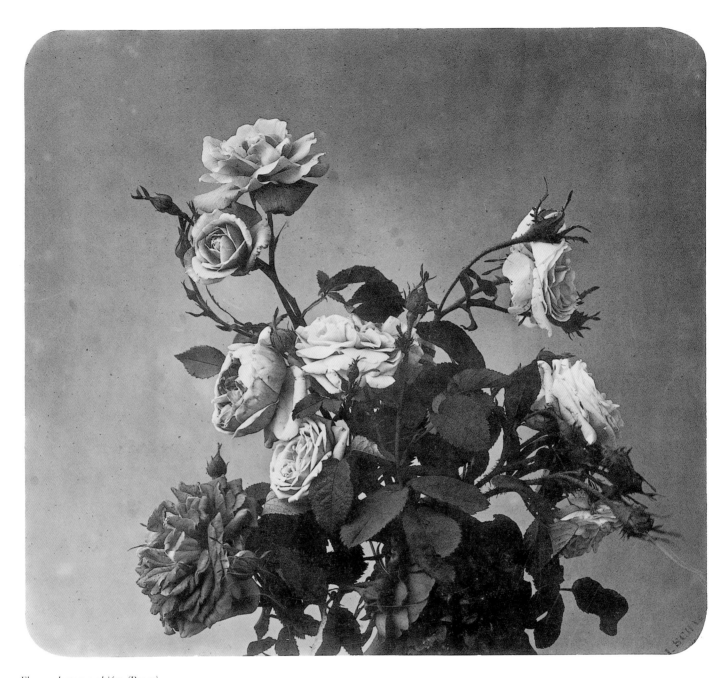

Fleurs photographiées (Roses)
Photographs of Flowers (Roses)
Albumen silver print
ca. 1854

became aware of an emerging, but insistent, demand for a special class of artists who could impose a high standard of design on mass-produced items.[21]

From the start, Braun's ambitions surpassed those of a regional *dessinateur de fabrique* (designer for manufacturers). Instead of remaining in Mulhouse, where the work of even the most talented designers would be incorporated anonymously into the factory's production, he moved to Paris in 1828 to begin his design apprenticeship. Over the next decade he advanced in his profession and undertook a number of commercial ventures that led to the establishment of his own design firm. In 1842, following prototypes such as the albums of Lyonnais designer Joseph

Reybaud,[22] he published the *Recueil de dessins servant de matériaux, destinés à l'usage des fabriques d'étoffes, porcelaines, papiers peints &.&. Dédiés à Mr. Daniel Dollfus, par son Ami A. Braun*, a collection of lithographs illustrating intricately stylized flower and plants. These plates were intended to inspire designs for decorative surfaces, signaling Braun's interest in creating products to serve the thriving industrial design market. His awareness of opportunities in the fine-art market would come later.

Braun may already have been considering the applications of photography when he published his *Recueil de dessins* in 1842. After exploring commercial possibilities for more than a decade in Paris, he could not have ignored the explosion of public interest when the processes of Daguerre and Talbot were made public in 1839. Even so, a dozen more years would pass before the appearance of Braun's first album of photographs. During this time he returned to Mulhouse, became chief designer for the firm of Dollfus-Mieg, and established professional roots in Alsace.

The circumstances surrounding Braun's embrace of photography and the steps that led to the introduction of his *Fleurs photographiées* are frustratingly unclear. Christian Kempf believes that Braun, like most photographers in the 1840s and 1850s, experimented with various processes as an amateur until he found one that met his demand for quality.[23] This breakthrough occurred in 1851, when the introduction of the wet collodion process gave him the means to bypass the limitations of both daguerreotypes and paper negatives and to seize the commercial potential of glass negatives and albumen prints. When his *Fleurs photographiées* appeared in 1854, the images were similar in purpose and content to the *Recueil de dessins*, but unprecedented as a photographic commodity. In

both quality and number, they represented the mastery of a new technology that dramatically expanded Braun's potential market and sharpened his ambitions.

During the twelve years that elapsed between the *Recueil de dessins* and the *Fleurs photographiées*, Braun would have followed photography's advances in the surging numbers of photographic portrait studios, amateur societies and journals, and reports in the popular press. Some of these same sources provided access to the current state of critical discourse on the medium. Specialized publications, such as *La Lumière*, first published in 1851, were widely available by subscription. Braun fit the profile of readers who enjoyed the informative mix of technical and critical commentary on the progress of photography and its applications to science and art.[24]

It was in the pages of *La Lumière* that the first important notice of Braun's *Fleurs photographiées* appeared in 1854. The critic "A.-T. L." not only commended Braun's proficiency as a photographer, but also identified him as an artist/designer of great merit whose photographs were conceived with *"beaucoup d'art"* (great skill). He applauded Braun's photographs for their tasteful composition and for their success in depicting nature in all its vigor and beauty. Members of the Académie des Sciences also noted Braun's use of a transparent varnish, which enhanced the images and was similar in appearance to the finishes used by painters.[25]

Only six months earlier, an article in *La Lumière* had predicted the influence of photography on the future of the design arts, identifying numerous ways in which this medium might serve artists. In a statement that seems to anticipate the *Fleurs photographiées*, Pierre Caloine declared that photographs would provide the painter of flowers with "the means to

render lasting that which is condemned to sparkle for mere moments."[26] Citing a genre of painting that had enormous importance in eastern France, particularly in Lyon, Caloine set the stage for Braun's introduction of a photographic resource of the highest quality.

While Braun was aware of the realist movement that was replacing an art dominated by historical and allegorical allusion with subjects drawn from life, his primary motivation for producing photographs "from nature" was to improve the visual resources (drawings, engravings, models, casts) currently available to both the applied and fine arts. Photography seemed a logical instrument for providing prototypes that were closer to nature, but it also had its limitations. The vocabulary of early nineteenth-century French flower painting was deeply indebted to the language of floral still lifes of the past in its elaborate structure, in its iconographic references to history and religion, and in its exquisite re-creation of exotic blossoms. Admired as decorative painters and awarded with commissions, flower painters, who were Braun's most likely audience, still adhered to these tenets.

Braun's formula for the individual images of the *Fleurs photographiées* contradicted that of the traditional floral still life. Unlike the formal organization of flowers found in paintings and in some examples of textile design, Braun's bouquets seem gathered rather than arranged. While his images often include various types of flowers and leaves in appropriately seasonal combinations, they are not designed to represent "luxury," "abundance," "mortality," or to allude to floral symbolism and other iconographic themes. In general, the photographs are distinguished by their neutral backgrounds and absence of accessories, and by their even lighting and frank presentation. Compositionally, they project little sense of containment: in the largest of the prints, the specimens often fill the frame and sometimes extend beyond the top and side edges.

Braun's style was also influenced by the extraordinary variety and consistent freshness of materials available to him. His flowers appear to have been recently plucked from the greenhouse or garden, and stand upright to be photographed. Stems and branches support blossoms and fruit without hidden wires or armatures. Vases and flowerpots are concealed from view, and only rarely does the neck of a tin garden container reveal itself at the base of an arrangement. The notable exceptions to Braun's loosely structured floral compositions are the wreaths that appear as single motifs or as arrangements framing plaster or wooden religious figures.[27] This subcategory presents the *couronne* (wreath) as the traditional floral embellishment of devotional images that included statuettes of the Virgin with Child and of the Crucified Christ. These thematic wreaths are composed of comparatively small flowers, massed at the base of the composition and diminished in fullness at the top. Resembling provincial *calvaires* (roadside shrines), they may have been intended to serve as perpetually adorned devotional items for the home. This genre had recently been revived by the Lyonnais painter Simon Saint-Jean, whose *Offrande à la Vierge*, 1842 (Musée des Beaux-Arts, Lyon), depicting a grisaille of the Virgin and Child surrounded by a vivid polychrome wreath of flowers, was singled out at the Salon of 1843 (see p. 76).[28]

Braun's unadorned floral crowns (see p. 79) had similarly adept organizations of blossoms but were liberated from religious narrative. A long-standing tradition in the decorative arts, the wreath motif was revived in the years following Braun's photographic

debut by Pierre Adrien Chabal-Dussurgey and Jules Médard (see p. 78) and even emerged in the work of the American John La Farge.[29] Both Médard and La Farge shared Braun's taste for abandoning iconographic content that might compete with the blooms, although they elaborated their backgrounds to suggest the contrasting textures of walls. Exuberant compositions of roses, peonies, and dahlias in full bloom attest to the profusion of cultivated flowers available to Braun and also imply the specialized skill of professional arrangers.

While the artfully constructed wreaths could be directly adapted for design purposes, the bunches, branches, and bouquets of the informal arrangements served as raw material to be selected and rearranged by designers to suit individual styles. Their potential use by artists presumably paralleled their function for designers. In addition to the obvious applications in still-life paintings, realist painters often included flowers in portraits, bourgeois interiors, kitchen scenes, and genre subjects. An arrangement might be placed in a vase beside a seated figure, a bunch of flowers carelessly laid on a table beside vegetables and crockery, or a bouquet carried by a child in a religious procession. For these purposes, a photograph of the flowers might help the artist to correct his drawing, once the natural models had wilted. Even when flowers were incidental to the subject of a painting, public expectation for truth to nature often demanded photographic precision. In an 1861 Salon review of Alphonse Legros's *The Ex-Voto*, 1860 (Musée des Beaux-Arts, Dijon), a painting of women praying before an outdoor shrine, Léon Lagrange complained that "the plants which cover the ground and are of a normal size are not studied with the same accuracy as the individuals."[30]

Simon Saint-Jean
Offrande à la Vierge
Offering to the Virgin
Oil on canvas
1842

Flower painters, including those who worked within the luxury industries, were never far from nature in their sources. Braun's photographs assisted painters but did not replace living flowers for artists who were known for their skillful translation of color and texture from petal to canvas. Between 1840 and 1860, appreciation of flowers as domestic ornaments expanded, and the creation of private conservatories flourished, thanks to the perfecting of interior heating systems and greenhouses.[31] In 1843, when the Zuber workshop in nearby Rixheim launched a panoramic wallpaper entitled "Isola Bella," the successful introduction of the winter-garden theme, with its profusion of unseasonal flowers, relied upon the

resources in the company's private gardens and greenhouses. Like Zuber's artists, Braun also required access to both domestic and exotic blooms. The sheer freshness and variety of the examples he included in the *Fleurs photographiées* were only possible thanks to exceptional horticultural resources, grown either in his own gardens in Dornach or in those of his second wife's family, the renowned Baumanns of Bollwiller.[32]

The success of *Fleurs photographiées* with viewers, aside from artists and designers, led Braun to explore other subjects in the world of nature. He entered the field of animal photography around 1860, having already acquired a farm in Dornach that provided him with a selection of horses, cows, bulls, and sheep. The genre of farm animals had already been introduced by other photographers in France, including Olympe Aguado, a wealthy amateur who was a founder of the Société Française de Photographie and a member of the inner circle of Napoleon III.[33] Aguado's photographs were made for his own pleasure and for the enjoyment of his friends, and were not intended for public distribution. Professional photographers, such as Édouard Baldus, Achille Quinet, Camille Silvy, and Adrien Tournachon, on the other hand, marketed animal photographs expressly as zoologic images and as aids for artists.

The continuing popularity of animal paintings, revived in the nineteenth century by the Barbizon painters and by the artists of the Hague school, suggested a need for photographs among artists who did not have access to livestock of their own. Braun's catalogs eventually included an inventory of just over 160 farm-animal images and an additional series of stereographic views. They appeared at a time when the animal paintings of Charles Jacque, Constant Troyon, Philippe Rousseau, and others held a position of considerable importance at the Salon, with their continued appeal to both French and American collectors. Although there were artists who, like Rosa Bonheur, had their own estates and farms, few had the advantage of custom-built studios in which to paint their barnyard models year-round, and most could benefit from convenient and accurate photographic sources.

There are no records of the commercial success of Braun's *Animaux de ferme*, but judging by the limited size of this genre within the company's catalog and the absence of critical commentary, they were not in strong demand. Formally, if coincidentally, the images have visual properties that suggest parallels with contemporary painting styles. The distinct separation of sharply focused animals against the blurred backgrounds of Braun's photographs recalls Courbet's idiosyncratic staging of his subjects. Already established by the 1850s in paintings such as *Young Ladies of the Village* and *The Bathers*, 1853 (Musée Fabre, Montpellier), Courbet's style was to place well-modeled figures against broadly painted landscapes. The peculiar physical detachment of Courbet's figures suggests actors posed against artificial backdrops, a particularly odd sensation when the dramatis personae are cattle. This incongruity prevailed both in studies of animals and in larger compositions like *The Rest during the Harvest Season*, 1867 (Musée du Petit Palais, Paris) in which two pairs of cows provide the dominant figural interest. Similar visual disruption occurs in Braun's *Animaux de ferme* images: due to the difficulty of restraining the animals for an extended period of time, he was forced to use a wide lens opening that distorted the depth of field and produced a vignetting effect around the subject (see p. 81).[34] Neither Braun's nor Courbet's staging was intended to be pictorial.

Jules Médard
Couronne de camélias
Wreath of Camellias
Oil on canvas
1874

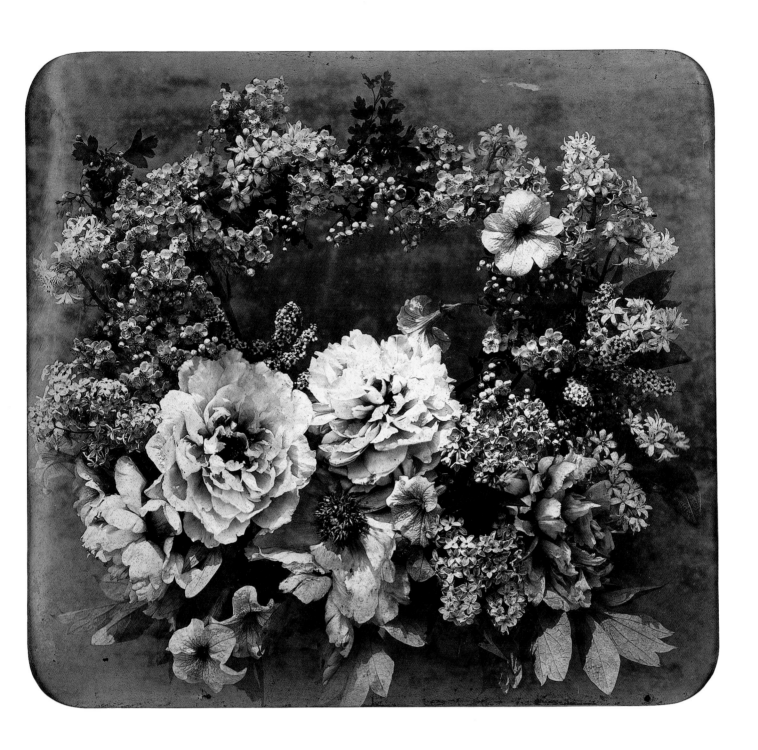

Fleurs photographiées (Couronne de fleurs)
Photographs of Flowers (Wreath of Flowers)
Albumen silver print
ca. 1854

They share a matter-of-factness derived from direct observation of nature, as much as they reflect a reference to seventeenth-century animal imagery and an exchange with other paintings, prints, and photographs of the nineteenth century.

Braun made a more conscious effort to reflect the concerns of contemporary painting with a suite of stereographic views that he called *Paysages animés* (Animated Landscapes). His views included a fisherman with his line cast, bathers splashing beside a waterfall, hunters pursuing game, harvesters gathering grapes, and peasants returning to their village at the end of day. Contemporary Salon exhibitions were filled with images of the labors and pleasures of rural life, most effectively represented in the paintings of Jean-François Millet and in the works of a growing number of figure painters whose themes were enhanced by close attention to local custom and dress. According to Ernest Lacan, who praised Braun in the pages of *La Lumière* in 1858, the *Paysages animés* were an original category of stereoscopic imagery: neither solely landscape views nor animated scenes of figures, but a separate genre whose qualities rivaled those found in paintings and revealed Braun as not only an imaginative photographer but also an artist and poet. As numerous and varied as these images were, Lacan declared, each one could be transferred to canvas without a painter wishing to change or add a single detail.[35]

The *Paysages animés* series marks the stage at which Braun advanced from making merely useful images to creating products that arranged subjects from nature in deliberately artistic ways. These efforts coincided with early interests in pictorial photography in England and were supported in French publications, such as Mayer & Pierson's

La Photographie (1862) and André-Adolphe-Eugène Disdéri's *L'Art de la photographie* (1862), which insisted upon photography's legitimate place among the fine arts.[36] Braun's desire to produce images that might compete with decorative prints or paintings seems to have intensified around this time. Instead of pursuing new ways to assist painters, he began to attempt themes that were modeled on existing artistic prototypes.

Still-life compositions were an obvious choice for photographers, as they consisted of discrete inert components that could be imaginatively composed on a table top and were already traditionally represented in paintings. British photographers, such as Roger Fenton, excelled at selecting objects that reflected sophisticated taste and arranging them in shallow interior settings. Hunt trophies, which were an important element of seventeenth-century still-life paintings, were also attempted by photographers in the 1850s and 1860s. In the style of Fenton, photographers such as Thomas G. Mackinlay and Hugh W. Diamond[37] created game compositions, on backgrounds of damask and tapestry, replete with arrangements of tankards, baskets, vases of flowers, and elegant slippers.

Braun first embraced this theme around 1860 in stereo views that included small game birds hung on rustic exterior walls.[38] This simple aesthetic, in stark contrast to the refinements of British taste, had antecedents in seventeenth-century Dutch painting, as well as in subjects by Chardin and Jean-Baptiste Oudry. In the 1860s, it reappeared in contemporary realist paintings, notably in the work of Claude Monet (see p. 82), Frédéric Bazille, and Alfred Sisley.

Braun's concept for a series of still-life arrangements with game, *Panoplies de gibier*, fell somewhere between rustic simplicity and aristocratic

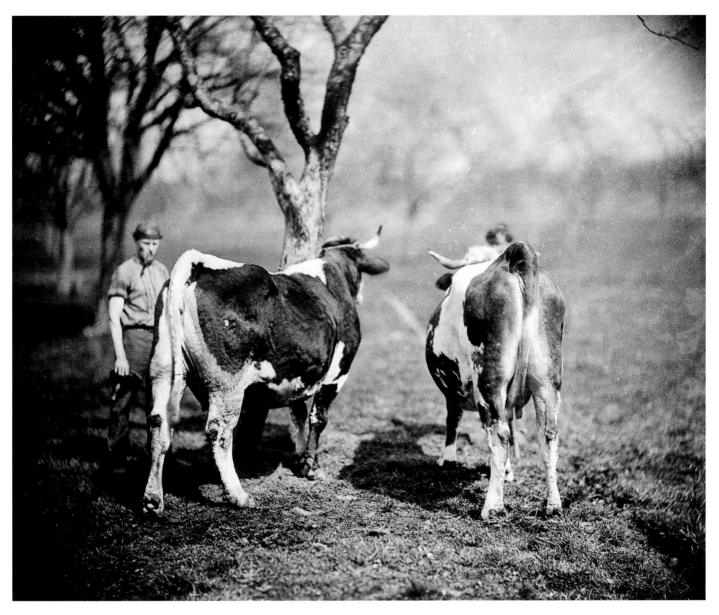

Animaux de ferme
Farm Animals (Farmer with Cows in a Field)
Albumen silver print
ca. 1860 (printed later)

hubris. Around 1867, having attained the technical ability to produce what he thought would be a unique interpretation of the hunt trophy, he introduced the first six of an eventual eight compositions that exploded both subject and format into nearly life-size images. These were intended to be framed and hung in dining rooms.[39] The *Panoplies de gibier* were printed from large glass negatives (about 32 x 24 in. [80 x 60 cm.])

that were similar in size to easel paintings and reproduced images in the realistic scale that had made Braun's *Fleurs photographiées* so effective. Equally impressive, and of great importance to Braun, was the use of a carbon process in which a selected tone, such as warm red-brown, was added to the gelatin coating of the paper to enrich the color and surface of the photograph (see p. 83).

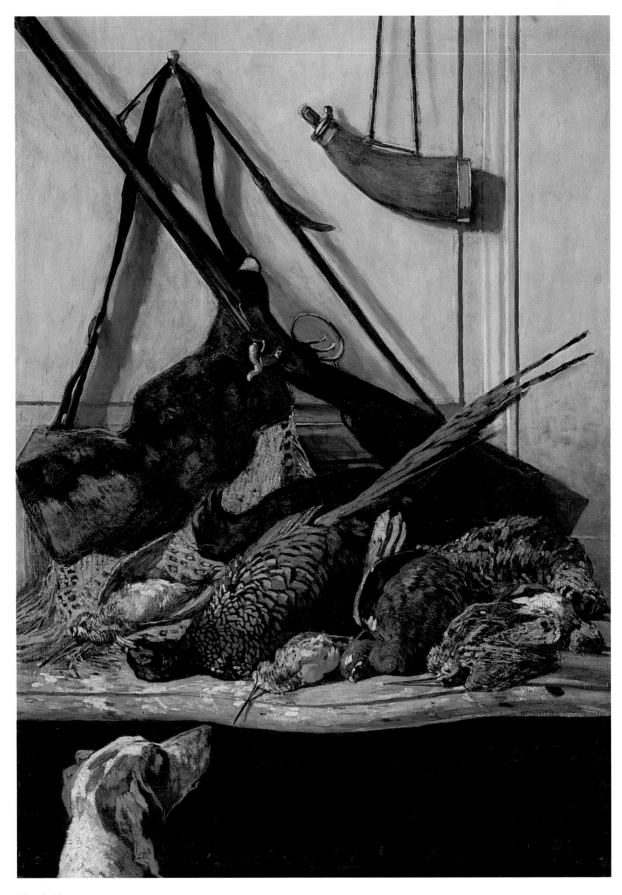

Claude Monet
Trophée de chasse
Hunting Trophy
Oil on canvas
1862

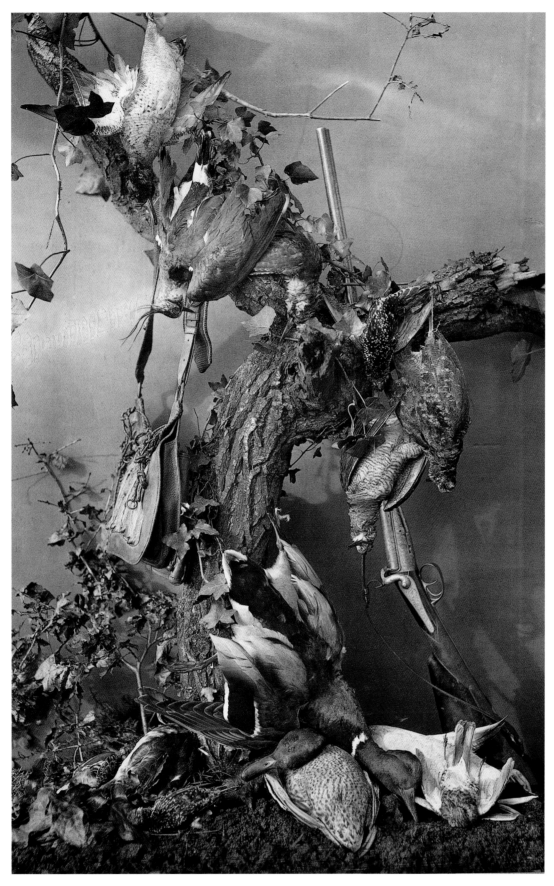

Still Life: Dead Game
Carbon print
1867 (printed ca. 1880)

The subject of game trophies was familiar to Braun through its long currency in designs for luxury products, including in the elaborately carved woodwork of noble country houses. Not only did game trophies recall the hunting privileges of royalty, but they also represented a popular culinary theme. In the nineteenth century, as now, game was a seasonal delicacy in France, where autumn menus featured wild boar, hare, and duck, as well as venison, partridge, grouse, and pheasant. Braun's bountiful compositions represented middle-class well-being, as opposed to the urns, statuary, and small live animals that were intrinsic to more aristocratic still-lifes. The arrangements of the *Panoplies de gibier* were more conscious and artful than the factual approach of the *Fleurs photographiées*, but high taste and allegory were excluded. The primary motif—a fox, hare, or boar—was accompanied only by appropriate hunting accessories, branches, leaves, and other small prey.

Braun placed his *Panoplies de gibier* in a shallow plane and took advantage of natural light that struck the composition as if cast by a setting sun or filtered through branches. The dappled effect randomly highlights the compositions' richly juxtaposed textures, catching the downy feathers of a fowl, the white underbelly of a deer, or the glint of a rifle. Through the enhanced tone of the carbon process, the bounty of the season was emphasized and the harsh reality of black-and-white photography mitigated. The combined dramatic impact of scale, content, style, color, relief, and lighting produced images that were artful mirrors of nature without the awkwardness of earlier still-life hunt photographs or the stiffness of taxidermy. Framed, glazed, and hung in a dimly lit dining room, the *Panoplies de gibier* must have appeared from a distance to be *trompe-l'œil* paintings.

Up close, they had both remarkable resolution and surface allure, as well as a unified effect that approximated the veil of art.

The *Panoplies de gibier* tested the limits of photography as a substitute for painting or the decorative arts, by providing the highest level of artistic and technical quality for the viewer. They were tastefully composed and lit, and given an overall wood-colored tone that enhanced their pictorial appearance and suggested age. They could be considered contemporary versions of traditional Dutch and French prototypes, simplified to represent a realist style that had become acceptable to bourgeois taste. Their easel-size format meant that they could be framed and hung as permanent decorations, not merely viewed privately, while use of the carbon process prevented noticeable fading. At fifty francs, although somewhat costly for photographs, they were less expensive than paintings; but, despite constituting the pinnacle of still-life photography in the 1860s, they may also have been ahead of their time. Whether or not the scale, medium, and subject matter met the needs of the middle-class viewer for dining-room decoration is hard to determine. As substitutes for paintings, as interior decorations, or as symbols of taste, they seem to have left little trace of their reception in the marketplace. Only eight were produced, but they remained in the Braun catalog as potentially marketable for twenty years.[40] Although not the final exercise in artistic genre or still-life photography in the Braun catalog, they were arguably the most ambitious and most reflective examples of a bourgeois realism that attempted to wed contemporary technique to traditional iconography.

In a subsequent body of work, Braun continued to pursue his artistic aspirations with a theme that straddled the fine-art and tourist markets. In 1869

he deposited with the French government forty-six 12 x 9½ in. (30 x 24 cm.) images of *Costumes de Suisse* (Costumes of Switzerland),[41] combining elements of formal portrait photography, stage design, costume history, and genre painting, and surpassed his handling of the subject in the formats of stereo views, cabinet cards, and *cartes de visite*.

The photographs in the larger format reflect the involvement of a team of painters, stylists, cameramen, and art directors. Photographed in the garden studio at Dornach, they feature individual young women attired in traditional costumes of the Swiss cantons.[42] Certain women appear in more than one image, but the choice of model took into account the ethnic characteristics of the particular region of Switzerland. Although several of the models appear in interior settings, the majority are posed against painted backdrops that depict specific touristic monuments or sites, such as the cathedral in Basel, the Lake of Lucerne, or the suspension bridge in Fribourg. Occasionally either the backdrop or another aspect of the set reappears in the representation of a second canton, but never without the appropriate alterations or props. The costumes include traditional aprons, coifs, and footwear, and variants within a single canton were sometimes represented in a second photograph.

Within the format of a staged portrait, the individual images of the *Costumes de Suisse* reflect a widespread interest in regional costumes and traditions and in various types of people at work. Artists had long relied on series of engravings as sourcebooks for rural and urban "types." During Braun's years in Paris these included *Les Français peints par eux-mêmes* (1839–1842), a series that presented essays on Parisian, provincial, and colonial life and occupations, along with illustrations of figures performing tasks or dressed in traditional costumes.[43] Artists, writers, and cultural historians participated in the documentation of specific regional customs, particularly seasonal and religious observances. Images of young women in traditional Swiss costumes were a particularly popular category, and were published as engravings and lithographs throughout the nineteenth century.[44] Braun was familiar with a deluxe series of lithographs by Forge and Lemercier, published by Wild in Paris in 1859, and even included an example as a wall decoration in one of his *Costumes de Suisse* interiors (see p. 86).

There were prototypes for the *Costumes de Suisse* in earlier genre photography in both France and England and closer parallels can be found in contemporary photographs of actors on stage. However, the images that comprised Braun's *dépôt légal* are distinctive in their visual refinement and highly researched documentary qualities. The undertaking required the equivalent of a production team to coordinate its various aspects. Locations had to be selected and then painted (presumably with the aid of Braun's photographs of Swiss views), sets constructed, models hired, and authentic costumes acquired and fitted. Each vignette needed its own collection of props, which might include baskets of produce, game birds, flowers, music boxes, an exterior staircase, a window or door, or even a small boat. Individual figures were then posed with subtle theatrical direction: an Appenzell maiden might pause while climbing a mountain path, and a girl from Schaffhausen might lift her hem and reach for a branch, as she emerges from a wood.

Other sets re-create bourgeois interiors with regional furnishings and examples of typical wall decorations and accessories. In one, a model is seen from behind as she looks into a mirror to adjust her lace cap (see p. 87), like a provincial version (in reverse)

Forge and Lemercier (Éditions Wild)
"Contentel," Canton d'Unterwalden
Lithograph
1859

Costumes de Suisse: Canton de Fribourg, partie allemande
Costumes of Switzerland: Canton of Fribourg, German-Speaking Section
Albumen silver print
1869

of Jean Auguste Dominique Ingres's *La Comtesse d'Haussonville*, 1845 (Frick Collection, New York). In another interior more reminiscent of Jan Vermeer, a figure sits at a table and knits, while a different view has a homely Chardinesque quality provided by a glimpse through a kitchen doorway to pots and pans on a *trompe-l'œil* stove. The consistency and restraint of the Braun studio style proved an artistic advantage in the construction of the *Costumes de Suisse*, as it permitted these images to be read seamlessly, like paintings, without the kind of informational excess that prompted the disdain of art critics.

Braun's progression from designer to artist-designer evolved over a period of time and within the context of a company that included other artists and cameramen. The look of the *Panoplies de gibier*, like that of the *Costumes de Suisse*, presumably reflected the input of more than one authorial vision and undoubtedly was influenced by Braun's son Henri, who had studied painting in Paris. Since both of these projects were completed in the garden studio at Dornach, Braun's personal involvement and direction seems assured. Their concepts, however, develop from the artistic momentum of the *Fleurs photographiées* and establish a mature method of making photographs that adopt the values of contemporary still-life and genre paintings. In a sense, the visual excitement of Braun's experiment with flowers, which still maintains its

Costumes de Suisse: Canton de Saint-Gall
Costumes of Switzerland: Canton of Saint-Gall
Albumen silver print
1869

freshness and appeal for modern viewers, was replaced with an intentionally "artistic" vision that appropriated existing conventions.

The subjects that convinced Braun's audience that a photograph could, like a painting, stir human emotions, were deeply linked with the outcome of the Franco-Prussian War. In 1871, when Alsace and Lorraine were ceded to the Prussian victors, Braun conceived their personifications as young girls—sisters—in regional costumes. Combining his perfected carbon-printing technique with his experience in staging and lighting, he abandoned the studio props of the *Costumes de Suisse* and interjected the sentiments of a population that had been torn from its motherland. Embracing

popular realist conventions, this final gesture toward painting found an appreciative and lasting market. The photographs of *L'Alsace* and *La Lorraine* accurately read the public need for images that represented the longings and hopes of a region. Emotionally fraught, these subjects wove various threads of nineteenth-century figure painting into a meaningful photographic product. They incorporated the elevated sentiment of history painting, the allure of classical female beauty, and the popular appeal of traditional costume into a single artistic statement.

It was the dark-haired figure of *L'Alsace* (a regional equivalent of "Marianne," the female symbol of the French Republic) whose image (see p. 89) seized the population's imagination and silently represented its resistance to political reality. Although Prussian authorities discouraged an emblematic reading of *L'Alsace* and attempted to interpret the model as the fiancée of one of their own officers,[45] the figure quickly became a symbol of French pride. Braun's image of the sturdy peasant girl was widely published as an engraving and reproduced on ceramic plates. It became so embedded in the viewers' consciousness that it continued to be used in posters up to the First World War. The impact of *L'Alsace* on contemporary realist painting seems evident in Jules-Émile Bastien-Lepage's *Joan of Arc Listening to Voices (Jeanne d'Arc écoutant les voix)*, 1879 (Metropolitan Museum of Art, New York) (see p. 88). A native of Damvillers, a small town in Lorraine, the artist had served in the war and brought patriotic conviction to his interpretation of France's patron saint. Bastien-Lepage studied the young peasant girls of his own village for his Joan of Arc and, in his final version of the painting, depicted her straining to hear the voices that called her to battle. Her costume, posture, and intense hooded gaze are indebted to

L'Alsace and show the influence of Braun's photograph on an artist who was widely admired for his "frank, sincere, discreet, intelligent naturalism."[46]

If Braun's initial intention was to produce photographic images for the marketplace as sources for designers and artists, his talent and eventual success lay in his ability to create new products for a more heterogeneous population. His flagships, the landscape and museum series, were produced with the participation of his family and staff, publicizing his enterprise and providing a steady stream of revenue for the company. The smaller "artistic" ventures—the *Fleurs photographiées, Animaux de ferme, Panoplies de gibier, Costumes de Suisse,* and finally *L'Alsace* and

Jules-Émile Bastien-Lepage
Joan of Arc Listening to Voices (Jeanne d'Arc écoutant les voix)
Oil on canvas
1879

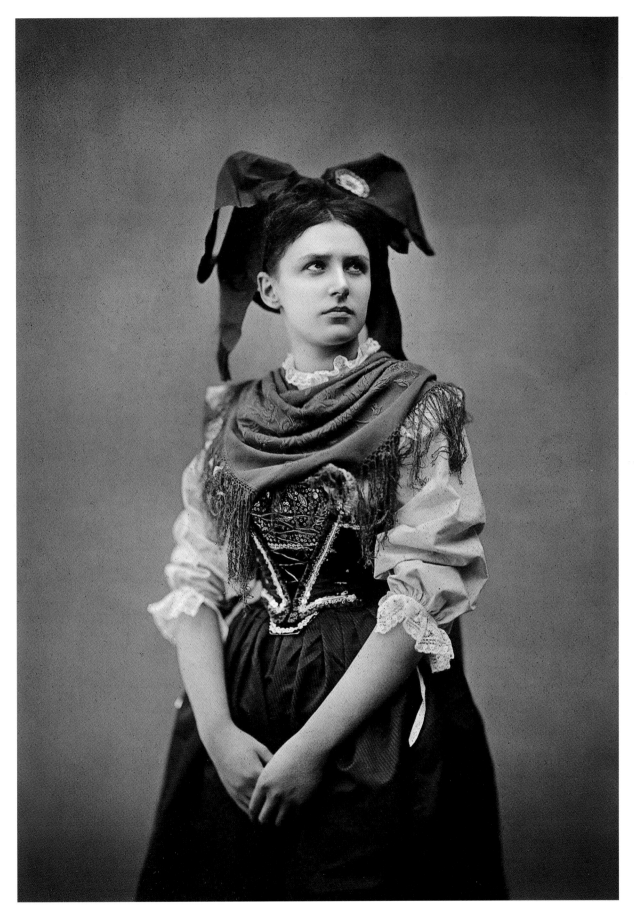

L'Alsace
Carbon print
ca. 1871

La Lorraine—were executed at home, in his own garden and farm, where resources were conveniently organized and where he could focus on the motifs that were most familiar to him.

Braun's "realist" images presented varying levels of intentionally artistic content. Ironically, it is the earliest of the series, the *Fleurs photographiées*, that most appeals to viewers today. The qualities Braun achieved in these photographs might arguably be seen as inherent in the medium and unpremeditated by the photographer. Almost accidentally, they provide an acutely modern response to nature. The subjects, although framed by the lens, appear as if they have been perceived by the naked eye. This coincidence made the images useful as sources for realist painters, but their appealing and technically refined presentation of discrete aspects of reality also encouraged them to be considered in a similar light to paintings: as objects that provide direct visual pleasure. While this was not Braun's primary intention for the *Fleurs photographiées*, the favorable critical and public reception made it apparent that a market existed for photographs that were not only useful and instructional, but also intrinsically decorative. Once introduced into the marketplace, such creations assumed a life of their own, directly and indirectly influencing art and subtly changing critical expectations for both photography and painting.

[1] American as well as French painters consulted Braun's photographs. American landscape painter Samuel Colman owned a collection of Braun's panoramic views of Switzerland that he gave to the National Academy of Design, New York (now in the collection of The J. Paul Getty Museum, Los Angeles).

[2] Laviron's theories are discussed by Gabriel Weisberg in "The Realist Tradition: Critical Theories and the Evolution of Social Themes," in Weisberg, ed., *The Realist Tradition: French Painting and Drawing, 1830–1900*. Bloomington: 1980, p. 1.

[3] Henri de Lacretelle, "Beaux-Arts. Salon de 1852," *La Lumière*, year 2, no. 15 (April 3, 1852), p. 57.

[4] Ibid., year 2, no. 21 (May 15, 1852), p. 81. Cabanel's *The Death of Moses* is now in the collection of the Dahesh Museum, New York.

[5] Francis Wey, "Du Naturalisme dans l'art; De Son Principe et de ses conséquences," *La Lumière*, year 1, no. 8 (March 30, 1851) p. 31.

[6] Jules-Antoine Castagnary, *Salons, 1857–1870*, 2 vols. Paris: 1892; quoted in Patricia Mainardi, *Art and Politics of the Second Empire: The Universal Expositions of 1855 and 1867*. New Haven and London: 1987, p. 119.

[7] Théophile Thoré, *Nouvelles tendances dans l'art*. Paris: 1856, p. 34.

[8] See Pierre Rosenberg, *Chardin, 1699–1779*. Paris: 1979, for a history of the critical re-evaluation of Chardin.

[9] Charles Blanc, "École française. J. B. Siméon Chardin," *Histoire des peintres de toutes les écoles*, vol. II, Paris: 1865, p. 6. Blanc also describes the extreme sobriety that characterizes his pictures and contrasts the Flemish tendency to accumulate details to Chardin's desire to abbreviate them (p. 9).

[10] Léon Wulff, "Exposition photographique," *La Revue photographique* (1859), p. 169, cited in Pierre Tyl, *Adolphe Braun: photographe mulhousien, 1812–1877*. Dissertation, University of Strasbourg, 1982, p. 41. Wulff noted that Braun shared with the Bisson brothers "le privilège d'attirer les regards, de captiver l'attention, de produire parmi la foule ce sentiment unanime qui s'incline seulement devant le beau!"

[11] Aaron Scharf, *Art and Photography*. London: 1968, p. 131, and figs. 83 and 84, demonstrates the close similarity between the nude female in Courbet's *The Studio of the Artist* (1855) and a nude study by photographer Julien Vallou de Villeneuve that was submitted as a *dépôt légal* in 1854 (Collection, Bibliothèque Nationale de France, Paris).

[12] Courbet hoped that these reproductions, which were "sold everywhere," would provide him with an additional source of revenue. For an exhibition in Le Havre in September 1868, he sent a selection of framed photographs to his dealer with the instructions to "place a register close by in which people who would like either the series or the individual photographs could write their names." (See "Courbet to Ferdinand van der Haeghen," in Petra ten-Doesschate Chu, ed. and trans., *Letters of Gustave Courbet*. Chicago and London: 1992, no. 68-20, pp. 342–43).

[13] Courbet, *Portrait of P.-J. Proudhon in 1853*, 1865 (Musée du Petit Palais, Paris). See Hélène Toussaint's discussion of this painting and Courbet's use of photography, in *Gustave Courbet (1819–1877)*. London: 1978, pp. 154–57.

[14] The relationship of Courbet's painting to Braun's photograph was first noted by Scharf, op. cit., p. 135, figs. 89–90. See Courbet's *Le Château de Chillon*, 1874 (Musée Gustave Courbet, Ornans), p. 203, in Sarah Faunce and Linda Nochlin, *Courbet Reconsidered*, Brooklyn: 1988, in which Ann Dumas [A. D.] notes that Courbet painted several versions of this popular subject in order to support himself while in exile in Switzerland.

[15] See *Corbeille de fleurs renversée dans un parc*, ca. 1848–1849 (Metropolitan Museum of Art, New York) and *Corbeille contenant des fruits posée dans un jardin*, ca. 1848–1849 (John G. Johnson Collection, Philadelphia Museum of Art). Vincent Pomarède discusses the importance of flower paintings in Delacroix's work in "Le Sentiment de la nature," in Réunion des Musées Nationaux, *Delacroix: les dernières années*. Paris: 1998, pp. 117–38.

[16] Baudry maintained gardens on his estate in the Saintonge region, and owned an extensive collection of books on flowers. See Karyn Esielonis, *Still-Life Painting in the Museum of Fine Arts, Boston*. Boston: 1994, p. 86.

[17] Courbet took critical pride in these compositions, and urged his Paris dealer to include *Magnolias* in the exhibition of the Société Nationale

des Beaux-Arts the following year. (See Courbet's letter to Jules Luquet, February–March 1863, in Chu, op. cit., no. 63-3, p. 217.)

[18] Fantin-Latour's paintings of flowers in glass vases also share an affinity with photographs by Charles Aubry. See Anne E. Havinga, "Charles Aubry's Poppies: the Floral Photograph as Model for Artists and Designers," *Journal of the Museum of Fine Arts, Boston*, vol. IV (1992), pp. 80–95; and Elizabeth Anne McCauley, *Charles Aubry, photographe*. Paris: 1996.

[19] See *White Lilies*, 1877; *Nasturtiums*, 1880; and *Cherries*, 1883 (all Victoria and Albert Museum, London); and *Gladioli*, 1879 (Boymans-van Beuningen Museum, Rotterdam).

[20] Ernest Lacan, "Album des fleurs par M. A. Braun," *La Lumière*, year 8, no. 4 (January 23, 1858), p. 13.

[21] Tyl, op. cit., pp. 8–11. In the chapter "La Formation d'un dessinateur," the author notes the growing importance of the profession of industrial designer in France in 1820 and discusses the training required to address the application of fine art to industry.

[22] See Elisabeth Hardouin-Fugier and Étienne Grafe, *Les Peintres de fleurs en France de Redouté à Redon*. Paris: 1992, for illustrations of the title pages of the *albums du dessinateurs* by Reybaud and Eugène Oyez in 1840, including *Couronnes de fleurs* and *Branches fleuries*.

[23] Christian Kempf, *Adolphe Braun et la photographie*. Strasbourg: 1994, p. 15.

[24] *La Lumière* was published regularly between 1851 and 1860. See Gilbert Beaugé's informative essay, "Un Monument de l'archive photographique: 'La Lumière,'" in *Collection du Journal La Lumière. Beaux-Arts. Héliographie. Sciences [Réimpression de l'édition de Paris, 1851–1860 parutions hebdomadaires]*. 2 vols. Marseille: 1995, vol. I, pp. 9–32. It had correspondents throughout France and in Switzerland, Germany, Holland, Belgium, Italy, Spain, England, and America and accepted subscriptions through these individuals. Photographer Charles Winter of Strasbourg was *La Lumière*'s correspondent in Braun's region (the *départements* of the Haut-Rhin and Bas-Rhin).

[25] A.-T. L., "Utile application de la photographie aux beaux-arts et à l'industrie," *La Lumière*, year 4, no. 45 (November 18, 1854), p. 178. The identity of "A.-T. L" remained unknown to Beaugé, op. cit., p. 19, who notes that "Le mystérieux A. T. L." was responsible for *La Lumière*'s regular account of the sessions of the Académie des Sciences between 1851 and 1860.

[26] Pierre Caloine, "De l'Influence de la photographie sur l'avenir des arts du dessin," *La Lumière*, year 4, no. 17 (April 29, 1854), pp. 65–66.

[27] Braun had also composed floral wreaths, which were common motifs in textile and wallpaper designs, for his 1842 *Recueil de dessins*.

[28] Simon Saint-Jean continued a long iconographic tradition of painting a garland of flowers around a cartouche. Marie-Louise Hairs, *Les Peintres flamands de fleurs au XVIIe siècle*. Tournai: 1998, p. 35, describes its vogue in the early seventeenth century, in works such as Daniel Seghers's *Guirlande de fleurs avec l'éducation de la Vierge* (Worcester Art Museum, Massachusetts).

[29] See, for example, John La Farge, *Agathon to Erosanthe (Votive Wreath)*, 1861 (Private collection); ill. in James L. Yarnall, *Nature Vivante: The Still Lifes of John La Farge*. New York: 1995, pl. 3; and *Wreath of Flowers*, 1866 (Smithsonian Institution, National Museum of American Art, Washington, D.C.), pl. 4. La Farge may have seen Braun's photographs in Paris, where La Farge studied from 1856 to 1857, or at the Manchester Art Treasures Exhibition which he visited at the end of 1857.

[30] Léon Lagrange, "Le Salon de 1861," *Gazette des beaux-arts*, year 3, vol. XI (July 1, 1861), p. 52.

[31] Hardouin-Fugier and Grafe, op. cit., p. 219.

[32] Kempf, op. cit., p. 20, n. 18, cites the likely complicity of Braun's in-laws, the Baumann family of Bollwiller, whose horticultural talents were known as far afield as Egypt.

[33] See, for example, Olympe Aguado, *Taureau et son vacher*, n.d., no. 137, p. 159, in Musées de Strasbourg. *Olympe Aguado, photographe (1827–1894)*. Strasbourg: 1997.

[34] See Tyl, op. cit., p. 82; and Kempf, op. cit., p. 43.

[35] Ernest Lacan, "Photographie stéréoscopique. M. Adolphe Braun." *La Lumière*, year 8, no. 16 (April 17, 1858), p. 61: "Il n'y a pas dans sa collection, si nombreuse et si variée, un seul sujet qui ne puisse être transporté sur la toile sans que le peintre voulut y changer ou ajouter le moindre détail."

[36] Scharf, op. cit., pp. 154–55.

[37] See Grace Sieberling, with Carolyn Bloore. *Amateurs, Photography, and the Mid-Victorian Imagination*. Chicago and London: 1986, pl. 57; Thomas G. Mackinlay, *Still Life (From Nature)*, mid-1850s; Hugh W. Diamond, *Still Life (From Nature)*, ca. 1853–1855 (both George Eastman House, International Museum of Photography, Rochester).

[38] Kempf, op. cit., p. 46, n. 60, states that Louise Laffon exhibited photographs of *oiseaux pendus* (hanging birds) at the Salon des Beaux-Arts of 1859 and at the Exposition de la Société de Photographie in 1861. Both Charles Nègre and Eugène Cuvelier also made photographs of small game birds around that time.

[39] Ibid., p. 45.

[40] Tyl, op. cit., p. 83.

[41] These are cataloged as *Série de costumes suisses*, Eo.57b, vol. 3, DL 1869 (Haut-Rhin), in the collection of the Bibliothèque Nationale de France, Paris.

[42] *"Costume de Suisse"—studio dans le jardin de Dornach*, 1869, in Kempf, op. cit., p. 47, shows a model seated before a painted backdrop hung from an exterior staircase.

[43] The importance of these prototypes to French realist painters and the long tradition of the genre known as the *cris de Paris* (illustrated workbooks providing historically accurate and detailed pictures of those involved in street industries) are discussed in Weisberg, op. cit., pp. 6–8.

[44] Albums at the Bibliothèque Nationale de France, Paris, include numerous versions of Swiss costume prints that were published in Paris from the 1820s through to the 1850s.

[45] Kempf, op. cit., p. 6.

[46] "Art Notes," *Magazine of Art*, vol. V (1882), p. xxvi.

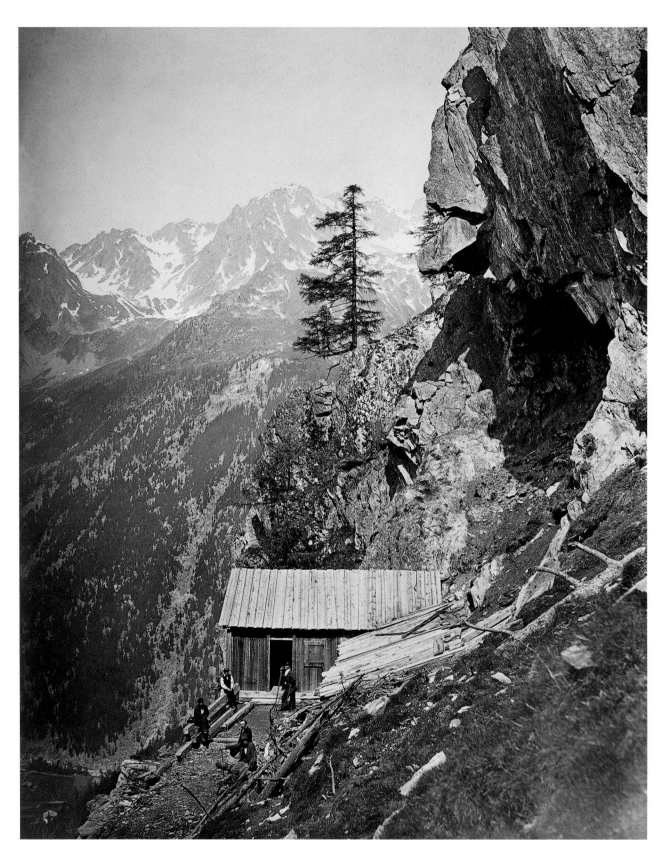

Savoie. Vallée de Chamonix. Le Pavillon du Chapeau
Savoy. Valley of Chamonix. The Pavillon du Chapeau
Albumen silver print
ca. 1862

Souvenirs of Progress
The Second-Empire Landscapes

DEBORAH BRIGHT

WHILE BROWSING IN a secondhand shop several years ago, I discovered a worn, leather-bound album of photographs of European views. The anonymous formality and technical competence of the images, as well as their deep-brown hue, indicated that they were probably albumen prints, purchased from a commercial distributor, as was customary until the 1890s, when personal snapshot photography became widespread. According to the inscription inside the front cover, the album had belonged to Mrs. L. Edith Hoopes of Providence, Rhode Island, who had organized its contents under the title, "General—foreign—from 1884 on." The opening photograph, labelled "Swiss Village and Mountain" in Mrs. Hoopes's gracefully penned script, depicts a craggy Alpine landscape with picturesque chalets clustered in the foreground. The following pages feature from one to four photographs of varying sizes, acquired on travels to Switzerland, Italy, Germany, Belgium, England, and France, as well as several pages of photographed reproductions of works from the Musée du Louvre, Paris, and the Galleria degli Uffizi, Florence.

The photographs Mrs. Hoopes collected and carefully arranged in her album are, for the most part, aesthetically unremarkable, even banal. They are the direct antecedents of the images we would expect to find in today's tourist gift shops or travel guides, publicizing the timeless charms of Rome, Paris, or the English countryside. These are essentially public rather than private images. They function less to mark the personal adventures of a tourist abroad than to reflect her individual participation in a collective public ritual: the holiday grand tour of sites already venerated by generations of informed travelers.

I suspect that it was precisely the overfamiliarity of these subjects and the photographers' treatments of them, as well as the prints' various states of fading, which prompted the shopkeeper to sell me the album for a paltry three dollars. There is little here to appeal to the modern landscape connoisseur's eye—no dramatic light effects, unusual vantage points, spatial ambiguities, fragmented forms, allusions to interior states, or mute topographic descriptions— nor does any photographer's name or studio stamp appear on or near the prints. There is only the hand

of Mrs. Hoopes, who has carefully inscribed a title beneath each image: "Bellagio on Lake Como," "Mont Saint-Michel," "Holyrood Chapel," "Cottage in Devonshire, England."

Mrs. Hoopes's album is as good a place as any to begin our study of Adolphe Braun's career as one of the largest producers of commercial landscape views in France during the second half of the nineteenth century. It was precisely these kinds of photographs—inexpensive mass-produced prints of popular travel subjects—that formed the core of Braun's business. The massive extant archive of the Braun firm gives us a rare opportunity to examine the formation of one of photography's most enduring commercial markets,

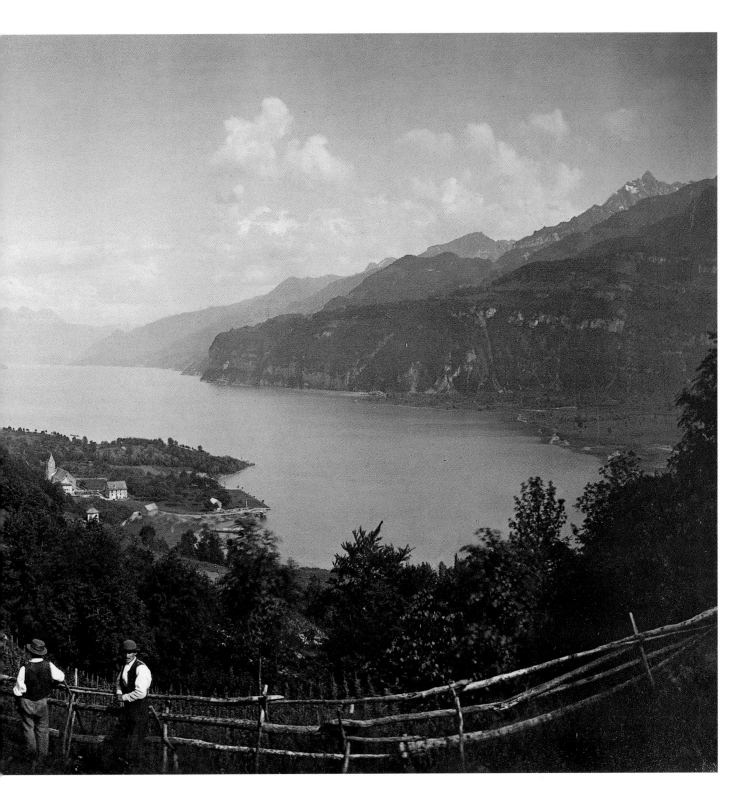

focused through the production of a single family-run
firm founded soon after the introduction of photography
in 1839 and thriving well into the twentieth century.

As with all new technological applications, the life
of early photographic enterprises could be short and
volatile. Possible miscalculation of location and
demand, studio overheads and overextended credit,

Weesen et le lac de Wallenstadt
Weesen and the Lake of Wallenstadt
Carbon print
1867

rapid boom-and-bust cycles in the economy, the increasing consolidation of the industry, and rapid technological advances made commercial photography a risky venture. Data in Paris commercial directories indicates that almost half of the studios founded in that city between 1852 and 1861 folded in less than five years.[1] To protect themselves from financial disaster, photographers frequently pursued several overlapping endeavors, such as caricature, illustration, fabric and wallpaper design, lithography, and engraving. Since Braun had already successfully established himself in 1843 as a fabric designer in Mulhouse, an important industrial city in Alsace, his branching out from that base a decade later into photographic mass production protected him from the ruder shocks of a highly speculative marketplace. By contrast, more celebrated photographic entrepreneurs of Braun's generation, including André-Adolphe-Eugène Disdéri, the Paris society portraitist, and Mathew Brady in the United States, went bankrupt.

The preservation of Braun's original archive is remarkable too, because, until recently, mass-market photographs held little interest for art collectors or museums. Prints, plates, and negatives from commercial studios and picture agencies were routinely weeded, purged, and dispersed from archives over the life of a firm, so that provenance and original production contexts are all but impossible to recover by even the most determined archivists. Such photographic materials were (and still are) primarily valued as visual records of public events and personalities, rather than as artifacts of artistic intention, so their collectable value has depended largely on the intrinsic historical interest of the subject matter.

The accelerated appropriation of photographs by the art market in the wake of pop art's elevation of vernacular photography by the mid-1960s, however, created its own complications by assigning new commodity values to old photographs. Using selection criteria borrowed from conventional art connoisseurship, historians and curators subordinated consideration of production contexts to the authentication of individual authorship, the condition and rarity of the artifact, and its representation of a known practitioner's style. Archives were scoured again—this time to retrieve examples of particular photographers' works that could be sold to institutions and collectors buying at the low end of the art market, or donated to museums for tax purposes. Gravures were cut from library books, prints were stripped from government reports, and sets of bound subscription folios were divided up to produce individual objects for sale.[2]

Braun's archive was not immune to this kind of highly selective re-editing. The large studies of flowers he produced and exhibited to great acclaim in both practical and artistic contexts in the early 1850s have been singled out in recent retrospective surveys of mid-nineteenth-century French photography, obscuring his larger role as a mass-producer of travel views and art reproductions.[3] Outside of France, few know of Braun other than as the early French "flower photographer" whose striking photographed arrangements of bouquets and garlands are often exhibited alongside the mountain views of the Bisson brothers and the architectural studies of Henri Le Secq.

Braun's activities as the proprietor of a prosperous photographic firm may reduce his appeal to art connoisseurs, but they make him interesting to cultural historians. Unlike his more celebrated contemporaries —Le Secq, Gustave Le Gray, Charles Nègre, Roger Fenton, Édouard Baldus, and Maxime Du Camp—

Braun was first and foremost an astute businessman, looking for ways to exploit the new technology profitably, making technical and procedural improvements, and cogently calculating the return on his investment. His approach to his *métier* differed significantly from that of his artist-peers, for he was steeped in the pragmatism and business ethic of his native Alsace, which at the time was enjoying its full flowering as the center of textile manufacturing in France. It was not the artistic potential of early photographic processes that interested Braun; as far as we know, he never took up the calotype so in vogue among artistic amateurs in the 1840s. Rather, it was only after the introduction of the wet collodion process in 1851 that Braun turned serious attention to the new medium, initially seeking ways to apply it to his own field of expertise, textile design.

As photography was rapidly usurping many of the more mundane tasks of naturalistic drawing, Braun perceived that life-size photographs of carefully arranged plant forms would be very marketable to designers and decorative artists interested in the accurate ornamental detailing of foliage and flowers for fabrics and wallpapers. In addition, botanists, horticulturalists, and art collectors would be a significant secondary market for such studies. The wet collodion on glass process, invented and donated without restrictions to the public by the English physician Frederick Scott Archer, made mass reproduction of photographic images both possible and profitable for the first time.

As there was little practicable enlarging before the incandescent bulb in the 1890s, negative size determined finished print size. This is what accounts for the huge size and bulk of some of the field and studio cameras used in the nineteenth century. Braun's studio,

as many others, boasted of its large plate sizes in its advertising, including 9 x 12 in. (23 x 30 cm.) and 16 x 20 in. (40 x 50 cm.) views, and studio still lifes in incredible 21 x 30 in. (53 x 76 cm.) and 28 x 36 in. (71 x 91 cm.) formats. Remembering that the camera itself had to accommodate a glass plate of that size for each exposure brings home that the physical labor of photography in the wet-plate period was no small matter, requiring the assistance of one or two technicians in addition to the camera operator. The labor-intensive method of plate preparation, exposure, and processing made it cost-effective to operate on a large production scale and to replace workers, as Braun did in 1866, with steam-driven machines to the furthest extent possible.

Other inventions and improvements to photographic technologies during the 1840s and 1850s boosted the medium's commercial potential and made it attractive to entrepreneurs like Braun. The invention of albumenized emulsions in 1847 led to the industrial manufacture and standardization of pre-coated printing-out papers that greatly reduced the time and expense of large-scale commercial print production. Disdéri immediately capitalized on this by inventing the *carte de visite*, or photographic calling card; they became a craze throughout the industrialized world during the 1850s and put personal portrait photography within every consumer's reach for the first time.

Another mid-century development that had immediate commercial pay-off was the stereograph, a format that remained popular until after the First World War, when it was finally outmoded by more immediate forms of mass visual communication, chiefly newsreel films and the illustrated press. Stereoviews had not received much attention from photographic historians until recently because of their ubiquity,

anonymity, and lack of material uniqueness as collectable objects. Unlike grand vintage plate views, which were comparatively costly to produce and aimed at a more elite market, stereoviews were a mass medium in the true sense of the word: mundane, cheap, and widely available.

As anyone who has peered through a stereoscope knows, stereoviews have a unique visual presence which has not been duplicated in any photographic format since. In the viewing instrument, the twinned photographs merge into a self-contained theatrical spectacle, where the image is scrutinized in private darkness and appears as large as life. One does not look *at* a stereoview in two dimensions, but *into* it, perceiving it as an accumulation of visual data from foreground to background and back again, an experience very unlike looking at photographs in books or hung on a wall. It is a viewing that unfolds in time, producing a more protracted and intensive engagement with the visual information presented.[4] As with the ViewMaster that succeeded it, this new kind of optical consciousness had immediate appeal for mass audiences, providing both entertainment and the sensation of access to privileged knowledge, as card after card of "Man's Works and Nature's Phenomena" (to quote one distributor's catalog) was shuffled past the stereoscope's lenses.

Another advantage of the stereoview was the stereo camera's ability to capture rapid action due to the short focal length of its twin lenses. Because the image size was small, the exposure time was short—fractions of a second, compared to the standard half to full minute for a large plate view. Therefore, until the perfection of faster-acting silver gelatin emulsions and mechanical shutters in the late 1870s, it was only in stereographs that a viewer could enjoy stop-action photography.

Foreshadowing the advent of direct photojournalism at the end of the century, Braun's stereo camera operators captured the rescue of a mountaineering guide from a crevasse on the Grindelwald glacier (see p. 5), allowing viewers to relive the drama through their scopes from the safety of their armchairs.

The production of stereoviews was the second mass photographic industry to be consolidated, following portraiture. After stereoviewing was popularized at the 1851 Great Exhibition at the Crystal Palace, London, Braun's firm, no less than Brady's or Anthony and Company in New York, depended on the stereo market for a major share of its revenues. It was no accident, either, that stereography's popularity coincided with the explosive growth of railroads and urbanism, and with imperialist expansion abroad. As a mass medium, stereoviews supplied images and information about a rapidly changing world, giving powerful new form to modern concepts of identity, nationalism, and global relations.

In the industrializing nations, railroads exposed formerly isolated regions to flows of commerce and tourism, creating new classes of travel consumers. These included middle-class families on a limited budget and schedule, who purchased views as souvenirs (and later took their own pictures), and the ranks of armchair tourists, who conjured in the stereoviewer vivid simulations of journeys never made. It would be these growing mass markets that Braun would target, selling his stereoview collections to middle-class and affluent buyers for fourteen francs a dozen—the weekly wages of a factory worker. He distributed them through the most reputable channels in Paris, including Alexis Gaudin, publisher of the prestigious photography journal *La Lumière*, and Goupil & Co., the leading dealer in art reproductions. View photography in

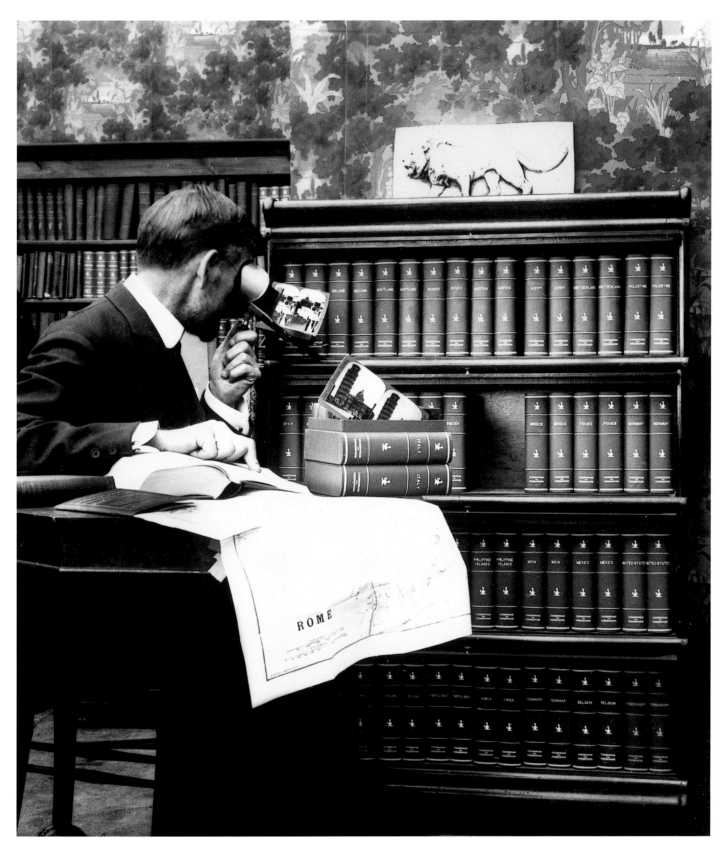

Underwood & Underwood

Man in Study Looking Through Stereo Viewer

Albumen silver print on stereoscopic mount

ca. 1900

mid-nineteenth-century France developed in relation to the commerce of mass tourism, as well as to the intensive campaign by government and business leaders to forge the idea of France as a progressive nation-state entering the modern era.

When Braun turned his attention to scenic photography in the early 1860s, his reputation as an artistic producer was already well established. He had won acclaim at international expositions for his flower studies, including a coveted silver medal in the 1855 Paris Exposition Universelle. Braun's floral still lifes were also featured in two juried exhibitions at the prestigious Société Française de la Photographie and won a medal at the 1862 London Universal Exposition. Gaudin distributed the flower photographs in various plate sizes and even marketed them in stereo formats after 1857. Early success encouraged Braun to try his hand at other artistic subjects in demand, particularly landscapes and architectural views.

The Second Empire's prodigious efforts to rebuild and celebrate France's architectural patrimony after decades of political turmoil, vandalism, and neglect were meant to link symbolically the establishment of Louis Napoleon's imperial court with the glory of past absolute rulers, whether the *ancien régime* or his illustrious ancestor, Napoleon I. The restorations were overseen by architect and court favorite Eugène Viollet-le-Duc, and it was at the latter's urging that photographers received state commissions to document France's historic monuments. In 1851, the year of Napoleon III's *coup d'état*, the Commission des Monuments Historiques of the Ministry of the Interior organized the Mission Héliographique, hiring five calotypists, including Le Gray, Le Secq, Mestral, and Baldus, to survey and photograph monuments scheduled for restoration. Le Secq photographed in Alsace, bringing both national and local attention to the region's architectural heritage. In 1855, at the urging of the Bas-Rhin (Lower Rhine) departmental prefect and archivist, a society dedicated to the conservation of Alsace's historic monuments was established in Strasbourg.

The same year that the Mission Héliographique was launched, Louis Blanquart-Évrard founded a printing establishment in Lille for producing illustrated portfolios of photographed landscapes and monuments. Aimed at the upper-middle-class collector and institutions, or at artists for use as studies, Blanquart-Évrard's prints from paper negatives were priced at the same levels as contemporary etchings, engravings, and lithographs. Interested buyers could subscribe to sets of prints organized around particular subjects, such as reproductions of works of art, landscapes, and architecture. Because of the considerable capital needed to finance photographic expeditions, advance subscription sales were necessary unless state or private patronage could be secured.

Unable to compete with the more established, cost-effective print market, Blanquart-Évrard's operation closed in 1855. Two years later, however, Braun began marketing subscriptions for a proposed collection of large-plate views of sights, monuments, and landscapes of Alsace, *L'Album de l'Alsace*. With his brother Charles, he began photographing in 1858, using 20 x 20 in. (50 x 50 cm.) plates (to produce 16 x 20 in. [40 x 50 cm.] albumen prints) and exposure times of two to three minutes.

Perhaps mindful of Blanquart-Évrard's failure to thrive, Braun deployed his Paris connections to the fullest, sending a set of preview photographs to Napoleon III for royal approval. Accepting the album's formal dedication to himself, the Emperor ordered five copies for his library and allowed his name to be added

to the list of subscribers. With this prestigious backing, Braun could price his album at a substantial five hundred francs. Though it went through several editions, the definitive version of *L'Album de l'Alsace* consisted of 120 photographs, mounted on heavy card stock with imprinted titles. The volume was divided into three sections: châteaux and medieval ruins; Romanesque and Gothic religious architecture; and landscapes, locales, and civic buildings from the Middle Ages and the Renaissance.

In addition to individual prints, Braun included three fold-out panoramas composed of two to three prints mounted together. His three-part panoramic view of Alsace's industrial center, the city of Mulhouse, was singled out as a tour de force when exhibited at the Palais de l'Industrie in Paris in 1859. Panoramic views were extremely popular in the mid-nineteenth century, linking older modes of visual spectacle, such as the diorama, to a modern scientific concept of the city as an organism to be viewed from a more detached critical

Vues d'Alsace, Dedié à Sa Majesté l'Empereur par Ad. Braun
Album cover
1859

Paul Huet
Château de Pierrefonds en ruines
Ruins of the Château of Pierrefonds
Oil on canvas
ca. 1867–1868

distance. The urban boulevard was transformed "into a great mechanical belt that distributed people, goods, and information throughout the city, and represented this kind of motion as a sign of vitality."[5] The novels of Gustave Flaubert and Émile Zola provided the literary analogue to this radically new objectifying vision. Nadar's sensational experiments in the 1860s with balloon photography over Paris, as well as the construction of the Eiffel Tower in the following decade, attest to the fascination of this dramatically distanced and kinesthetically alienated view of the city, a sensibility soon to be augmented by the airplane and celebrated in modernist art.

In choosing his camera vantages and subjects for *L'Album de l'Alsace*, Braun was clearly indebted to previously published engravings of Alsatian views, such as Jacques Rothmuller's *Vues pittoresques*.[6] Rothmuller's illustrations of château ruins on rocky outcroppings, looming against stormy skies, followed pictorial tastes inherited from the popular Dutch landscapes of Meindert Hobbema and Jacob van Ruisdael, the widely collected engravings of Giovanni Piranesi, and the late eighteenth-century

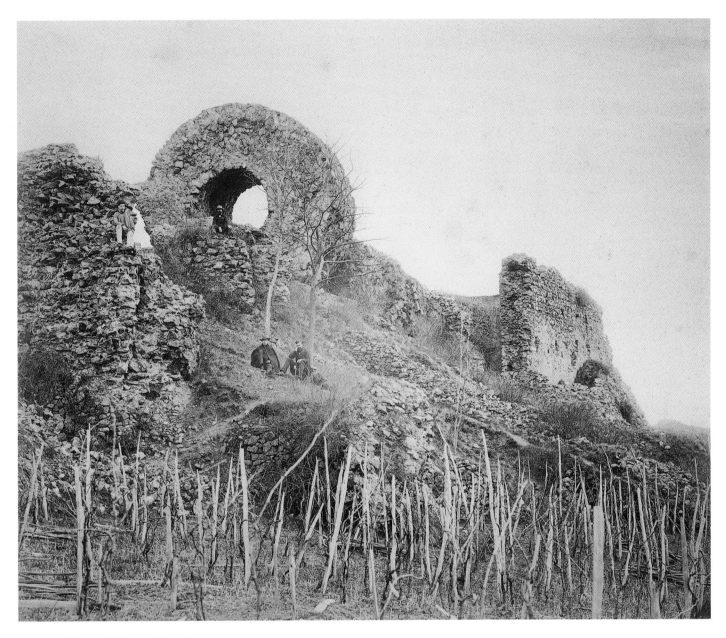

Album de l'Alsace: Château d'Engelbourg
Album of Alsace: Château of Engelbourg
Albumen silver print
1859

French academic taste for crumbling classicism most obsessively realized in the paintings of Hubert Robert, known as Robert des Ruines or Robert of the Ruins. In his engraving of the Château d'Ortenbourg (Plate CX), Rothmuller embellished the castle's sinister mood by having crows circle portentiously over its keep.

By the mid-nineteenth century, picturesque ruins had become a thoroughly middlebrow taste, and Braun featured numerous examples in his Alsace album. In a region with few notable features of physical geography, hillsides pocked with crumbling castle walls, abbeys, and towers provided admirable subjects for literary and aesthetic delectation. The vivid contrast between the rough and weathered masonry of ancient monuments and the encroaching vegetation was a stock visual metaphor of the romantic imagination. In a noted

essay for the *London Quarterly Review* in 1857, Lady Elizabeth Eastlake remarked that the great artistic strength of photography was in its rendering of rough and broken surfaces. "The mere texture of stone, whether rough in the quarry or hewn on the wall, [is] its especial delight."[7]

Eastlake, whose husband was president of the Royal Academy of Arts, echoes the pre-eminent English theorist of the picturesque landscape, William Gilpin, who had argued in 1792 that picturesque views should be irregular, highly textured, and composed of things rugged, rustic, or antique, stripped of their utilitarian associations. Such telling details would provoke in the sensitive viewer poetic reflection on the passage of time, on the brevity of glory, and on the ephemeral nature of human achievement.[8] Braun's striking studies of the up-ended keep of the Château of Engelbourg (see p. 103), of the ruins of Schwarzenbourg, or of the overgrown interior courtyard of Haut-Koenigsbourg evince that intermixture of wildness and culture and "pleasing melancholy," so central to the picturesque contemplation of ruins.

If the depiction of texture and minute detail was landscape photography's greatest aesthetic asset for Eastlake, its greatest failing was its inability to render skies as anything but a "glaring white background," especially when compared to the celestial glories of Claude Lorrain or John Constable. The sky posed a real problem for wet-collodion photographers with artistic aspirations. The limited sensitivity of the collodion emulsion and the intense luminosity of the sky made the recording of clouds almost impossible if the exposure was correct for the tonal values of the landscape. This technical limitation would be overcome with the introduction of panchromatic films and yellow and red filters, but wet-plate photographers often solved the "sky problem" by combining cloud details from a second negative during contact printing in the studio. Albumen papers were so slow to expose, that switching negatives and masking during contact printing was a relatively easy procedure.

Another staple convention from neoclassical landscape painting, that was visible in Rothmuller's engravings and emulated by Braun, was the inclusion of figures (hikers or sketching observers) in the foreground. They served both to indicate scale and to give the viewer a visual point of identification in the landscape. This convention was so engrained that even the earliest engravings made from daguerreotypes (for example, Noel-Marie Lerebours's *Excursions daguerriennes*, 1840) had figures added to the landscape by hand because the slow exposures could not capture anything that moved. We see this device repeatedly in Braun's Alpine views, where posed figures highlight the immensity, precipitousness, and danger of the rugged terrain.

Stereographs were especially suited to the introduction of figures because of their palpable sensation of depth; climbers perched on the brink of a crevasse could induce thrilling vicarious vertigo in the armchair viewer. Indeed, so great was the expectation that climbers would be visible in Alpine views that in one uncharacteristic instance, Braun (or one of his retouchers) added a group of Alpinists by hand in the foreground of a scene, entirely out of scale with the surrounding landscape!

As Rothmuller's *Vues pittoresques* suggests, the burgeoning market for landscapes and architectural

Album de l'Alsace: Cour du Château de Haut-Koenigsbourg
Album of Alsace: Inner Courtyard, Château de Haut-Koenigsbourg
Albumen silver print
1859

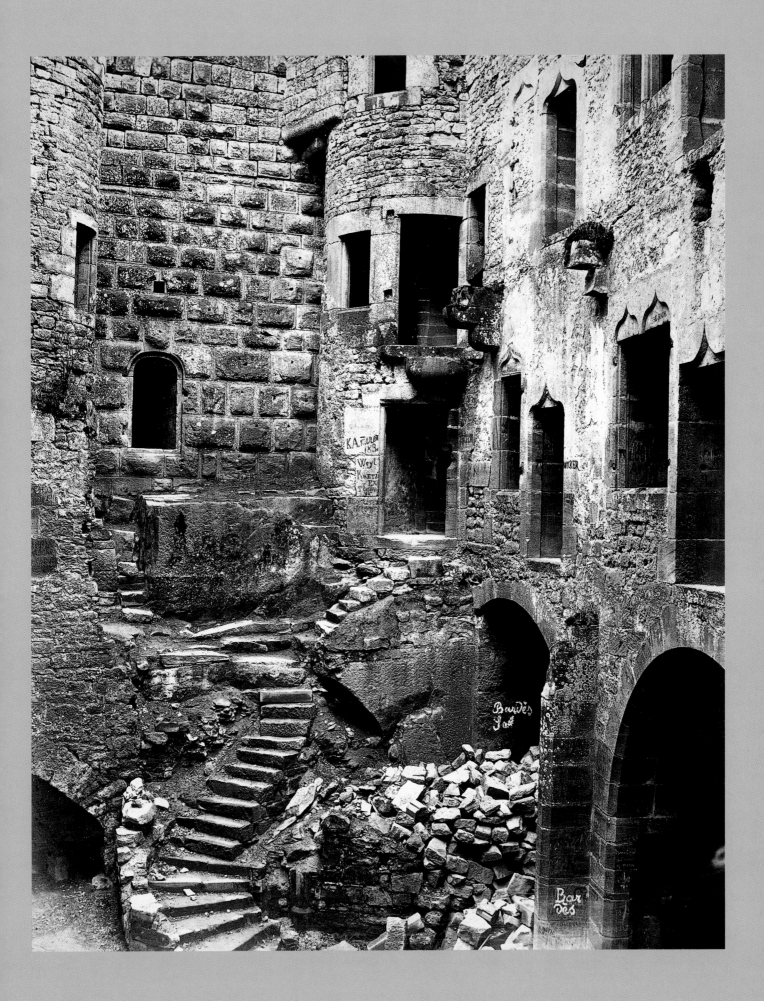

views extended well beyond elite taste. Braun's early success with *L'Album de l'Alsace*, which garnered him the coveted Legion of Honor in 1859 and the official title of Photographer of His Majesty the Emperor, established the Braun imprint as a mark of high quality and artistic value. Ultimately, however, the real money was not to be made in selling subscriptions for embossed leather albums to elite customers, but in marketing individual prints to mass consumers on holiday.

In a panoramic view made at an unnamed Alpine resort, Braun (or one of his operators) recorded a revealing scene showing how his prints were marketed to visiting tourists. Much like color postcards and tourist views today, albumen prints of varying formats and stereoviews were displayed singly, in frames or in racks, outside shops selling curios and supplies (see pp. 108–9). Undoubtedly, such emporia were the source of Mrs. Hoopes's prints. The sale of professionally produced views destined for personal scrapbooks and albums proved a reliable market until the advent of do-it-yourself mass consumer photography in the 1880s. The efficacy of Braun's operation is attested to in one observer's claim that in 1866 it was virtually impossible to take a step in Switzerland without stumbling upon a shop selling Braun prints and stereoviews.[9]

In the photographic views produced by Adolphe Braun from the 1860s to the 1880s, we see the same dichotomous sensibilities that mark the more celebrated landscapes of the period by the Barbizon painters of the 1850s and 1860s and by the impressionists a decade later: nostalgia for a vanishing agrarian past and pride in the latest technologies and in national industrial enterprises that were dramatically transforming the countryside. Emblematic of this latter theme is Braun's *Ligne du Gotthard*, a photographic series of the construction of the Gotthard Pass rail tunnel in Switzerland (see pp. 110–11), built between 1872 and 1880. In a manner reminiscent of William Henry Jackson's contemporaneous views of railroad building in the Colorado Rockies, Braun records to dramatic effect the nine miles (fifteen kilometers) of successive engineering feats in steel and stone: double-arched spans over treacherous gorges, switchbacks up mountainsides, the hall of giant compressors that drove the drilling machinery, and the awesome boring machine that excavated the tunnel from solid rock.

That the spectacle of railroad construction would be a marketable subject in the 1870s is indicative of the importance that railroads had assumed in the public consciousness by mid-century. Just as the building of transcontinental railroads embodied a unifying myth of Manifest Destiny for white Americans, following a divisive civil war, railroad building for the French symbolized the consolidation of a stable, modern industrial nation-state after six decades of unceasing revolution and reaction. Like President Franklin Roosevelt's dam building during the Great Depression, or President John F. Kennedy's space program during the Cold War, Napoleon III's large-scale investment in public works and advanced technology showed his grasp of its strategic political value both in boosting national pride and in projecting France's image in the world as an economic power. Between 1851 and 1861, the French government had pumped more than seven percent of the nation's gross national product into railway construction, which had fueled real-estate speculation, the creation of new wealth, and the massive ebb and flow of population between country and city.[10]

Rail lines now linked all major provincial and international cities to Paris, the glittering, bustling capital which had been radically redesigned and refurbished by Baron Georges Haussmann. The advent of train, tram, and light rail services had made it both possible and desirable for urban dwellers to take short holidays in the countryside since the 1850s. The wealthy, of course, had always retreated from the filth, stink, and noise of the industrial city to their well-appointed rural enclaves. Now, for the first time, this privilege was made available to the middle and working classes on a time scale compatible with the industrial work cycle that governed their lives.[11] The new industrial commodity of "leisure time," at weekends and for a few weeks or a month in the summer, promoted the development (often by railroad companies) of class-stratified resort hotels, parks, beaches, and spas to which workers and managers could migrate en masse. Fontainebleau, the forest retreat near Paris popularized in Barbizon painting, was overrun with hotels by 1860 and satirized as a tourist trap by Flaubert in his 1869 novel, *L'Éducation sentimentale*.[12]

Newspapers and magazines, railroad promotional materials, and popular novels, such as those of George Sand, touted the country life as socially elevating and a cure for neurasthenia, the nervous fatigue observed in overly sensitive city dwellers. The ritual August exodus of Parisians to the countryside became an enduring part of the lore of France. *Le weekend* and *les vacances d'été* (summer holidays) were institutionalized as necessary adjuncts to family life at a time when the rising standard of living made the family the primary focus of industrial consumption. For factory workers, the day trip by train, tram, or omnibus to the beach or amusement park was a more affordable alternative—a form of excursion less associated with wholesome and ennobling pursuits, than with popular entertainment and, to the middle-class mind, with dangerous moral laxity.

It was no accident that the landscapes painted by the impressionists in the 1870s were the suburban landscapes within several hours' train commute of Paris. As many have noted, the new rapidity and fragmentation of their painting method and their choice of compositional devices resonated with the startling speed and disjunctive visual experience of train travel.[13] Their subject matter, too, prominently featured details of a growing industrial infrastructure: bridges, tunnels, highways, and railroad tracks criss-crossing fields and canals. Like the railroads and iron bridges in Braun's photographs, these may look quaint to us today, but at the time they were seen as signs of the new, the modern, and the future.

The 1839 appearance of Rothmuller's *Vues pittoresques* had signaled the explosion of the tour map and of the illustrated travel guide industry, and the guidebook-toting tourist soon became the butt of jokes. "Without the Joanne guidebook in his pocket," quipped one essayist in 1876, [the tourist] hardly knows where he is!"[14] Railroads commonly published their own guides to scenery and monuments along their routes, and a popular journal, *Les Chemins de fer illustrés*, appeared twice monthly. Viollet-le-Duc remarked that "the railroad has allowed us to see more monuments in a week than it could previously have been possible to visit in a month." Through the mass dissemination of travel books, inexpensive engravings, and the illustrated press, every literate citizen could learn by mid-century what the country and its prominent features looked like. These media provided the models followed by Braun and other commercial

photographers, and the mass distribution of their photographs would increasingly determine how these subjects would be received. Visitors would measure their own experiences against the images they already knew.

Most of Braun's views either followed the railroad routes south across the Rhine River into Switzerland with its sublime Alps and crystalline lakes, or down along the picturesque Rhone River to the Côte d'Azur and Italy, or up through the newly annexed Haute-Savoie region with the famous Mont Blanc and resort of Chamonix. These were the areas where Braun and company concentrated their efforts, with added catalog listings in neighboring Germany, Holland, and

Belgium. All sites were within convenient rail access
from Mulhouse, and with the closing of the Bisson
brothers' photographic firm in 1864, Braun was
uniquely well positioned to monopolize the lucrative
Alpine view market.

Of course, Adolphe Braun did not take all of the
exposures himself, but shared the camerawork with

Savoie. Chamonix et le Mont Blanc: Hôtel Royal de l'Union
Savoy. Chamonix and Mont Blanc: Hôtel Royal de l'Union
Albumen silver print
1867

GOTTHARDBAHN

Tunnel Eingang in Airolo
(Vor der Vollendung)

Photographie von Ad. Braun & C.ie Dornach, ⅟Elsass.

Ligne du Gotthard: Tunnel du Gotthard, machine à perforer
Gotthard Railroad Line: Gotthard Tunnel. Boring Machine
Albumen silver print
ca. 1875–1880

Ligne du Gotthard: Tunnel du Gotthard, les compresseurs
Gotthard Railroad Line: Gotthard Tunnel. The Compressors
Albumen silver print
ca. 1875–1880

brother Charles and, later, with son Gaston. Jean-Claude Marmand and a younger cousin, of the same name, are also listed as important photographers for Braun and company. The older Marmand was cited in *La Lumière* for the quality of his romantic views in Germany and along the Rhine. As did many large enterprises, Braun's employed teams of operators and assistants to make extended expeditions to bring back plates and stereoviews. Alpine photography required considerable capital outlay for guides, porters, and equipment (see p. 112), and each successful plate was a triumph, in that high altitudes and freezing temperatures made working with wet-collodion plates almost impossible.

With the exception of one six-week photographic expedition to Egypt in 1869 as part of an official artistic delegation to document the inauguration of the Suez Canal, Braun remained untempted by orientalist

Gotthardbahn: Tunnel Eingang in Airolo (Vor der Vollendung)
Gotthard Railroad: Tunnel Entrance at Airolo (Before Completion)
Albumen silver print
ca. 1875–1880

subjects—another popular genre fueled by expansionary colonialism and the romantic iconography of Napoleon I's earlier campaigns in North Africa. Gaston Braun made the Egypt tour, along with such notables as Jean Léon Gérôme and Eugène Fromentin, but the resulting hundred or so photographs, listed in company catalogs in both medium-plate formats and stereoviews, are lackluster by comparison to the better-known Egyptian views of Francis Frith and John B. Greene. Even so, it was profitable for any studio to keep Egyptian subjects and architectural details on hand as these were always in demand by illustrators and engravers.

Braun had no particular aesthetic axes to grind in his landscape photography. He supplied what the marketplace demanded—conventional views of subjects whose images were already familiar—with competent, even brilliant, execution. The pictorial conventions and themes on which he and his photographers drew in the 1860s were profoundly non-partisan and catholic, embracing, in turn, romanticism's taste for melancholy

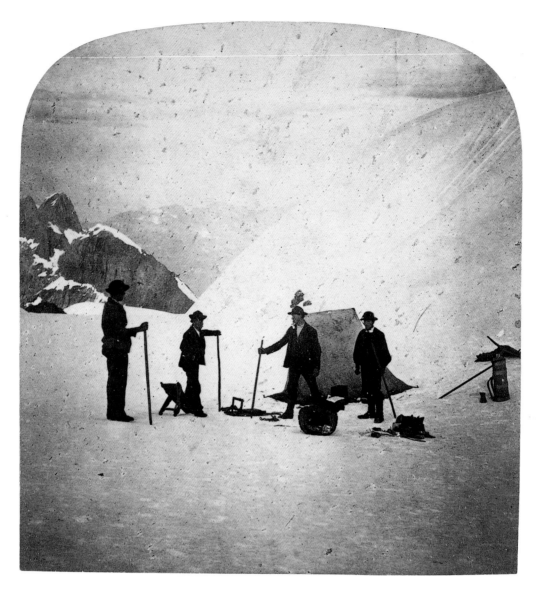

Suisse. No. 4645. Tente laboratoire installée au sommet du Mont Titlis (detail)
Switzerland. Laboratory Tent Installed at the Summit of Mont Titlis
Albumen silver print on stereoscopic mount
ca. 1864

ruins and savage nature; the vigorous pastoralism of the Barbizon school; and the dramas of modern technology and industry, rendered in the precise descriptive realism to which photography seemed particularly well suited.

Braun's Alpine subjects are the most numerous in his archive and are concentrated in Switzerland and the mountainous region of Haute-Savoie. The latter was acquired in 1860, along with Nice, from the Duchy of Savoy, following Napoleon III's confused and inconclusive intervention in Italy's wars for independence. The Alps gave Braun plenty of vantage points for playing out the drama of the romantic Sublime: sheer rock faces with plunging waterfalls; immense glaciers ruptured by deep crevasses and other snares for the climber; mirror lakes and ice caves such as that of Grindelwald with its eerie subterranean luminescence; and lines of roped hikers perched riskily on jagged promontories on Mont Titlis, where an ill-placed step would meet with certain disaster.[15]

The influential English aesthete and critic John Ruskin had himself sketched and painted Alpine landscapes, both directly from nature as well as

from daguerreotypes purchased on his travels. While Ruskin initially praised photography as an indispensable tool for artists, by the late 1860s, he had become one of the medium's most outspoken adversaries. Art historians have speculated that Ruskin's change of heart had to do with the very enterprise in which Braun was immersed. Like his French counterpart, Charles Baudelaire, Ruskin viewed the mass production of photographic views as debasing aesthetic judgment, valuing mere fact above personal intuition. For them, the great lie resided in the popular notion, fostered by logical positivism and ascendant technocratic thinking, that photographs spoke truth to the falsity of art. Both critics denounced the dumbness of the machine when compared to the genius of the artist.[16] It seems very likely that Ruskin had Braun's photographs in mind when he wrote in 1874: "Anything

more beautiful than the photographs of the Valley of Chamouni [*sic*], now in your print-sellers windows, cannot be conceived. For geographical and geological purposes, they are worth anything; for art purposes, worth—a good deal less than zero."[17] While operatic displays of painting genius, such as Joseph Mallord William Turner's *Valley of Aosta*, 1837 (Art Institute of Chicago), and Philippe de Loutherbourg's *An Avalanche in the Alps*, 1803 (Tate Gallery, London), had helped popularize the Alps as a *locus classicus* of romanticism and its cult of the Sublime, the French landscape painting tradition remained more firmly rooted in the classicism of Nicolas Poussin and Claude Lorrain and in the arcadian ideal, with its calm horizons and gentle Italian light falling on noble ruins. By the 1840s, the Barbizon painters had replaced Lorrain's Roman Campagna with distinctively French

Suisse. No. 3296. Oberland Bernois. Glacier inférieur de Grindelwald
Bernese Oberland. Lower Glacier at Grindelwald
Albumen silver print on stereoscopic mount
ca. 1863–1864

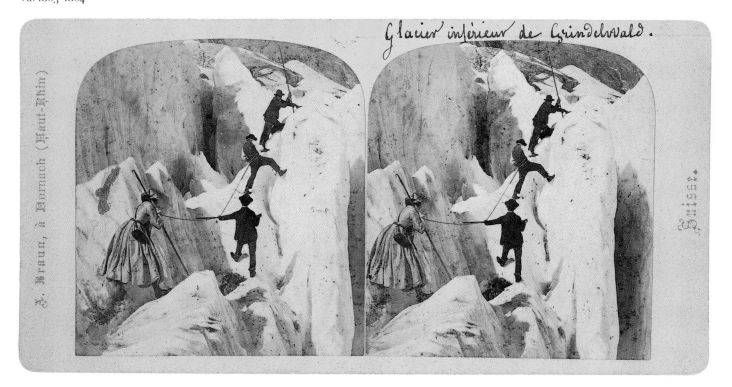

landscapes, reflecting the decline of the classicizing Renaissance tradition; the increasing belief that art should concern itself with modern experience; and a new scientific accuracy manifest in *plein-air* painting. Their subjects, however, were not urban but rural, in part a protest against the moral corruption and depredations of industrialism, *à la* Ruskin, and in part an identification with the radical republican ideals that culminated in the Revolution of 1848.[18]

By Braun's time, Barbizon styles and subjects had moved into the mainstream, and Jean-François Millet, Théodore Rousseau, Charles-François Daubigny, and Jules Dupré had all received important state commissions. Artistic photographers saw a natural affinity with Barbizon subjects and styles, and a Barbizon school of photography flourished from the 1850s to 1870s, led by Le Gray, Eugène Cuvelier, Charles Famin, Achille Quinet, and others. A number of Braun's photographs, such as *Un Moulin à Stosswihr* from *L'Album de l'Alsace*, as well as his series of *Animaux de ferme*, his rustic still lifes, and his studies of regional peasant costumes, clearly appeal to Barbizon sensibilities. Barbizon painters were self-consciously engaged in documenting a way of life they saw as rapidly slipping away under the pressures of industrialization. Farm animals had symbolic resonance as the antithesis of the machine. Where the steam locomotive or power loom was an alien, noisy, man-made object of iron and steel, unthinking and unfeeling, the draft horse and the cow were divinely created, innocent, expressive, and unchanging.[19]

Rather than promoting his own vision or even a regional, national, or imperial style, Braun's formal and rhetorical strategies as an image producer were clearly driven by the demands of his various commercial markets. He could adopt the iconographic signs and codes of classicism, romanticism, rural realism, and a more sentimental genre with equal facility, depending on the destination of the image and its potential profitability. In the latter half of the nineteenth century, photography would become the preferred medium for recording what were perceived as vanishing traditions, and this elegiac, nostalgic function has since infused a great deal of aesthetic practice in the medium.

Braun tapped photography's potential for sentimentality most blatantly following Germany's 1871 annexation of Alsace and Lorraine and France's humiliating defeat in the Franco-Prussian War. Dressing two attractive young women in regional peasant costumes, the photographer posed them in the studio as stoically grieving allegorical embodiments of the two provinces (see p. 25), mourning their lost union with France. The wild success of these images and their rapid proliferation as popular icons signify not only their immediate appeal in the wake of the regional and national trauma of annexation and reparation, but the already established personification of France as a wholesome country maid of the soil, fecund, innocent, and unsullied by modern values. The irony, of course, was that the great economic value of Alsace-Lorraine for Germany was not agricultural, but industrial: its coal and iron mines, its steel mills, and its productive factories.

Such overt plays on sentiment are rare in Braun's production. Another series of images made in the war's aftermath is strategically understated in its topographic realism, and, in retrospect, it is all the more effective for eschewing both romantic bombast and appeals to nostalgia. In the plate views assembled in the album *Le Théâtre de la guerre*, Braun exploits the descriptive realism that has been elevated as the privileged

aesthetic of modernist photography: the camera's ability to transcribe surface textures and details with hyperreal precision. Visually, it is these plate views of the ruins of Belfort, of the deserted and damaged fortifications at Vanves and Ivry, and of the shattered ruins of Paris that would seize a connoisseur's eye today. Far more than mere accumulations of details suspended in time, these images would have spoken loudly to

contemporary audiences in France, particularly in the immediate aftermath of Adolphe Thiers's crushing of the insurgent Paris Commune in 1871 and the establishment of the Third French Republic.

Photographs were a potent propaganda tool for both sides during the Commune, a fierce six-week insurrection of middle- and working-class Parisians who had suffered terribly during the German siege.

Album de l'Alsace: Un Moulin à Stosswihr
Album of Alsace: A Mill at Stosswihr (in reality, a sawmill at Soultzeren)
Albumen silver print
1859

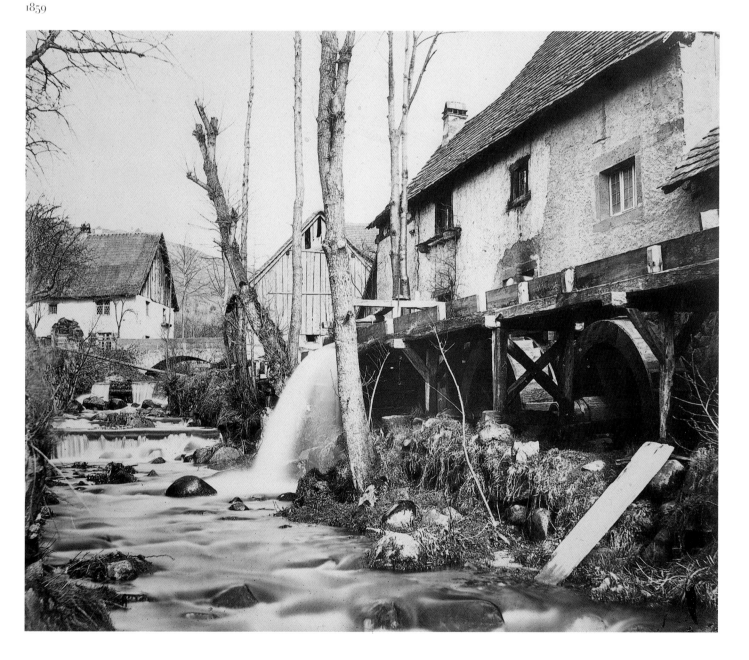

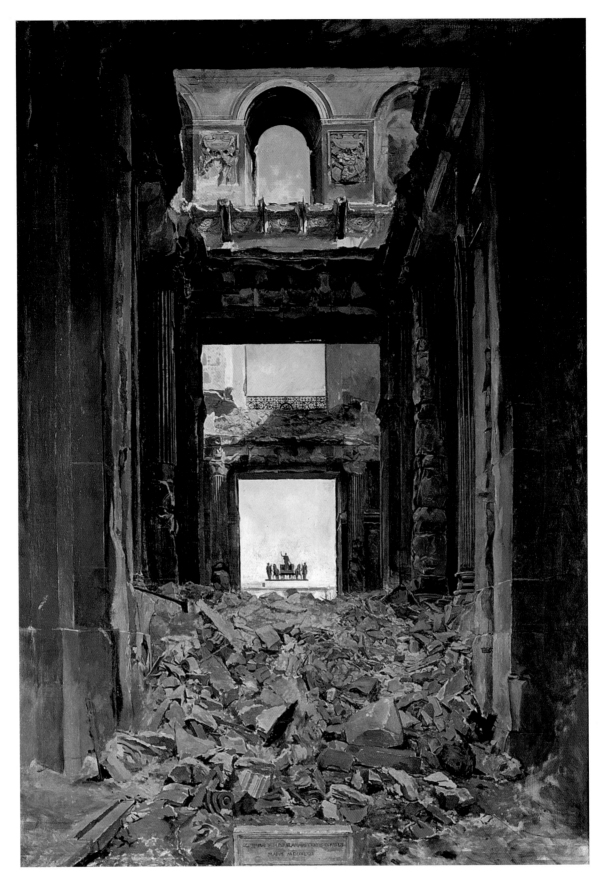

Jean-Louis-Ernest Meissonier
Les Ruines des Tuileries
The Ruins of the Tuileries
Oil on canvas
ca. 1871

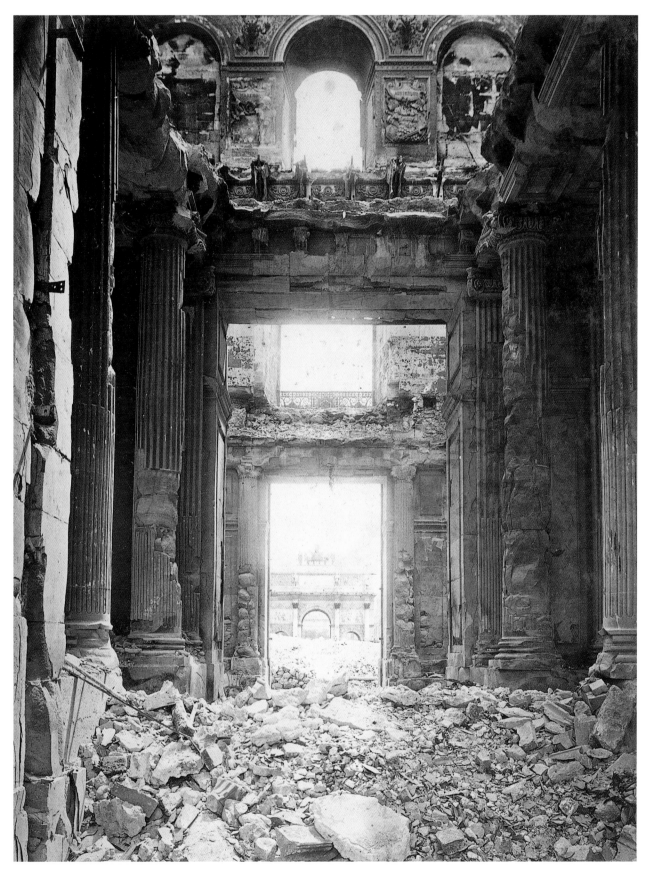

Le Théâtre de la guerre, 1870–1871.
Paris: Les Tuileries, le Péristyle
The Theatre of War. 1870–1871.
Paris: The Tuileries, the Peristyle
Albumen silver print
1871

When the Thiers government brokered a humiliating peace with the Prussians and retreated to Versailles, the Communards seized the National Guard's artillery at Montmartre, erected barricades, and proclaimed Paris a free city. As Thiers sent the French army to Paris to quash the rebellion, the press inflamed public opinion against the insurgents by presenting photographs—possibly Braun's—of gutted public buildings as the work of Communard vandals. After the Commune was destroyed, the academic history painter Jean-Louis-Ernest Meissonier produced a commemorative painting of *Les Ruines des Tuileries* (see p. 116) based on a photograph identical to one of those mounted in *Le Théâtre de la guerre* (see p. 117).

Albums such as this—or the hundreds of stereoviews of ruined monuments that sold briskly in the months following Bloody Week, when more than twenty thousand Parisians were massacred in the streets by French troops—would not have been neutral documents. Braun's own political stand on the Commune is not known, though public opinion outside of Paris overwhelmingly sided with the Versailles government. For most, such images would have been seen as clear evidence of the need for strong law and order and for the restoration of state and private property destroyed by a dangerous urban mob.

The annexation of Alsace and Lorraine by the Germans posed a difficult dilemma for those Alsatians who considered themselves French. They were given the choice of remaining in the region and submitting to German authority, or leaving their homes and livelihoods behind to emigrate to France. As did most industrialists, Braun chose to remain in Alsace, calculating that the costs of displacing his workers were too great to bear. Needless to say, the honorific title of Photographer of His Majesty the Emperor was hastily

shed after the capitulation of Napoleon III at the Battle of Sedan. In 1873, Gaston Braun married the daughter of Louis Pierson, former co-proprietor of Mayer & Pierson, one of the most prestigious portrait studios in Paris. The new alliance of Pierson & Braun Fils maintained the vital Paris connection that Adolphe needed during his exile in German Alsace, although the need to invest in new equipment and the opening of a retail store and studio in Mulhouse brought debts that hobbled the firm until after Braun's death in 1877. Taken over by Gaston Braun, Louis Pierson, and Léon Clément, another of Pierson's sons-in-law, the company survived various reorganizations and technological changes, producing prints in all formats from its vast stock of negatives, along with lantern slides of works of art, architecture, and costumes for educational purposes.

In assessing the importance of Adolphe Braun's photographic enterprise, it seems less useful to squeeze him into the reductive categories of conventional art-historical discourse, with their emphasis on individual authorship and stylistic analysis, than to make him the subject of a broad inquiry encompassing not only aesthetics, but the social, economic, technological and political conditions of Second-Empire France. Braun's approach to the landscape-view market was conservative, not innovative, skillfully reflecting well-established values and the immense faith in industrial progress promoted by France's dominant institutions and exemplified by the growth and success of Braun and company. The diverse images from Braun's archive—of sparkling Alpine scenery, of industry, of the desolate landscapes of war—provide a storehouse of clues to his society's prevailing values and self-conceptions: the promotion of personal and family consumption through mass tourism; the celebration of technological developments like the railroad and

prosperous industries; the opening up of isolated regions to commercial exploitation; the reordering of regional, class and national alliances; and the fostering of national identity and pride in the nation's geographical and architectural patrimony.

During the two and a half decades of Braun's involvement with it, photography grew from the hobby of privileged amateurs and science buffs to a fully fledged commercial mass medium, transforming the ways in which citizens of industrialized nations perceived their world. That world was thereafter mediated through photographic images, and one's experience of things, events, and places could be measured against the evidence of what photographs had already shown. Only recently have the material and ideological operations of these "image worlds," created by the camera and by more current visual technologies such as television and digital imaging, been systematically addressed. In a profound way, investigation of Braun's career is the starting point of a new kind of inquiry, one concerned less with defining subjectivity and personal vision than with examining how successful mass-producers—like today's media executives—strive to create images that satisfy the broad needs and aspirations of a complex and inherently contradictory marketplace.

1 Elizabeth Anne McCauley, *Industrial Madness: Commercial Photography in Paris, 1848–1871*. New Haven and London: 1994. p. 100. I am indebted to McCauley's excellent book for information on the business of photography and its applications during France's Second Empire.

2 See Douglas Crimp, "The Museum's Old/The Library's New Subject." in Richard Bolton, ed., *The Contest of Meaning: Critical Histories of Photography*. Cambridge, Mass.: 1987.

3 In the mid-nineteenth century, photography was embraced as the handmaiden of both art and science by leading aesthetes and intellectuals, such as François Arago, John Ruskin, and Oliver Wendell Holmes. It was only with the advent of mass-consumer photography at the end of the century that social and economic distinctions were made among those practices that Alfred Stieglitz termed the "artistic," the "professional" (commercial), and the "ignorant" (hobbyists).

4 Rosalind Krauss, "Photography's Discursive Spaces: Landscape/View." *Art Journal*, vol. XLII (Winter 1982). Also, see Oliver Wendell Holmes, "The Stereoscope and Stereograph," in Beaumont Newhall, ed., *Essays and Images*. New York: 1980.

5 Nancy Armstrong, "City Things," in Diana Fuss, ed., *Human, All Too Human*. London: 1996, p. 106. The successful market for photographic panoramas prompted Braun to look for ways to improve panoramic technology. Making panoramas from successive plate views was difficult because of problems with edge-to-edge matching and optical distortion. One of the first continuous-exposure panoramic cameras was built by English engineer David Hunter Brandon in Paris from a plan by John Johnson and John Harrison of London. It was demonstrated in 1865 at the Société Française de la Photographie. Braun acquired non-exclusive rights to use the Johnson and Brandon Pantascopic camera and collaborated closely with Brandon in making improvements to its design and functioning. According to Christian Kempf, the 1866 Braun catalog lists more than five hundred panoramas of Switzerland and Savoy. In 1867, Braun introduced the *grand aigle* (big eagle) panoramic format, measuring approximately 14 x 29 in. (36 x 74 cm.), but its use was limited to a few views of Paris and the valley of Chamonix. Christian Kempf, *Adolphe Braun et la photographie*. Strasbourg: 1994.

6 Jacques Rothmuller, *Vues pittoresques de chateaux, monumens et sites remarquables de l'Alsace [sic]*. Colmar: 1839.

7 Lady Eastlake, "A Review in the *London Quarterly Review*, 1857," excerpted in Vicki Goldberg, ed., *Photography in Print*. New York: 1981, p. 88.

8 Armstrong, op. cit., p. 129; also, Malcolm Andrews, *The Search for the Picturesque: Landscape Aesthetics and Tourism in Britain*. Palo Alto: 1989.

9 Kempf, op cit., p. 29.

10 McCauley, op cit., p. 195.

11 In the context of Braun's production, the main concern is the tourist exodus from city to country, but it should be noted that the reverse flow of those leaving the country to seek their fortune in the industrial city spawned an equally vast body of art and literature in the mid-nineteenth century.

12 Andrea P. A. Belloli, ed., *A Day in the Country: Impressionism and French Landscape*. Los Angeles: 1984, p. 59.

13 Ibid., p. 47. The Goncourt brothers wrote of the visual experience of rail travel as being a series of images and impressions perceived in rapid succession by the observer, who is forced into a space/time continuum by the linear movement of the train itself. This changed one's relationship to space and touch, substance and solidity—a touchstone, certainly, of impressionist and post-impressionist art.

14 Ibid., pp. 42 and 142. Adolphe Joanne published the first guidebook to Paris and its environs in 1856 and became the most successful popular French-language travel writer.

15 Edmund Burke's influential formulation of the Sublime in the 1750s defined this emotion as the "agreeable horror" experienced when viewing terrifying experiences from a safe distance.

16 Abigail Solomon-Godeau, "Photography and Industrialization: John Ruskin and the Moral Dimensions of Photography," *Exposure*, 21:2 (1983), p. 159; also, Charles Baudelaire, "The Modern Public and Photography" in Alan Trachtenberg, ed., *Classic Essays on Photography*. New Haven: 1980.

17 John Ruskin, "Various Writings, 1845–1879," excerpted in Goldberg, op. cit., p. 153.

18 See Robert L. Herbert, *Barbizon Revisited*. Boston: 1962, p. 38.

19 Ibid., p. 64.

Cupid and Psyche (Antonio Canova). Louvre

Carbon print

ca. 1871

VI

Art Enlightening the World

MARY BERGSTEIN

ERE A MONUMENT to be erected to
Adolphe Braun, wrote Gustav Kobbé at the beginning
of the twentieth century, it would take the form of an
allegorical statue of "Art Enlightening the World."[1]
Braun's most profitable company project was an
expanded photographic documentation of works of
art in European collections. This enterprise began in
1866 and remained viable long after Adolphe's death,
well into the twentieth century. The photography of
drawings, paintings, and sculpture may have
represented Braun and company's most effective
propulsion of images into the world.

Braun was hardly the first to photograph works
of art and to distribute the prints commercially. Louis
Blanquart-Évrard created albums of art reproductions
throughout the 1850s, and photographs of art were
a primary attraction in the Paris exhibitions of the
1850s and early 1860s.[2] At the international exhibition
of the Société Française de Photographie of 1859, for
example, photographic representations of drawings,
ancient monuments, and rare manuscripts were
exhibited by Roger Fenton, Caldesi & Montecchi,
Tommaso Cuccioni, Robert Jefferson Bingham, the
Alinari brothers, and others. The Bisson brothers, with

whom Braun had trained during his early years in
Paris, showed views of Romanesque sculpture from
Arles and Moissac. Braun's work was also presented
at this exhibition, but he was not yet involved in art
documentation; rather, he showed a series of his floral
compositions and a panoramic view of Mulhouse.[3]

Braun had included in his *Album de l'Alsace*
images of the thirteenth-century sculptural groups of
Vierges et vertues (Virgins and Virtues) on Strasbourg
Cathedral (see p. 122). However, the earliest sign of
Braun's interest in producing photographs of art
objects per se occurred in January 1865, when he
requested the cooperation of Frédéric Villot, curator
of paintings at the Louvre, to document selected
works for an album to be presented at the forthcoming
Exposition Universelle of 1867.[4] Photography in the
Louvre had generally been prohibited, however, and
Villot denied the permit, objecting that the state could
not afford to get involved in such risky speculation.[5] In
August 1866 the Comte de Nieuwerkerke, director of
the Louvre, formally announced his policy forbidding
any and all photography of the Louvre's permanent
collection. Among Nieuwerkerke's concerns was the
fear that photographers would treat the great galleries

Album de l'Alsace: La Cathédrale de Strasbourg
(Vierges et vertues) (detail)
Album of Alsace: Strasbourg Cathedral (Virgins and Virtues)
Albumen silver print
1859

as if they were workshops and spill corrosive chemicals on the carpets and staircases.[6]

Daunted as he may have been by this setback, Braun maintained his ambition to photograph the collections of sculpture and painting at the Louvre: to document and disseminate the most precious cultural inventory of the French empire. This would be his masterpiece, Braun later proclaimed, whether it be "in spite of or because of the difficulty of the enterprise."[7] Braun's project was realized during the early 1870s, but even then he needed special permission

from reluctant administrators. In 1883 the Braun firm (headed by Gaston Braun and Louis Pierson) finally received a thirty-year franchise as the official photographers of the Musée du Louvre, with an atelier and salesroom on the premises. The salesroom was inaugurated in 1885 by the President of the French Republic. In 1913 the accord expired and the stock of Louvre images was ceded to the French state; the negatives and prints are now conserved at the Fort de Saint-Cyr archive under the auspices of the Caisse Nationale des Monuments Historiques et des Sites.[8]

Although photographers were not permitted to work in the main galleries of the Louvre, they had access (as Charles Marville had had in 1864) to the collections of drawings and prints.[9] Braun's first successful enterprise in the documentation of art was based on the Louvre's collection of drawings. He undertook a carbon-process reproduction of master drawings from the Louvre and of drawings and paintings from the Basel Kunstmuseum in 1866.[10]

From our standpoint at the dawn of the twenty-first century, the use of photography as a system for the reproduction and replication of flat images (photocopying, offset printing, copy-stand photography) is so taken for granted as to be virtually invisible. Around 1860, however, reproductive engravings, etchings, and lithographs made after drawings and other two-dimensional works held an exceptionally high place in the visual culture hierarchy. The engraver was required to work as both artist and cicerone, grasping the spirit of a specific work of art— whether it be a Rembrandt etching, a Raphael fresco, or a fragment of ancient sculpture—and transmitting it to the viewer as effectively and economically as possible. Typical readers of the *Gazette des beaux-arts*, for instance, expected this level of bravura illustration

in every issue. From the engravers' point of view, the plastic arts had to be represented by a medium that was visually able to explain or compensate for the discrepancy between the original and the reproduction. This rhetoric had to be accomplished within the context of the reproduction itself.

The question of photography versus engraving signals an eventful shift in the way people perceived works of art and the issue generated debate among French critics and pedagogues. Some writers, including Francis Wey, Philippe Burty, and Ernest Lacan, embraced the phenomenon of photographic reproduction immediately, calling it a fine art in itself; but others, such as Charles Blanc, preferred the more "essential" linear, didactic, interpretive qualities of the engraving. He, like his contemporary Henri Delaborde (curator of prints at the Bibliothèque Nationale), looked upon photography with an uneasy mixture of awe and derision, dreading the intrusion of a mechanical process into the realm of the finer sensibilities.

Blanc, who was editor of the *Gazette des beaux-arts*, director of the Bureau des Beaux-Arts, and eventually director of the Louvre, was a populist, dedicated to the democratization of high culture. However, he favored engravings and casts above photography as methods of reproduction and even supported the idea that a universal Musée des Copies (Museum of Copies and Casts) be founded in the Grand Palais on the Champs Élysées, so that Parisians could become acquainted with the masterpieces of the world without leaving their own city.[11] In the 1850s and early 1860s, Blanc, who was himself a published engraver trained by Luigi Calamatta and Paul Mercuri, critiqued the photographic medium for its deadpan inclusiveness and its supposed inability to interpret the shape of ideas in the representation of historic sculptures, paintings,

drawings, and prints.[12] Blanc's opinion would be reversed, however, upon viewing Braun's work in 1867.

Adolphe Braun's use of the new inalterable carbon process (autotype) to reproduce drawings from museum collections posed a direct challenge to the engraver's craft. Braun's results were virtual *trompe l'œil* facsimiles, photographic replicas that allowed previously inaccessible master drawings, sketches, and prints to be diffused throughout Europe and North America en masse. Braun's carbon prints, which achieved color separation by using granules of pigment (such as sepia, sanguine, or umber) in the inks, were anything but gray or pedestrian in their facsimile reproduction of marks originally made in ink, chalk, and crayon.[13] Their graphic and coloristic qualities were fresh, and the condition and tint of the original paper surface was carried through in the replica. Since the original images begged the question of "explanation" or "interpretation," Braun's exact copies of the drawings made reproductive engravings obsolete.

Braun's carbon-printed facsimile drawings were shown at the Exposition Universelle of 1867, where they stunned Charles Blanc, who described them as photography's magnificent gift to art lovers.[14] The drawing reproductions were a commercial success. They were bought in large numbers by museums, libraries, and art schools, as well as by individual amateurs in Europe and America. Ernest Lacan was impressed by their potential use in art education, exclaiming, "These are the models that should be present in the ateliers and the *écoles de dessin*."[15] Odilon Redon, known to most of us as an eccentric ideist painter, made extensive use of Braun's photographs in his work. In 1868 Redon advocated that municipal libraries should not be without them: "How can provincial towns—especially those without museums—not think of owning one day

Tête de la Vierge. Album sur Léonardo da Vinci. Albertina de Vienne
Head of the Virgin. Leonardo da Vinci Album. Albertina. Vienna
Carbon print
1867

a collection of the superb reproductions of drawings unveiled by Braun?"[16]

European critics, who were freshly attuned to the notion of unifying scientific progress with the arts, noted the astonishing fact that the photographic copy was often a *more* accurate record of the artist's intention than the original itself. Details or *pentimenti* (earlier versions of the design that have since been corrected) that were virtually invisible in the context of a pale or faded drawing could be brought out with clarity and precision in the photographic print.[17] The camera's most prosaic and indiscriminate qualities were thought actually to heighten the experience of looking at art, much as a microscope or telescope might enhance one's

vision of nature. Braun was eventually praised by his contemporaries for bringing works on paper—formerly conserved in portfolios for the delectation of the very few—to light and replicating them in such numbers that they became available to the general public.[18]

The Braun venture was the answer to an issue that concerned the French regime after the London Great Exhibition of 1851, namely the artistic indoctrination of the French public in light of its industrial contest with England. Officials believed that art education through the diffusion of replicas would have a positive effect on French life, by improving instruction in the fine and applied arts, thereby raising the quality of architecture, textiles, ceramics, and manufactured goods. The elevation of public taste, which was so ardently desired by Napoleon III and Second-Empire pedagogues, could be accomplished, it was thought, by bringing master drawings—traces of the actual creative processes— to individuals in every stratum of French society.

The collaboration of industry with fine art was closely linked to the ideal of the democratization of art. The population could be educated in art through the inexpensive replication of published images. Optimistic Second-Empire writers called the carbon process a marriage of science and art, and acclaimed the fact that through photographic technology the bourgeoisie, art students, workers, and even peasants could avail themselves of master drawings that were formerly "more secret than buried treasures," filed away as they were in the closed portfolios of Europe's museums.[19] Braun's photography of works on paper was therefore considered a step forward in the application of industrial technology to the perception of art, as well as in the wholesale diffusion of fine art to the middle-class public, which would in turn help fine art to serve industrial production.

Following the success of the drawing facsimiles, Braun and company launched major campaigns throughout Europe, photographing the paintings, drawings, and sculpture of Europe's most prestigious collections, including those in Basel, Dresden, Florence, Milan, Rome, Venice, and Weimar. By 1875 the inventory of reproductions was so vast that it was impossible to list in a comprehensive catalog. Thanks to the firm's industriousness, the idea of the *musée imaginaire*, or imaginary art gallery, could be realized "with a vengeance."[20] By the 1880s, the Brauns had created what the art historian Adolfo Venturi matter-of-factly called "an emporium of photographs which are used by historians and critics of art for their collections and studies." Venturi went so far as to say that prior to the production of images by firms like Braun's, the teaching of history of art, "which for the Italians is the most splendid and glorious part of their history," had consisted mainly of "an overwhelming burden of arid erudition."[21] Venturi pioneered the use of photographic illustration on a grand scale in his multivolume *Storia dell'arte italiana*.[22]

Photography became the standard apparatus of art history. Following the precepts of thinkers such as Adolfo Venturi, Giovanni Morelli, Heinrich Wölfflin, and Bernard Berenson, photographic images were made not only to serve as vehicles for memory, but as instruments of research: for investigation, comparison, and as material evidence. Morelli made extensive use of Braun photographs in his method of comparative observation. In 1877 he visited the Braun atelier at Dornach to purchase a quantity of reproductions of master drawings.[23] In communications among scholars, the numbering of works in Braun catalogs substituted for the inventory numbers of museums, which were far less accessible.[24] Indeed, by the 1880s, the practice of

art history had become a concrete photographic procedure, quite distant from the "elastic metaphysics" that had so irked Venturi. Art history assumed the condition of a morphological science that was substantiated with photographic material; it actually came to *require* photographs as the mainstay of its vocabulary as a scientific/humanistic discipline.[25] This new imaging technology changed the way people studied the history of art, and libraries invested in photographs as they had formerly invested in books. In the 1880s, for instance, the Boston Athenaeum (then a pre-eminent art scholars' library) was not atypical in spending more than eight thousand dollars on Braun photographs over a period of five years.[26]

A favorable conjunction of technologies and personalities allowed Braun's art documentation project to expand to an international scale. On the technical side, not only did the inalterability of the carbon process guarantee that the prints would not fade, but the aesthetic of carbon prints appealed to contemporaries, who associated the ink used in Braun's printing process with the velvety, absolute quality of etchers' ink.[27]

Adolphe Braun's enterprise had taken on the structure of a corporation, as he delegated various specialized projects to his sons and associates. Adolphe's oldest son, Henri Braun, who had trained as a painter in Paris, relinquished his own calling and joined the firm to take charge of the art-documentation campaign.[28] This program was also propelled by another key individual, the art critic Paul de Saint-Victor who wrote for *La Presse* and *La Liberté*, but was also a personal friend of Henri Braun and a vigorous supporter of the enterprise. Paul de Saint-Victor was at the heart of a sophisticated Parisian milieu, together with his friends and co-authors Théophile Gautier and Arsène Houssaye.

Saint-Victor's mistress was Lia Félix, sister of Mademoiselle Rachel, the famous tragic muse of the French national theater, the Comédie Française, who was herself courted by Houssaye.[29] This Proustian cultural knot tightens when one realizes that Henri Braun and Paul de Saint-Victor attended the theater together on many occasions. Henri even envisioned a collaboration whereby Saint-Victor would compose a written critique to accompany a publication of Braun photographs.[30] The idea behind this unrealized project prefaced the notion of photographically illustrated art books as we know them today.

Although Saint-Victor insisted in print that Adolphe Braun had undertaken the "conquest of all museums" on his own, "without subvention, without patronage, by the force of his own desire and industry," it nevertheless appears that Saint-Victor himself intervened as a kind of patron through his published endorsements. He helped Henri Braun to outline photographic campaigns and navigate the complicated hierarchies of Second-Empire and Third-Republic cultural institutions.[31]

From 1867 to 1870, several entourages led by Henri Braun traveled to Italy. His activity in Rome was on an impressive scale and included the first systematic photo-documentation of the ceiling of the Sistine Chapel, as well as Raphael's frescoes in the Vatican. He also produced, in 1869, a definitive photographic study of the classical sculpture in the Vatican museums, an ambitious program that was encouraged by Saint-Victor, who corresponded with Henri from Paris.[32]

Photography in nineteenth-century Rome had its own particular tradition, in which themes of tourism, memory, and *romanitas* (the spirit of ancient Rome) merged, in images of scenic ruins, folkloristic models, and ancient monuments. Rome during the reign of Pope Pius IX was a city in an exquisite, protracted state of

decline, propped up in its last days only by the armies of Napoleon III. The sense of an expiring past that could be captured through visual experience was a constant lure for visitors and photographers.[33] In Nathaniel Hawthorne's *The Marble Faun*, 1860, the young American painter Hilda says that she has studied Guido Reni's portrait of *Beatrice Cenci* so carefully that it is "photographed" on her heart. The titular Capitoline faun was itself a widely dispersed photographic image collected by tourists as a memento of the emotional and nostalgic weight of ages.[34] Such photographs were

produced and purchased for personal travel albums, such as that compiled by Walter Baylies, now in the Boston Athenaeum. In the Baylies album, facing pages are covered with photographs of works of art, including both *Beatrice Cenci* and the *Marble Faun* (see p. 128).[35]

Grand-tour scrapbooks from the 1860s not only housed photographs of art, but were crammed with images of all that was vanishing, archaic, or merely quaint. Mary Huntington's travel album (see p. 129) of 1868 contains photographs of works of art, scenic views, and ancient monuments. These images are

Night (Michelangelo). Medici Chapel, Florence
Albumen silver print
ca. 1865

Various photographers
*Walter Cabot Baylies Album. Photographs of Places and Paintings
in Europe (Italian Paintings and Sculptures)*
Albumen silver prints
ca. 1890

interspersed with poetic texts, such as the "double
weight of ages…" passage that faces the Temple
of Antoninus and Faustina and the Church of
Saints Cosmas and Damian.[36] Such photographs
of Roman scenes and ruins had a seemingly
inexhaustible tourist and export market, and, at
the time, the idea of the tourist memento was closely
related to the realms of archaeology, art history, and
artistic practice.

Henri Braun, who had given up his vocation
as a painter in order to photograph art of the past,
was eminently suited to the Rome project. There,
he and his team devoted themselves to the Sistine
Chapel and the Vatican museums. In exhibitions of the
resulting plates, it seemed to the public that the camera
and photographic printing process were, once again,
a scientific aid to seeing. Passages of the ceiling frescoes
that were obscure in the ambient light of the chapel

became legible and fixed in photography.[37] For instance, Braun's photograph of the *Creation of Adam* revealed to contemporary viewers for the first time the figure of the nude woman within God's large embrace, thereby setting off a stream of iconographic controversy that continues among Renaissance scholars today.[38]

Henri Braun and his team faced one difficulty after another in the Sistine Chapel project, including the need to distribute gratuities to French and papal soldiers ("paying respect to the beautiful uniforms" as Henri put it in a letter to Saint-Victor); to work around the elaborate celebrations of the First Vatican Council; to deal with a steady stream of interruptions caused by feast days and papal processions; and even to survive a spell of malaria in the Borgo San Pietro (Celine Chantry, the wife of one of Braun's camera operators, perished). Technical considerations also presented challenges from the start. A huge, rotating pylon surmounted by a *chambre photographique* (photographic chamber) had to be constructed for the job, and daylight amplified and directed by an intricate series of mirrors. It took the Brauns two years of trial and error (1868–1870) to complete a full set of satisfactory prints.[39] The resulting album of 121 plates was dedicated to Pope Pius IX.[40]

Art critics claimed that with the exhibition and publication of the Braun photographs "the world seems to understand for the first time what a royal treasure-house this Vatican chapel is."[41] In view of the much-disputed cleaning of the Sistine frescoes today and the value placed upon the color photographs made by Takashi Okamura after the restoration, it is interesting that the idea of photography as the ultimate form of art preservation had already taken hold by 1870. In that year a critic praised the Brauns for having placed the frescoes "as far as the exact record is concerned, beyond the reach of destruction, whether by war, by earthquake, or by that continued atmospheric degradation from which they have already greatly suffered."[42]

The Braun 1869 photographs of antique sculpture at the Vatican strike today's viewer as gorgeous and precious. In 1870 they were also appreciated as beautiful and authentic images, but for slightly different reasons. F. Roubiliac-Conder called them "the greatest triumph that has yet been obtained by this [carbon-print] branch of photographic art....They give the very texture of the marble, the granulations of its crystallization, and the stains caused by weather and neglect. No doubt they give a better idea of the original than an ordinary

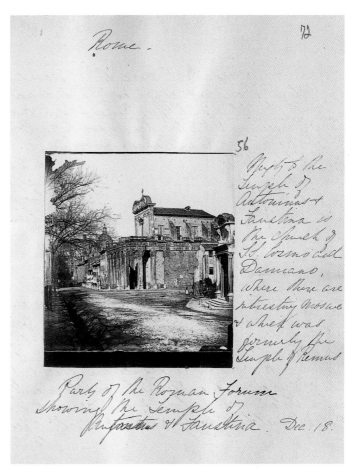

Unknown photographer
Mary Huntington's European Travel Journal. Temple of Antoninus and Faustina, Church of Saints Cosmas and Damian
Albumen silver print
1868

Aphrodite of Melos
Carbon print
ca. 1871–1872

Danaïde
Carbon print
1869

Charles Gleyre
The Bath
Oil on canvas
1868

cast would do; and they have the advantage that they cannot be placed, as casts most invariably are in this country [England], in a false light."[43] The fact that two-dimensional images were considered in the nineteenth century more accurate representations of statuary than three-dimensional casts has influenced art-historical methods and artistic practice to the present day.[44]

Henri Braun and Paul de Saint-Victor believed that exploiting the scientific aspects of archaeology, photography, and art history could contribute to a more accurate vision of the past, as well as to a more meaningful artistic application of historical styles.

Since it was expected that documentary photography would be factual and correct, the medium was able to validate and even to naturalize archaeological interventions, such as restorations and official installations, all the while maintaining an appropriately romantic sense of distance. In museum photography, the photograph itself is a construct wherein the physical restoration of ancient sculpture is authenticated with finality for the historical record. In Braun's Vatican photographs, inclusion or exclusion of settings and inscriptions within the semiotic structure of the image affects the historical or political meaning of the work.

Laocoön. Vatican Palace, Rome
Carbon print
ca. 1865

A statue's environment could be historically specified, coded with signs and symbols, as in Braun's rendition of the *Apoxyomenos*, excavated and restored during the reign of Pius IX. The photographic image expresses historical patrimony through the grill-work of the papal keys and the inscription to the great antiquarian Pius VII Chiaramonti (Pius IX's namesake), which appear as obvious framing devices. Alternatively, as in Braun's *Danaïde* (see p. 131), the museum surroundings could be dissolved into darkness so that the sculpture stands alone, illuminated against a dark ground, a moveable symbol in an unbounded historical schema.

To the extent that these photographic images embodied ideals of classical painting, they were absorbed by painters to facilitate and authenticate artistic practice. The photographs of antique sculpture had a reciprocal relationship with classical paintings in the French galleries and Salons: paintings and photographs reflected each other in a fluid dialectic. Braun's image of the *Danaïde*, for example, makes a historically credible whole from a pastiche of restorations and accommodations. The *Danaïde* sculpture was reconstructed from a broken Roman copy of a Hellenistic Aphrodite. The ensemble is a tour de force of archaeology, sculpture, and museology. The arms, head, and *all'antica* details were added as a restoration by a sculptor in the late eighteenth or early nineteenth century.[45] Through photography, the neoclassical reconstruction is silently subsumed into a painterly, transparent vignette that mediates between antiquity and its modern revival. Where the setting dissolves into a free-floating mixture of shadow and light, the tonal gradation accomplishes an image of ideal completion. The statue stands neither indoors nor outdoors, but rather resides in multiple locations of collective historical imagination.

It is not simple coincidence that photographs like the *Danaïde* correspond to visions of antiquity expressed in classical Second-Empire artworks, such as *The Bath*, 1868 (The Chrysler Museum of Art, Norfolk, Va.), by Charles Gleyre (see p. 131).[46] Painters of classical nudes typically worked from a composite of Roman sketches and memory, with additional reference to posed live models. Photographs of antique sculpture composed according to painterly formulae could stimulate ideas for figure types in paintings. Not least, these photographs carried a particular sensitivity to lighting under the impeccably smooth and varnished surface of the print. The photographs also claimed for themselves what might be called an "aesthetic of authenticity," in terms of archaeological accuracy and illumination, qualities much valued in paintings of the period. Jean-Jacques Henner was another painter of classical nudes who is known to have collected Braun's photographs of artworks.[47] Paintings by Gleyre, Henner, Alexandre Cabanel, Jean Léon Gérôme, and Adolphe William Bouguereau were constructed as historical pastiches in a manner similar to Braun's documentary photographs and finished with an equally smooth surface; moreover, these artists then had their own works photographed for publication by Braun and company.[48] This fact may or may not illustrate a particular affinity between academic painters and Braun's photography of art, but it does point to an important historical juncture where photography and painting came together.

At Paul de Saint-Victor's suggestion, Adolphe Braun sent a complete set of the Sistine ceiling prints to Charles Blanc, who was named director of the Louvre in 1870. The gift must have pleased him, because in 1871 Saint-Victor's petitions to allow the Brauns to create an album of the Louvre's sculpture collections finally

succeeded.[49] The photographs from this campaign (1871–1872) are again devoted to the promotion of a romantic/classical mystique, as exemplified by the well-known representation of the *Aphrodite of Melos* (more commonly known as the *Venus de Milo* [see p. 130]), by Michelangelo's *Slave*, and by the photographs of sculptural ensembles executed by nineteenth-century artists, such as James Pradier.

Traditional aesthetic values during the Second Empire and Third Republic were still generally focused on the idealization of the human form in classical statuary, a stock-in-trade allusion in figurative academic painting. This tradition continued steadily (if not unopposed) throughout the 1860s and 1870s, gaining force in reaction to painters like Gustave Courbet, Édouard Manet, and Claude Monet. The academic artists who were favored by the majority of critics (and by the Emperor himself) in the Second Empire included Gleyre, Cabanel, Gérôme, and Bouguereau, who tended to represent human figures as classical or neoclassical statues.

Critics such as Charles Blanc, Paul de Saint-Victor, and Théophile Gautier were frequent apologists for the classical ideal. For Gautier, ancient sculpture was still the absolute *primus mobile* of figurative art: he claimed that without ancient statues, the "secret of beauty" would have been lost forever.[50] In 1867 Charles Blanc proclaimed that the antique was "sacred."[51] Paul de Saint-Victor was equally steeped in art history, with all its Wölfflinian concepts and emphasis on the primacy of classical art. He was particularly hyperbolic about the cultish status at the Louvre of "the great *Venus de Milo* which, scarcely retrieved from the dust, reduced all would-be masterpieces to an inferior rank."[52] Saint-Victor's mystical attachment to this Greek statue was so famous that in 1859 Philippe Burty praised the intensity

of a photographic portrait of him by Nadar in which Saint-Victor seemed to be "sculpting the *Venus de Milo* in his brain."[53]

The primacy of Greco-Roman sculpture in fine art was advanced in a volume entitled *Les Dieux et les demi-dieux de la peinture*, by Gautier, Saint-Victor, and Houssaye. In the view of these authors every artist was to be compared to Phidias or Raphael, because Greek antiquity and the Italian Renaissance were the benchmarks of artistic transcendence. The Greeks were the "most excellent masters," Pradier was "immortal," and the "figure of man" served art to "formulate its concept in its elevation, purification, and disengagement from the accidental and the specific."[54]

Jean Léon Gérôme
Moorish Bath
Oil on canvas
ca. 1874–1877

Cupid and Psyche by Pradier. Musée du Louvre
Carbon print
ca. 1871

Such notions are apparent in the work of painters such as Gleyre, Gérôme, Cabanel, and Bouguereau, where many pictures are representations (literally or figuratively) of ancient statues come to life. An inevitable, if later, example of this phenomenon is Gérôme's *Pygmalion and Galatea*. Works like Gérôme's *Phryné devant l'Aréopage* (exhibited at the Exposition Universelle of 1867) and his *Moorish Bath* partake of the same mentality wherein the nude female is presented as though she were made of marble: smooth, luminous, and intact. The sculptural paradigm ran from source to copy, and a number of Gérôme's paintings actually inspired the manufacture of

sculptural "replicas" of the painted figures, the most striking of these being the marble copy of his *Phryné* produced by Jean Alexandre Joseph Falguière for Goupil & Co. in 1868.[55]

Braun's photographs of French neoclassical sculpture in the Louvre continued the same outlook, with the paradoxical twist that although the photographic medium seemed to bring statues to life in representation, it succeeded in banishing real bodies, with all their human properties of imperfection and impermanence, from the realm of art. The hypergraceful erotic effects of Pradier's *Cupid and Psyche* and his *Sappho Invoking the Gods* are heightened in Braun's photographic prints.[56] The inviting surface of finished marble becomes at once more alive and polished when viewed under the delicate skin of the print.

Pradier's *Cupid and Psyche* was carved in Rome in 1824 in response to the Hellenistic *Aphrodite of Melos*, which had arrived at the Louvre in 1821 and continued to be an aesthetic touchstone throughout the nineteenth century. Photographing Pradier's *Psyche* had a twofold charge. The erotic *Psyche* was considered something of a scandal in the 1820s: in 1871 the feelings it evoked were both heated and cooled by Braun's image. Even though the sculptural subject is brought to life by the photograph, the nude body is kept at an emotional distance when seen through the camera's lens. Since photographs, like paintings of classical or neoclassical statuary, tend to be devoted to presenting an impeccable surface, they validate and reinforce the exquisite tension between the sexual and the purely aesthetic qualities of the female nude.[57]

Braun's dissemination of photographs of classical nude statuary becomes particularly meaningful when seen in opposition to the disturbing presence of the

Édouard Manet
Olympia
Oil on canvas
1863

nude in realist and Salon des Refusés (the special exhibition of works refused by the 1863 Salon) paintings. Two salient examples of nudes that challenged the classical paradigm are Courbet's *Bather*, 1853, and Manet's *Olympia*, 1863. In fact, Braun's photographs of classical and neoclassical sculpture presented a reactionary alternative to works like Manet's *Olympia*, which was perceived as unfinished, grim, and obscene. All too real and not sufficiently ideal.[58] *Olympia* is deliberately too close for comfort. It is interesting that she, too, emerged from a photographic milieu, although of an entirely different sort. *Olympia* recalls the many photographic images of living nudes, with bodies often tainted with signs of age and fatigue, gazing toward the viewer in sullen or mocking defiance. Manet looked to photography to help produce the illusion of a deliberate engagement with the temporal, accidental, and specific, as opposed to Saint-Victor, Gautier, and Houssaye, and their quest for a classical disengagement from those qualities in the nude. It is revealing that in an autobiographical essay, Gautier remembers his shock on first seeing a naked female model in art school and confesses that he continued to prefer statues to real women.[59]

Viewing photographic studies of classically posed naked models, such as Eugène Durieu's nude, crouching

Eugène Durieu
Nude by Urn
Salted paper print
ca. 1855

like Venus beside an urn, raised awareness of the disjunction between the idealized subject and attitude and the physical human reality of the model; she is a living, mortal woman with body hair, blemishes, a model's prop for her legs, and a tired countenance. Embedded deeply and persistently in Durieu's photograph is the notion expressed by Camille Lemonnier in 1870 that "nude is not the same as undressed, and nothing is less nude than a woman emerging from a pair of drawers or one who has just taken off her chemise."[60] Braun's images of neoclassical statues are apprehended from a

tremendous psychological distance. Naked marble bodies of women and boys represent nymphs, goddesses, and cupids, which in turn refer to ancient Greek and Roman artworks: neoclassical nudes are essentially statues of statues, rather than images of mythical beings. Their psychological distance is then increased by the impeccable, uninflected finish of photographic prints.[61] Braun's photographs of sculpture have the extraordinary ability to bring the statue to life, as exemplified in his suggestive *Aphrodite of Melos* (see p. 130), and yet at the same time to banish human flesh, with its properties of mortality, blemish, and decay. These images belong wholly to the sphere of high art and to the continuing tradition of classical art.

For Braun and his mentors, photographic campaigns like those at the Vatican museums and at the Louvre could potentially close the gap between scientific progress and the supposed decline of the arts. Through the unification of art and science, the visual and intellectual challenges posed by the first modern artists could be answered by placing a new emphasis on historicity and on the replication of instructive works of art from the past. That these photographic reproductions were informed by academic painting and that they could be used in public art schools to streamline drawing methods and to inculcate classical principles made them seem like the product of cultural necessity. The enterprise to reproduce and disseminate images of monuments from the past was in itself an action of historiographic consequence.[62] The Brauns' documentation campaigns represent a kind of cultural selection and replication aimed, whether it be in the sphere of historical-archaeological studies or of design, at insuring the desired continuity of tradition— a tradition that would be questioned, but never abandoned, as the twentieth century drew nearer.

Head of a Horse from the Pediment of the Parthenon. British Museum
Albumen silver print
ca. 1872

1. Gustav Kobbé, "A Noted Family of Fine Art Publishers," reprinted from *Lotus Magazine* in *Maison Ad. Braun & Cie: Paintings, Sculpture, Architecture*. New York: n.d., pp. 3–5.

2. Elizabeth Anne McCauley, *Industrial Madness: Commercial Photography in Paris 1848–1871*. New Haven: 1994, chapter 7, "Art Reproduction for the Masses," esp. pp. 269–73.

3. Philippe Burty, "Exposition de la Société Française de Photographie," *Gazette des beaux-arts*, vol. II (May 1859), pp. 209–21; pls. 212–15.

4. Albert Boime, "The Teaching of the Fine Arts and the Avant-Garde in France During the Second Half of the Nineteenth Century," *Arts Magazine*, vol. LX (December 1985), pp. 46–57, pl. 46.

5. McCauley, op. cit., pp. 284–86.

6. *Le Moniteur de la photographie*, August 15, 1866.

7. Letter from Adolphe Braun to Paul de Saint-Victor, 1871; collection of forty-three letters from Adolphe Braun, Gaston Braun, and Henri Braun to Paul de Saint-Victor; conserved in the collection of Naomi Rosenblum, who has generously shared this material with me for researching this essay.

8. Ministry of Arts, Photographic Archives Services, Fort de Saint-Cyr, *Historique des collections*, unpublished synopsis of the collections, n.d. I am grateful to Marie-Jeanne Archaix for having acquainted me with these collections, and to Jacques Garreau, head of the department.

9. See McCauley, op. cit., p. 284.

10. Naomi Rosenblum, "Adolphe Braun, Revisited," *Image*, vol. XXXII (June 1989), pp. 1–14, pl. 2. The primary work on Braun's art reproductions was done by Pierre Tyl, *Adolphe Braun: photographe mulhousien, 1812–1877*. Dissertation, University of Strasbourg, 1982. See chapter IX, "Les Reproductions d'œuvres d'art," pp. 98–127.

11. Misook Song, *Art Theories of Charles Blanc: 1813–1882*. Ann Arbor: 1984, pp. 13–15.

12. Ibid., p. 11.

13. Rosenblum, op. cit., pp. 1–3.

14. Charles Blanc, "Exposition Universelle de 1867. Les Dessins des grands maîtres, photographiquement reproduits par M. Adolphe Braun de Dornach," in Alexandre Blanc, *Les Artistes de mon temps*. Paris: 1876, pp. 528–38.

[15] Quoted by Tyl from the *Moniteur universel* of January 14, 1868.

[16] Ted Gott, "Old Master Echoes: Odilon Redon, Photography, and 'La Vie Morale.'" *Australian Journal of Art*, vol. V (1986), pp. 46–72.

[17] J. C. Robinson. in Braun & Cie., *Catalogue général des photographies inaltérables au charbon et héliogravures faites d'après les originaux peintures, fresques, dessins, et sculptures des principaux musées d'Europe, des galeries et collections particulières les plus remarquables*. Paris and Dornach: 1887, p. xxxii; presumably Robinson's remarks were culled from an earlier publication.

[18] "Introduction de Paul de Saint-Victor à l'Édition de 1880," in Braun & Cie., op. cit., pp. v–ix, pl. VI.

[19] Ibid., pp. vi–viii.

[20] Gott, op. cit., p. 52.

[21] Adolfo Venturi, "Prefazione della presente edizione," in Braun & Cie., op. cit., pp. xxxvii–xl.

[22] Published in serial form by Hoepli, 1901–1940.

[23] See Giacomo Agosti, "Gli Studi del Kunstkenner. Le Passioni del marchand-amateur. Uno Sguardo alla Biblioteca di Morelli sui disegni antichi." in Giulio Bora, ed. *I Disegni della Collezione Morelli*. Bergamo: 1988, pp. 31–44, pl. 35; Ettore Spalletti, "La Documentazione figurativa dell'opera d'arte, la critica e l'editoria nell'epoca moderna (1750–1930)," in Giulio Ballati and Paolo Fassati. eds., *Storia dell'arte italiana*, vol. II. Turin: 1979, pp. 417–82, pl. 474.

[24] Agosti, op. cit., p. 35.

[25] See Wolfgang M. Freitag, "Early Users of Photography in the History of Art," *Art Journal*, vol. XXXIX, no. 2 (1979–1980), pp. 112–23.

[26] See Boston Athenaeum, "Braun Photographic Statistics, Feb. 9, 1884–Sept. 24, 1889." handwritten record, January 1, 1891.

[27] J. C. Robinson, Braun & Cie., op. cit., p. xxxi.

[28] Tyl, op. cit., p. 114, n. 4.

[29] Rachel Brownstein, *Tragic Muse*. New York: 1993, p. 174.

[30] Tyl, op. cit., pp. 106–7.

[31] Saint-Victor in Braun & Cie., op. cit., p. vi; for Saint-Victor's role in the Brauns' art documentation, see Rosenblum, op. cit., *passim*.

[32] Tyl, op. cit., pp. 98–127; Rosenblum, op. cit., *passim*.

[33] See Mary Bergstein, "The Mystification of Antiquity under Pius IX: Photography of Sculpture in Rome 1846–1878." in Geraldine Johnson, ed., *Sculpture and Photography: Envisioning the Third Dimension*. New York: 1999.

[34] *The Marble Faun: Or, The Romance of Monte Beni*. Boston: 1860. Reprinted New York: 1990, p. 65. Early editions of Hawthorne's novel served as photographic albums, the text interleaved with Roman photographs, as in several volumes conserved at the Museum of Fine Arts, Boston. See *Transformation: Or, The Romance of Monte Beni*. Leipzig: 1860.

[35] Boston Athenaeum, *Walter Cabot Baylies Album. Photographs of Places and Paintings in Europe (Italian Paintings and Sculptures)*. ca. 1890, pp. 10–11. Bound album, scrapbook of anonymous photographs.

[36] Boston Athenaeum, *Mary Huntington's European Travel Journal*. 1868, pp. 71–72. Bound album of handwritten notes and photographs.

[37] Saint-Victor said of the photographs of the Sistine Chapel that "for the first time, illuminated in all their details, are parts of Michelangelo's *œuvre* that have been almost inaccessible to human sight, and that previously could only have been glimpsed briefly in a ray of sunlight, patiently waited for" (author's translation): Braun & Cie., op. cit., pp. viii–ix.

[38] Leo Steinberg, "Who's Who in Michelangelo's *Creation of Adam*: A Chronology of the Picture's Reluctant Self-Revelation," *Art Bulletin*, vol. LXXIV (December 1992), pp. 552–66.

[39] Christian Kempf, *Adolphe Braun et la photographie*. Strasbourg: 1994, pp. 67–71.

[40] For Braun's Sistine photographs, see Marina Miraglia, in Alida Moltedo, ed., *La Sistina riprodotta*. Rome: 1991, pp. 236–41.

[41] William Bell Scott, "Michelangelo in the Sistine Chapel (Braun's Photographs)," *The Portfolio*, vol. I (1871), pp. 11–12.

[42] F. Roubiliac-Conder, "Heliography," *The Art Journal* (London, November 1, 1870), pp. 325–26; A. Richard Turner, review of *The Vatican Frescoes of Michelangelo*, photographed by Takashi Okamura, Tokyo and New York: 1980, in *Visual Resources*, vol. I (Fall 1980–Winter 1981), pp. 229–32.

[43] Roubiliac-Conder, op. cit., pp. 325–26.

[44] On this general topic, see Trevor Fawcett, "Plane Surfaces and Solid Bodies: Reproducing Three-Dimensional Art in the Nineteenth Century," *Visual Resources*, vol. IV (Spring 1987), pp. 1–23.

[45] I am grateful to Rolfe Winkes for having corroborated my observations about this work.

[46] Philadelphia Museum of Art, *The Second Empire, 1852–1870: Art in France under Napoleon III*. Philadelphia: 1978, pp. 310–11. In the early 1870s Braun and company reproduced sixty of Gleyre's works; Tyl, op. cit., p. 111.

[47] I am grateful to Henri Zerner for having told me of Henner's collection of Braun's photographs of art.

[48] Rosenblum, op. cit., checklist.

[49] Rosenblum, op. cit., pp. 3–5. In 1876 Blanc wrote in his *Histoire des peintres* that Braun's photographs of the Sistine ceiling showed how inadequate engravings had been in translating Michelangelo's work: "École florentine." *Histoire des peintres de toutes les écoles*, vol. VI, Paris: 1876, p. 88.

[50] Wolfgang Drost, "Gautier critique d'art en 1859," in Wolfgang Drost and Ulrike Henninges, eds., *Théophile Gautier, Exposition de 1859*. Heidelberg: 1992, pp. 10, 100, 467, 485 and 489.

[51] See Patricia Mainardi, *Art and Politics of the Second Empire: The Universal Expositions of 1855 and 1867*. New Haven and London: 1987, p. 158.

[52] Brownstein, op. cit., p. 174.

[53] Philippe Burty, "Exposition de la Société Française de Photographie," *Gazette des beaux-arts*, vol. II (May 1859), pp. 209–21, pl. 215.

[54] Théophile Gautier, Arsène Houssaye and Paul de Saint-Victor, *Les Dieux et les demi-dieux de la peinture*. Paris: 1864, see esp. pp. ii, 61, 62, 340 and 384.

[55] See Gerald M. Ackerman, *The Life and Work of Jean-Léon Gérôme*. New York and London: 1986.

[56] These photographs were made during the seige of Paris in the Franco-Prussian War, 1871.

[57] See Jennifer L. Shaw, "The Figure of Venus: Rhetoric of the Ideal and the Salon of 1863," *Art History*, vol. XIV (December 1991), pp. 540–70, pl. 541.

[58] See T. J. Clark, *The Painting of Modern Life*. New York: 1985, pp. 79–145.

[59] Brownstein, op. cit., p.173.

[60] Quoted by Clark, op. cit., p.128.

[61] See Marcia Pointon, *Naked Authority*. London: 1990, pp. 13–39 and 90.

[62] For notions of "reproducibility" and "tradition" in Western society, see Raymond Williams, *The Sociology of Culture*, 2nd edn. Chicago: 1981, pp. 182–98.

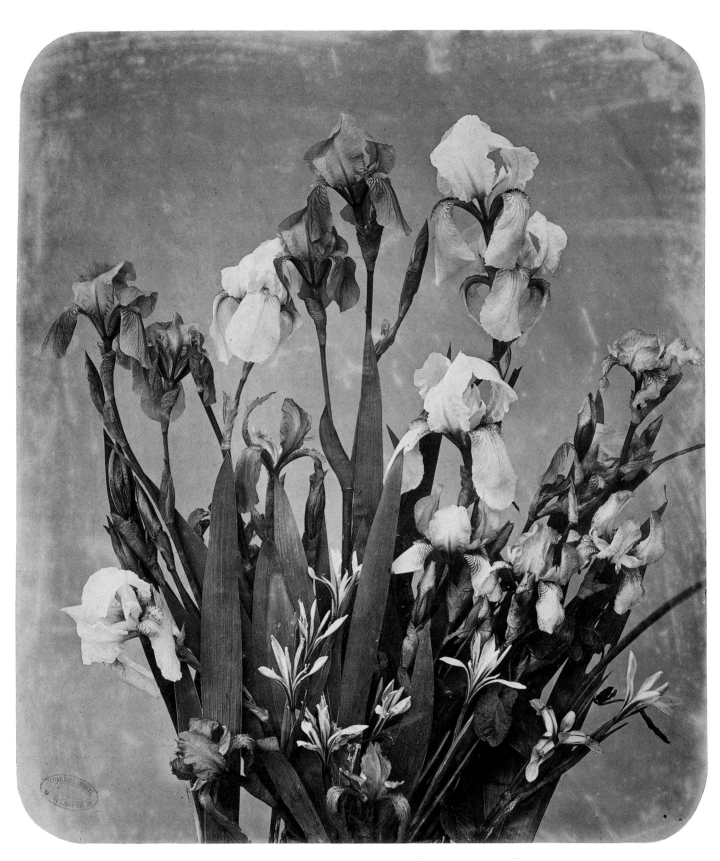

Iris et freesia
Iris and Freesia
Albumen silver print
ca. 1854

Checklist of Works by Adolphe Braun

Fleurs photographiées
[Photographs of Flowers]
ca. 1854–1857

1 *Fruit Tree Blossoms*
Albumen silver print
17½ x 20⅛ in. (44.5 x 51.1 cm.)
Museum of Art, Rhode Island
School of Design
Mary B. Jackson Fund
Illustrated on p. 30

2 *Magnolias*
Albumen silver print
12⁹⁄₁₆ x 14¹¹⁄₁₆ in. (31.9 x 37.3 cm.)
Bibliothèque de la Ville de Colmar

3 *Rose of Sharon*
Albumen silver print
14¾ x 16½ in. (37.5 x 41.9 cm.)
The Metropolitan Museum of Art, New York,
1987.1161 Gift of Gilman Paper Company in
memory of Samuel J. Wagstaff, Jr., 1987
Photograph © 1992 The Metropolitan
Museum of Art

4 *Pavots*
[Poppies]
Albumen silver print
15³⁄₁₆ x 17¾ in. (38.6 x 45 cm.)
Musée de l'Impression sur Étoffes, Mulhouse
Illustrated on p. 63

5 *Roses*
Albumen silver print
11¾ x 13¼ in. (29.9 x 33.6 cm.)
Musée de l'Impression sur Étoffes, Mulhouse
Illustrated on p. 73

6 *Couronne de roses, dahlias et nasturtiums*
[Wreath of Roses, Dahlias, and Nasturtiums]
Albumen silver print
14⁵⁄₁₆ x 16⅞ in. (36.3 x 42.9 cm.)
Musée de l'Impression sur Étoffes, Mulhouse
Illustrated on p. 1

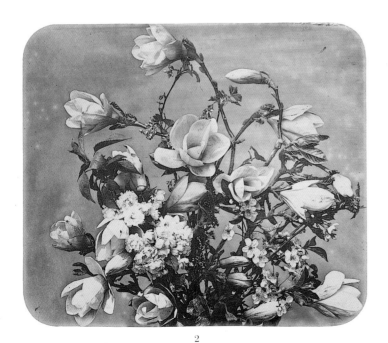

2

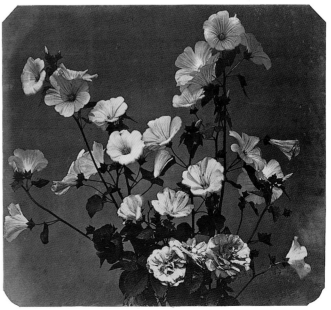

3

7 *Iris et freesia*
[Iris and Freesia]
Albumen silver print
17³/₁₆ x 15¹/₁₆ in. (43.7 x 38.3 cm.)
Musée de l'Impression sur Étoffes,
Mulhouse
Illustrated on p. 140

8 *Grappes de raisin* [Grapes]
Albumen silver print
17³/₈ x 18⁹/₁₆ in. (44.1 x 47.2 cm.)
Musée de l'Impression sur Étoffes,
Mulhouse
Illustrated on p. 44

9 *Pivoines*
[Peonies]
Albumen silver print
16⁷/₈ x 18¹/₂ in. (42.9 x 47 cm.)
Bibliothèque de la Ville de Colmar

10 *Double Poppies*
Albumen silver print
15³/₁₆ x 17⁷/₈ in. (38.6 x 44.7 cm.)
International Museum of Photography
and Film, George Eastman House

11 *Couronne de fleurs*
[Wreath of Flowers]
Albumen silver print
17³/₈ x 18¹⁵/₁₆ in. (44.2 x 48.1 cm.)
Musée d'Orsay, Paris
Illustrated on p. 79

12 *Bouquet*
Albumen silver print
14⁷/₁₆ x 12¹/₂ in. (36.8 x 31.8 cm.)
The Cleveland Museum of Art
L. E. Holden Fund

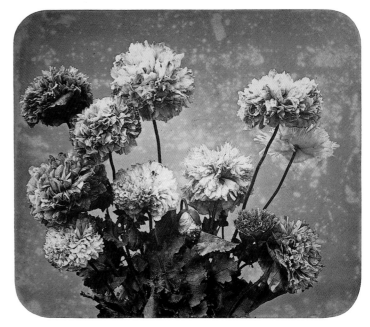

10

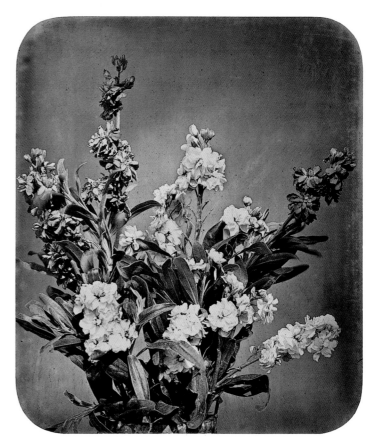

12

13

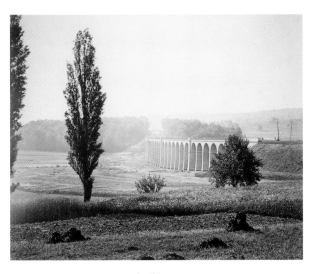

14

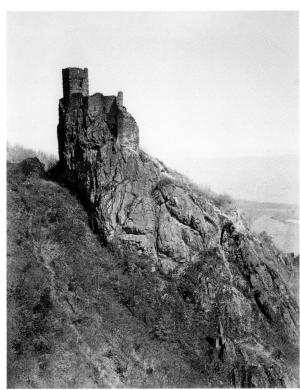

18

Album de l'Alsace
[Album of Alsace]
1859

13 *Strasbourg: la Porte des Pêcheurs*
[Strasbourg: The Fishermen's Gate]
Albumen silver print
12⁷⁄₁₆ x 18⁷⁄₈ in. (31.6 x 48 cm.)
Bibliothèque de la Ville de Colmar

14 *Petit viaduc de Dannemarie*
[Small Viaduct of Dannemarie]
Albumen silver print
14 x 17½ in. (35.6 x 44.4 cm.)
Bibliothèque de la Ville de Colmar

15 *Cour du Château de
Haut-Koenigsbourg*
[Inner Courtyard, Château of
Haut-Koenigsbourg]
Albumen silver print
21⁷⁄₁₆ x 16⁵⁄₈ in. (54.5 x 42.3 cm.)
Private collection
Illustrated on p. 105

16 *Un Moulin à Stosswihr*
[A Mill at Stosswihr]
(in reality, a sawmill at Soultzeren)
Albumen silver print
14⁹⁄₁₆ x 17³⁄₈ in. (37 x 44.2 cm.)
Bibliothèque de la Ville de Colmar
Illustrated on p. 115

17 *Château d'Engelbourg*
[Château of Engelbourg]
Albumen silver print

15¹⁄₁₆ x 17¹³⁄₁₆ in. (38.3 x 45.2 cm.)
Bibliothèque de la Ville de Colmar
Illustrated on p. 103

18 *Château de Giersberg*
[Château of Giersberg]
Albumen silver print
17¹³⁄₁₆ x 14³⁄₈ in. (45.3 x 36.6 cm.)
Bibliothèque de la Ville de Colmar

19 *Strasbourg: rue générale et
cathédrale* [Strasbourg: General
View and Cathedral]
Albumen silver print
17¹³⁄₁₆ x 18⁵⁄₈ in. (43.7 x 47.3 cm.)
Bibliothèque de la Ville de Colmar

20 *Château de Saint-Ulrich*
[Château of Saint-Ulrich]
Albumen silver print
14¹³⁄₁₆ x 17⁷⁄₁₆ in. (37.7 x 44.3 cm.)
Bibliothèque de la Ville de Colmar
Illustrated on pp. 2–3

21 *Ruines de Schwarzenbourg*
[Ruins of Schwarzenbourg]
Albumen silver print
16 x 18¹¹⁄₁₆ in. (40.5 x 47.5 cm.)
Bibliothèque de la Ville de Colmar

22 *Colmar, maison Pfister*
[Colmar, Pfister House]
Albumen silver print
15 x 17¹¹⁄₁₆ in. (38 x 45 cm.)
Bibliothèque de la Ville de Colmar

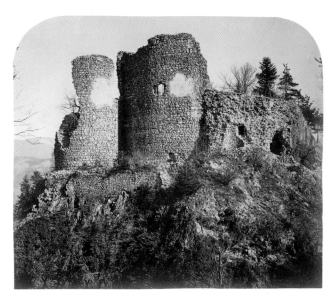

21

Vues stéréoscopiques [**Stereoscopic Views**]
Standard dimensions of stereoscopic mount
3⅜ x 6⅞ in. (8.6 x 17.7 cm.)

Fleurs photographiées
[**Photographs of Flowers**]
ca. 1857
23 No. 8. *Fleurs* [Flowers]
Albumen silver prints on stereoscopic mount
Private collection

24 No. 25. *Fuchsias*
Albumen silver prints on stereoscopic mount
The J. Paul Getty Museum, Los Angeles

Paysages Animés
[**Animated Landscapes**]
ca. 1858
25 No. 213. *Colin-maillard*
[Blind Man's Bluff]
Albumen silver prints on stereoscopic mount
Private collection

26 No. 259. *Groupe au bord de la Thur*
[Group on the Banks of the Thur]
Albumen silver prints on stereoscopic mount
Private collection

Animaux de ferme
[**Farm Animals**]
ca. 1862–1864
27 No. 116. (Farmer with Horses and Sheep)
Albumen silver prints on stereoscopic mount
Private collection

28 No. 156. *Man Standing Next to
Oxen-Drawn Cart*
Albumen silver prints on stereoscopic mount
The J. Paul Getty Museum, Los Angeles

Other Subjects
ca. 1857–1859
29 No. 306. *Turtles* (inscribed *"Morrill"*)
Albumen silver prints on stereoscopic mount
The J. Paul Getty Museum, Los Angeles

Suisse
[**Switzerland**]
1860–1870
30 No. 699. *Route du St.-Gotthard. Pont du
Diable* [St. Gotthard Route. The Devil's Bridge]
Albumen silver prints on stereoscopic mount
Museum of Art, Rhode Island School of Design
Georgianna Sayles Aldrich Fund

24

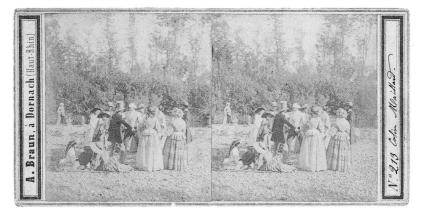

25

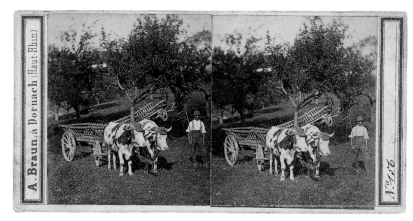

28

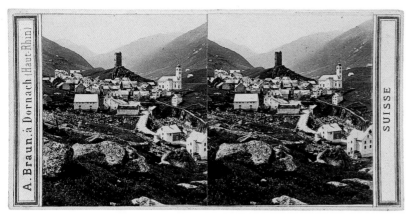

33

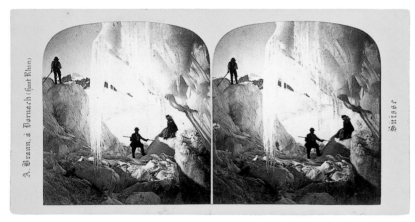

37

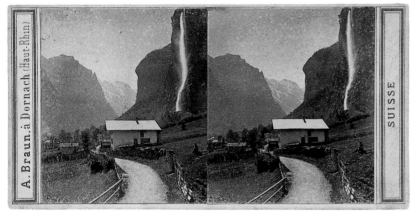

39

31 No. 3077. *Route du St.-Gotthard.*
Gorge de Schoellenen
[St. Gotthard Route. The Schoellenen Gorge]
Albumen silver prints on stereoscopic mount
Museum of Art. Rhode Island School of Design
Georgianna Sayles Aldrich Fund

32 No. 3211. *Lucerne et le Mont Pilate (6700')*
[Lucerne and Mont Pilate]
Albumen silver prints on stereoscopic mount
Museum of Art. Rhode Island School of Design
Georgianna Sayles Aldrich Fund

33 No. 4729. *Canton d'Uri. Hospenthal*
[Canton of Uri. Hospenthal]
Albumen silver prints on stereoscopic mount
Museum of Art. Rhode Island School of Design
Georgianna Sayles Aldrich Fund

34 No. 1063. *Cascade inférieure de Barbarine*
[Lower Falls of Barbarine]
Albumen silver prints on stereoscopic mount
Museum of Art. Rhode Island School of Design
Georgianna Sayles Aldrich Fund

35 No. 3296. *Oberland Bernois,*
Glacier inférieur de Grindelwald
[Bernese Oberland. Lower Glacier at Grindelwald]
Albumen silver prints on stereoscopic mount
Private collection
Illustrated on p. 113

36 No. 3278. *Oberland Bernois,*
Mer de Glace de Grindelwald
[Bernese Oberland. Mer de Glace of Grindelwald]
Albumen silver prints on stereoscopic mount
Private collection

37 No. 4746. *Canton du Valais,*
glacier supérieur du Rhône
[Canton of Valais. Upper Glacier of the Rhone]
Albumen silver prints on stereoscopic mount
Private collection

38 No. 4645. *Tente laboratoire installée*
au sommet du Mont Titlis
[Laboratory Tent Installed at the
Summit of Mont Titlis]
Albumen silver prints on stereoscopic mount
Private collection
Illustrated on p. 112

39 *Le Staubbach, Vallée de Lauterbrunnen*
[Staubbach Falls. Valley of Lauterbrunnen]
Albumen silver prints on stereoscopic mount
The J. Paul Getty Museum. Los Angeles

40 No. 3283. *Oberland Bernois, Grotte de glace au glacier supérieur de Grindelwald* [Bernese Oberland. Ice Cave on the Upper Glacier at Grindelwald] Albumen silver prints on stereoscopic mount The J. Paul Getty Museum, Los Angeles

41 No. 3301. *Oberland Bernois, Sauvetage du guide Jean-Michel, tombé dans une crevasse du glacier inférieur de Grindelwald* [Bernese Oberland. Rescue of the Guide, Jean-Michel, who had Fallen into a Crevasse on the Lower Glacier at Grindelwald] Albumen silver prints on stereoscopic mount The J. Paul Getty Museum, Los Angeles Illustrated on p. 5

Costumes de Suisse **[Costumes of Switzerland] ca. 1869** 42 *Canton d'Appenzell* [Canton of Appenzell] Albumen silver prints on stereoscopic mount Private collection

Animaux de ferme **[Farm Animals] ca. 1862–1864** 43 *Cheval* [Horse] Albumen silver print 9⁷⁄₁₆ x 11⅝ in. (24 x 29.5 cm.) Private collection

44 *Vache et vacher* [Cow and Cowherd] Albumen silver print 10½ x 14¹³⁄₁₆ in. (26.7 x 37.7 cm.) Private collection

45 *Farmyard Scene* Albumen silver print 9¾ x 13¹³⁄₁₆ in. (24.8 x 35.1 cm.) The J. Paul Getty Museum, Los Angeles

46 *Le Petit Veau* [Little Calf] Albumen silver print 9¾ x 11¼ in. (24.7 x 28.5 cm.) Private collection

47 *Farm Animals* Albumen silver print 11 x 15½ in. (28 x 39.4 cm.) The Cleveland Museum of Art Norman O. Stone and Ella A. Stone Memorial Fund

43

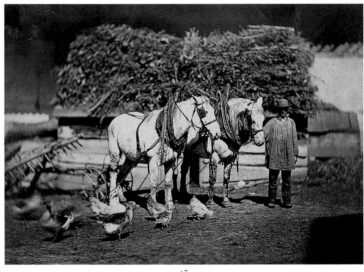

45

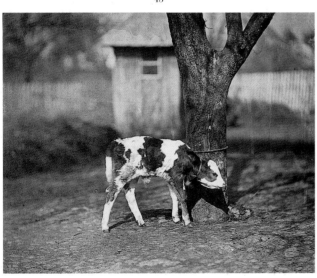

46

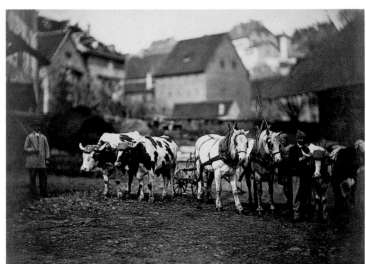

47

Vues de Suisse et de Savoie
[**Views of Switzerland and Savoy**]
ca. 1859–1867
Braun cameramen: Samuel Braun,
Charles Braun, Gaston Braun, and
Jean-Claude Marmand

48 *Savoie. Le Mont Blanc.*
Station des Grand Mulets
[Mont Blanc. Grand Mulets Station]
Carbon print
8⅞ x 19⅛ in. (22.5 x 48.6 cm.)
Boston Athenaeum

49 *Suisse. Vevey*
Carbon print
8⅞ x 19⅛ in. (22.5 x 48.6 cm.)
Boston Athenaeum

50 *Suisse. Glacier supérieur de Grindelwald:*
Source de la Lutschine
[Upper Glacier at Grindelwald:
Source of the Lutschine]
Carbon print
4⁹⁄₁₆ x 7¼ in. (11.6 x 18.5 cm.)
Private collection

51 *Suisse. Lucerne et le Pilate*
[Lucerne and Mont Pilate]
Carbon print
8⅞ x 19⅛ in. (22.5 x 48.6 cm.)
Boston Athenaeum

52 *Savoie. Mont Blanc. Vue du jardin*
[Mont Blanc. View from Le Jardin]
Carbon print
8⅞ x 19⅛ in. (22.5 x 48.6 cm.)
Boston Athenaeum

53 *Suisse. Weesen et le lac de Wallenstadt*
[Weesen and the Lake of Wallenstadt]
Carbon print
8¾ x 18⁷⁄₁₆ in. (22.3 x 46.8 cm.)
The J. Paul Getty Museum, Los Angeles
Illustrated on pp. 94–95

54 *Suisse. Château de Chillon*
et la Dent du Midi
[Castle of Chillon and the Dent du Midi]
Carbon print
8⅞ x 18¾ in. (22.5 x 47.6 cm.)
Boston Athenaeum

55 *Savoie. Chamonix et le Mont Blanc*
[Chamonix and Mont Blanc]
Albumen silver print
15³⁄₁₆ x 18⅞ in. (38.6 x 48 cm.)
Bibliothèque de la Ville de Colmar

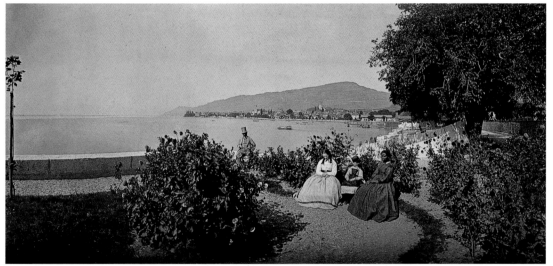

49

50

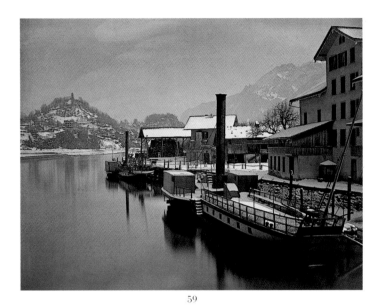

59

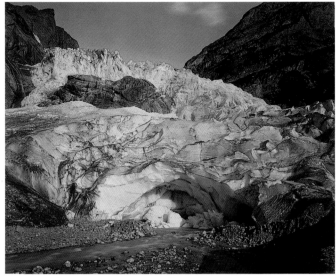

60

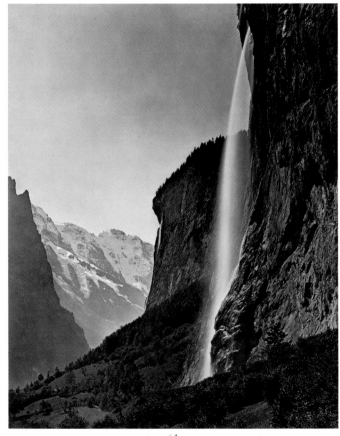

61

56 *Savoie. Vallée de Chamonix.*
Le Pavillon du Chapeau
[Valley of Chamonix. The Pavillon
du Chapeau]
Albumen silver print
18¹¹/₁₆ x 14⁵/₈ in. (47.5 x 37.2 cm.)
Bibliothèque de la Ville de Colmar
Illustrated on p. 92

57 *Suisse. Environs de Zermatt-*
Schwarzsee. Le Mont Cervin et
le Theodorpass
[Zermatt-Schwarzsee Region.
Mont Cervin and Theodorpass]
Albumen silver print
15 x 18¹¹/₁₆ in. (38 x 47.4 cm.)
Bibliothèque de la Ville de Colmar

58 *Suisse. Environs de*
Zermatt-Schwarzsee.
Glacier du Gorner et Breithorn
[Zermatt-Schwarzsee Region.
Gorner and Breithorn Glacier]
Carbon print
16¹/₄ x 19³/₄ in. (41.3 x 50.2 cm.)
Museum of Art, Rhode Island
School of Design
Gift of Christian Kempf
Illustrated on p. 8

59 *Switzerland. Lake Steamer*
at Winter Mooring, Interlaken
Carbon print
14 x 18³/₄ in. (35.5 x 47.6 cm.)
The J. Paul Getty Museum,
Los Angeles

60 *Suisse. Grindelwald, glacier*
supérieur, source de la Lutschine
[Grindelwald. Upper Glacier,
Source of the Lutschine]
Carbon print
ca. 1875–1885
15¹/₄ x 19 in. (38.8 x 48.2 cm.)
The Cleveland Museum of Art
The A. W. Ellenberger Sr.,
Endowment Fund

61 *Suisse. Vallée de*
Lauterbrunnen. Le Staubbach
[Valley of Lauterbrunnen.
Staubbach Falls]
Carbon print
ca. 1875, printed ca. 1900
30⁵/₁₆ x 24³/₁₆ in. (77 x 61.5 cm.)
Private collection

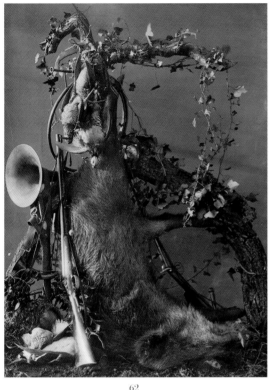

62

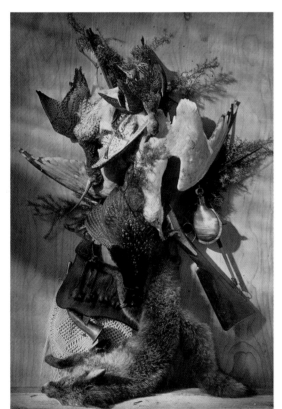

64

Panoplies de gibier, sujets de chasse
[Game Trophies, Hunt Subjects]
ca. 1867
62 *Hunting Still Life*
Carbon print
30⁷⁄₁₆ x 22⅛ in. (77.3 x 56.2 cm.)
The J. Paul Getty Museum, Los Angeles

63 *Trophy of the Hunt*
Carbon print
30¹¹⁄₁₆ x 23½ in. (77.9 x 59.7 cm.)
The Cleveland Museum of Art
Andrew R. and Martha Holden
Jennings Fund

64 *Trophée de chasse au renard*
[Still Life with Fox]
Carbon print
28¹⁵⁄₁₆ x 20¹⁄₁₆ in. (73.5 x 51 cm.)
Musée d'Orsay, Paris

Photographs of Works of Art
Braun cameramen: Gaston Braun,
Jean Braendlin, and Henri Braun

65 *Ignudo (Michelangelo),*
Sistine Chapel, Rome
Carbon print
1869
18⅝ x 14⅜ in. (47.3 x 36.5 cm.)
The J. Paul Getty Museum, Los Angeles

66 *Head of a Horse from the Pediment*
of the Parthenon, British Museum
Carbon print
ca. 1872
8¹⁄₁₆ x 10¹¹⁄₁₆ in. (20.5 x 27.1 cm.)
The J. Paul Getty Museum, Los Angeles
Illustrated on p. 138

67 *Night (Michelangelo),*
Medici Chapel, Florence
Carbon print
ca. 1865
14½ x 20 in. (36.8 x 50.8 cm.)
Museum of Modern Art, New York
Anonymous Purchase Fund
Illustrated on p. 127

68 *Head of Medusa,*
Vatican Palace, Rome
Carbon print
ca. 1872–1874
13¾ x 18⅛ in. (35 x 46 cm.)
Photography Collection, Miriam
and Ira D. Wallach Division of Art,
Prints and Photographs
The New York Public Library,
Astor, Lenox and Tilden Foundations

69 *Laocoön, Vatican Palace, Rome*
Carbon print
ca. 1865
18⁷⁄₁₆ x 14½ in. (46.9 x 36.8 cm.)
Bryn Mawr College Photograph
Collection
Gift of M. Carey Thomas
Illustrated on p. 132

70 *Cupid and Psyche*
(Antonio Canova), Louvre
Carbon print
ca. 1871
18½ x 14¾ in. (47 x 37.5 cm.)
Museum of Fine Arts, Boston
Francis Welch Fund
Illustrated on p. 120

71 *Tête de la Vierge, Album sur*
Léonardo da Vinci, Albertina de Vienne
[Head of the Virgin, Leonardo da Vinci
Album, Albertina, Vienna]
Carbon print in bound album
1867
8⁹⁄₁₆ x 9⅞ in. (21.7 x 25 cm.)
Private collection
Illustrated on p. 124

Costumes de Suisse
[Costumes of Switzerland]
1869

From *dépôt légal*

72 *Canton d'Appenzell*
[Canton of Appenzell]
Albumen silver print
10³⁄₄ x 8¹¹⁄₁₆ in. (27.4 x 22 cm.)
Bibliothèque Nationale de France, Paris

73 *Canton de Thurgovie*
[Canton of Thurgau]
Albumen silver print
11¹⁄₈ x 8³⁄₄ in. (28.2 x 22.3 cm.)
Bibliothèque Nationale de France, Paris

74 *Canton de Berne* [Canton of Berne]
Albumen silver print
11¹⁄₈ x 8⁵⁄₈ in. (28.2 x 21.9 cm.)
Bibliothèque Nationale de France, Paris

75 *Canton de Tessin* [Canton of Tessin]
Albumen silver print
11¹⁄₈ x 8⁵⁄₈ in. (28.2 x 21.9 cm.)
Bibliothèque Nationale de France, Paris

76 *Canton de Schaffouse*
[Canton of Schaffhausen]
Albumen silver print
11¹⁄₄ x 8¹⁵⁄₁₆ in. (28.5 x 22.7 cm.)
Bibliothèque Nationale de France, Paris

77 *Canton d'Appenzell*
[Canton of Appenzell (interior setting)]
Albumen silver print
11¹⁄₁₆ x 8³⁄₄ in. (28.1 x 22.2 cm.)
Bibliothèque Nationale de France, Paris

78 *Canton de Bâle* [Canton of Basel]
Albumen silver print
11¹⁄₈ x 8⁷⁄₈ in. (28.3 x 22.5 cm.)
Bibliothèque Nationale de France, Paris
Illustrated on p. 66

79 *Canton de Saint-Gall*
[Canton of Saint-Gall]
Albumen silver print
11¹⁄₈ x 8⁵⁄₈ in. (28.2 x 21.9 cm.)
Bibliothèque Nationale de France, Paris
Illustrated on p. 87

Cabinet cards

Standard dimensions of cabinet card
mount: 6¹⁄₂ x 4³⁄₈ in. (16.5 x 11.2 cm.)

80 *Canton d'Appenzell*
[Canton of Appenzell]
Albumen silver print on cabinet
card mount
5¹³⁄₁₆ x 3⁷⁄₈ in. (14.7 x 9.9 cm.)
Boston Athenaeum
Gift of Aimée and Rosamond Lamb

81 *Canton de Fribourg*
[Canton of Fribourg]
Albumen silver print on cabinet
card mount
5¹³⁄₁₆ x 3⁷⁄₈ in. (14.7 x 9.9 cm.)
Boston Athenaeum
Gift of Aimée and Rosamond Lamb

82 *Canton de Tessin*
[Canton of Tessin]
Albumen silver print on cabinet
card mount
5¹³⁄₁₆ x 3⁷⁄₈ in. (14.7 x 9.9 cm.)
Boston Athenaeum
Gift of Aimée and Rosamond Lamb

83 *Canton de Schaffouse*
[Canton of Schaffhausen]
Albumen silver print on cabinet
card mount
5¹³⁄₁₆ x 3⁷⁄₈ in. (14.7 x 9.9 cm.)
Boston Athenaeum
Gift of Aimée and Rosamond Lamb

84 *Canton de Berne (Simmenthal)*
[Canton of Berne (Simmenthal)]
Albumen silver print on cabinet
card mount
5¹³⁄₁₆ x 3⁷⁄₈ in. (14.7 x 9.9 cm.)
Boston Athenaeum
Gift of Aimée and Rosamond Lamb

85 *Canton de Valais (Sion)*
[Canton of Valais (Sion)]
Albumen silver print on cabinet
card mount
5¹³⁄₁₆ x 3¹⁵⁄₁₆ in. (14.7 x 10 cm.)
Boston Athenaeum
Gift of Aimée and Rosamond Lamb

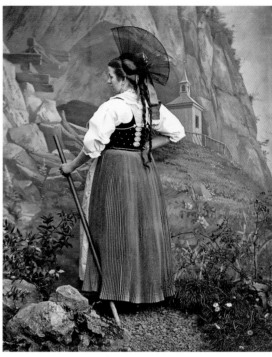

72

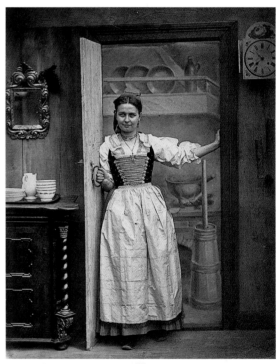

77

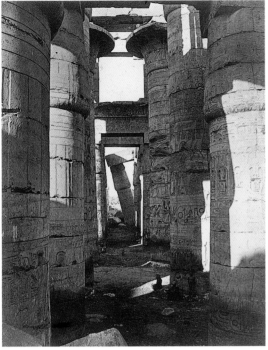

87

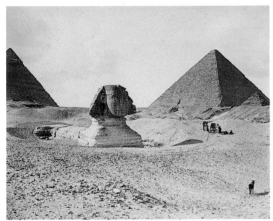

88

Egypt and Rome
ca. 1869
Braun cameramen: Gaston Braun
and Amédée Mouilleron

86 *The Ramesseum, Thebes*
Albumen print from wet
collodion negative
7¾ x 9¾ in. (19.7 x 24.8 cm.)
The Cleveland Museum of Art
75th anniversary gift of Dr. and
Mrs. Jerald S. Brodkey in honor of
Brenda and Evan Turner

87 *Haute-Égypte. Salle Hypostyle
à Karnak*
[Upper-Egypt. Hypostyle Hall
at Karnak]
Albumen silver print
9¹³⁄₁₆ x 7¾ in. (24.9 x 19.7 cm.)
The Metropolitan Museum of Art,
New York. 1973.607.1
Gift of Weston Naef, 1973
Photograph © 1999 The Metropolitan
Museum of Art

88 *Le Sphinx et les pyramides de Gyseh*
[The Sphinx and the Pyramids of Gizeh]
Albumen silver print
7¾ x 10 in. (19.7 x 25.4 cm.)
Private collection

89 *Rome. Colysée et arc de Constantin*
[Rome, Colosseum and Arch
of Constantine]
Albumen silver print
8⅞ x 18⅞ in. (22.6 x 48 cm.)
Société Schongauer
Musée d'Unterlinden, Colmar

90 *Pompéi. L'Amphithéâtre*
[Pompeii, The Amphitheater]
Carbon print
8⅞ x 18¾ in. (22.5 x 47.7 cm.)
Société Schongauer
Musée d'Unterlinden, Colmar

Le Théâtre de la guerre, 1870–1871
[The Theatre of War, 1870–1871]
ca. 1871
91 *Belfort. L'Église et la place
de l'Hôtel de Ville*
[Belfort. The Church and the
Place de l'Hôtel de Ville]
Albumen silver print
8¹⁵⁄₁₆ x 18¹⁵⁄₁₆ in. (22.7 x 48.1 cm.)
Private collection

92 *Belfort. Cour intérieur du château*
[Belfort. Interior Courtyard of the
Château]
Albumen silver print
7¼ x 8¼ in. (18.4 x 21 cm.)
Private collection

89

97

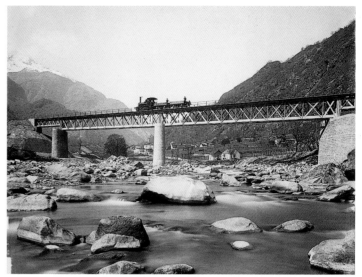

98

100

L'Alsace et La Lorraine
[Alsace and Lorraine]
ca. 1871
93 *L'Alsace*
Carbon print
16¼ x 11⅝ in. (41.3 x 29.5 cm.)
Boston Athenaeum
Gift of Ars Libri
Illustrated on p. 89

94 *La Lorraine*
Carbon print
16¼ x 11⁷⁄₁₆ in. (41.3 x 29 cm.)
Boston Athenaeum
Gift of Ars Libri
Illustrated on p. 160

Ligne du Gotthard
[Construction of the St. Gotthard
Railroad Line]
ca. 1875–1880
95 *Tunnel du Gotthard: Station à Lugano*
[Gotthard Tunnel: Station at Lugano]
Albumen silver print
8¹¹⁄₁₆ x 10¹³⁄₁₆ in. (22 x 27.5 cm.)
Private collection

96 *Tunnel du Gotthard: machine à perforer*
[Gotthard Tunnel: Boring Machine]
8¹¹⁄₁₆ x 10⅞ in. (22 x 27.7 cm.)

Albumen silver print
Private collection
Illustrated on p. 111

97 *Tunnel du Gotthard: une locomotive*
[Gotthard Tunnel: A Locomotive]
Albumen silver print
9⁷⁄₁₆ x 11¹³⁄₁₆ in. (24 x 30 cm.)
Private collection

98 *Pont inférieur sur le Tessin,*
près de Giornico
[Lower Bridge over the Tessin,
near Giornico]
Albumen silver print
9½ x 11⁹⁄₁₆ in. (24.2 x 29.4 cm.)
Private collection

99 *Pont de Kerstellenbach,*
en construction
[Bridge of Kerstellenbach
during construction]
Albumen silver print
12 x 9⁵⁄₁₆ in. (30.6 x 23.7 cm.)
Private collection

100 *Sortie du Tunnel de Leggistein*
[Exit of Leggistein Tunnel]
Albumen silver print
11⅞ x 9⅜ in. (30.2 x 23.8 cm.)
Private collection

Bibliography

Ackerman, Gerald M. *The Life and Work of Jean-Léon Gérôme*. New York and London: 1986.

Agosti, Giacomo. "Gli Studi del Kunstkenner. Le Passioni del marchand-amateur. Uno Sguardo alla Biblioteca di Morelli sui disegni antichi," in Giulio Bora, ed., *I Disegni della Collezione Morelli*. Bergamo: 1988, pp. 31–49.

Allemagne, Henri d'. *La Toile imprimée et les indiennes de traite*. Paris: 1942.

Andrews, Malcolm. *The Search for the Picturesque: Landscape Aesthetics and Tourism in Britain*. Palo Alto: 1989.

Armstrong, Nancy. "City Things," in Diana Fuss, ed., *Human, All Too Human*. London: 1996, pp. 93–130.

Arnold, H. J. P. *William Henry Fox Talbot: Pioneer of Photography and Man of Science*. London: 1977.

A.-T. L. "Utile application de la photographie aux beaux-arts et à l'industrie." *La Lumière*, year 4, no. 45 (November 18, 1854), p. 178.

Baudelaire, Charles. "The Modern Public and Photography," in Alan Trachtenberg, ed., *Classic Essays on Photography*. New Haven: 1980, pp. 83–90.

Beaugé, Gilbert. "Un Monument de l'archive photographique: 'La Lumière.'" in *Collection du Journal La Lumière. Beaux-Arts. Héliographie. Sciences [Réimpression de l'édition de Paris, 1851–1860 parutions hebdomadaires]*, 2 vols. Marseille: 1995, vol. I, pp. 9–32.

Belloli, Andrea P. A., ed. *A Day in the Country: Impressionism and French Landscape*. Los Angeles: 1984.

Bergstein, Mary. "The Mystification of Antiquity under Pius IX: Photography of Sculpture in Rome 1846–1878," in Geraldine Johnson, ed., *Sculpture and Photography: Envisioning the Third Dimension*. New York: 1999.

Blanc, Charles. "École française. J. B. Siméon Chardin." *Histoire des peintres de toutes les écoles*, vol. II. Paris: 1865, pp. 1–16.

Blanc, Charles. "Exposition Universelle de 1867. Les Dessins des grands maîtres, photographiquement reproduits par M. Adolphe Braun de Dornach," in Alexandre Blanc, *Les Artistes de mon temps*. Paris: 1876, pp. 528–38.

Blanc, Charles and Paul Mantz. "École florentine." *Histoire des peintres de toutes les écoles*, vol. VI. Paris: 1876.

Boime, Albert. "The Teaching of the Fine Arts and the Avant-Garde in France During the Second Half of the Nineteenth Century." *Arts Magazine*, vol. LX (December 1985), pp. 46–57.

Boston Athenaeum. *Mary Huntington's European Travel Journal*, 1868. Bound album of photographs and handwritten notes.

Boston Athenaeum. *Walter Cabot Baylies Album. Photographs of Places and Paintings in Europe (Italian Paintings and Sculptures)*, ca. 1890. Bound album, scrapbook of photographs.

Boston Athenaeum. "Braun Photographic Statistics, Feb. 9, 1884–Sept. 24, 1889." Handwritten record, January 1, 1891.

Boyer, Laure. *Adolphe Braun et la reproduction photographique des œuvres d'art*. Dissertation. University of Strasbourg, 1998.

Braun & Cie. *Photographies de fleurs, à l'usage des fabriques de toiles peintes, papiers peints, soieries, porcelaines, etc., par M. AD. BRAUN, à Dornach, près Mulhouse (Haut-Rhin)*. Mulhouse: 1855 (brochure). Published in English as *Photographic Flowers from Nature, by Ad. Braun, Dornach, near Mulhouse (Haut-Rhin)*.

Braun & Cie. *Catalogue général des photographies inaltérables au charbon et héliogravures faites d'après les originaux peintures, fresques, dessins, et sculptures des principaux musées d'Europe, des galeries et collections particulières les plus remarquables*. Paris and Dornach: 1887.

Brédif, Josette. *Printed French Fabrics: Toiles de Jouy*. New York: 1989.

Brownstein, Rachel. *Tragic Muse*. New York: 1993.

Bulletin de la Société Française de Photographie. Paris: 1865, p. 6.

Burty, Philippe. "Exposition de la Société Française de Photographie." *Gazette des beaux-arts*, vol. II (May 1859), pp. 209–21.

Caloine, Pierre. "De l'Influence de la photographie sur l'avenir des arts du dessin." *La Lumière*, year 4, no. 17 (April 29, 1854), pp. 65–66.

Castagnary, Jules-Antoine. *Salons, 1857–1870*, 2 vols. Paris: 1892.

Chassagne, Serge. *Oberkampf: un entrepreneur capitaliste au siècle des lumières*. Paris: 1980.

Chu, Petra ten-Doesschate, ed. and trans., *Letters of Gustave Courbet*. Chicago and London: 1992.

Clark, T. J. *The Painting of Modern Life*. New York: 1985.

Clouzot, Henri. *Painted and Printed Fabrics: The History of the Manufactory at Jouy and Other Ateliers in France, 1760–1815*. New York: 1927.

Crimp, Douglas. "The Museum's Old/The Library's New Subject," in Richard Bolton, ed., *The Contest of Meaning: Critical Histories of Photography*. Cambridge, Mass.: 1987.

Donné, Alfred. *Cours de microscopie*. Paris: 1844.

Drost, Wolfgang. "Gautier critique d'art en 1859," in Wolfgang Drost and Ulrike Henninges, eds., *Théophile Gautier, Exposition de 1859*. Heidelberg: 1992.

Esielonis, Karyn. *Still-Life Painting in the Museum of Fine Arts, Boston*. Introduction by Theodore E. Stebbins, Jr. and Eric M. Zafran. Boston: 1994.

Établissement de pisciculture de Huningue, atlas des bâtiments et appareils, ponts et chaussées. Strasbourg: 1868.

Faunce, Sarah, and Linda Nochlin. *Courbet Reconsidered*. Brooklyn: 1988.

Fawcett, Trevor. "Plane Surfaces and Solid Bodies: Reproducing Three-Dimensional Art in the Nineteenth Century." *Visual Resources*, vol. IV (Spring 1987), pp. 1–23.

Floud, Peter. *Industry Printed Textiles 1720–1836*. London: 1960.

Fohlen, Claude. *L'Industrie textile au temps du Second Empire*. Paris: 1956.

Fort de Saint-Cyr, Photographic Archives Services, Ministry of Arts. *Historique des collections*. Unpublished one-page synopsis of the collection, n.d.

Freitag, Wolfgang M. "Early Users of Photography in the History of Art." *Art Journal*, vol. XXXIX, no. 2 (1979–1980), pp. 112–23.

Gautier, Théophile, Arsène Houssaye and Paul de Saint-Victor. *Les Dieux et les demi-dieux de la peinture*. Paris: 1864.

Gerlach, Martin, ed. *Festons und decorative Gruppen nebst einem Zieralphabete aus Pflanzen und Thieren: Jagd- Touristen- und anderen Geräthen...*, 3rd edn, vol. I. Foreword by Richard Graul. Vienna: 1897.

Goldberg, Vicki, ed. *Photography in Print*. New York: 1981.

Gott, Ted. "Old Master Echoes: Odilon Redon, Photography and 'La Vie Morale.'" *Australian Journal of Art*, vol. V (1986), pp. 46–72.

Grad, Charles. *L'Alsace, le pays et ses habitants*. Turckheim: 1843–1890.

Greysmith, David. "Patterns, Privacy and Protection in the Textile Printing Industry." *Textile History*, vol. XIV, no. 2 (1983), pp. 165–94.

Hairs, Marie-Louise. *Les Peintres flamands de fleurs au XVIIe siècle*. Tournai: 1998.

Havart, Daniel. *Op-en Ondergang van Coromandel*. Amsterdam: 1693.

Havinga, Anne E. "Charles Aubry's Poppies: the Floral Photograph as Model for Artists and Designers." *Journal of the Museum of Fine Arts, Boston*, vol. IV (1992), pp. 80–95.

Hawthorne, Nathaniel. *The Marble Faun: Or, The Romance of Monte Beni*. Boston: 1860. Reprinted New York: 1990.

Hay, Susan. "Printed Textiles and Botanical Illustration: Some Examples from Jouy." *Bulletin de Liaison, Lyon, Centre International des Études de Textiles Anciens*, vols. LXIII–LXIV (1985–1986), pp. 113–22.

Herbert, Robert L. *Barbizon Revisited*. Boston: 1962.

Holmes, Oliver Wendell. "The Stereoscope and the Stereograph." *Atlantic Monthly*, vol. VIII (June 1859), pp. 738–48. Also in Beaumont Newhall, ed., *Essays and Images*. New York: 1980.

Jacqué, Jacqueline. "Fleurs imprimées au XIX siècle, exposition ouverte du 29 avril au 22 octobre 1989." *Bulletin d'information du Musée de l'Impression sur Étoffes*. Mulhouse: 1989, pp. 81–84.

Jacqué, Jacqueline. *Andrinople, le rouge magnifique: de la teinture à l'impression, une cotonnade à la conquête du monde*. Paris and Mulhouse: 1995.

Kempf, Christian. *Adolphe Braun et la photographie*. Strasbourg: 1994.

Kobbé, Gustav. "A Noted Family of Fine Art Publishers," in *Maison Ad. Braun & Cie: Paintings, Sculpture, Architecture*. New York: n.d. (brochure).

Koechlin-Ziegler, D. "Rapport sur les photographies de M. A. Braun." *Bulletin de la Société Industrielle de Mulhouse*, vol. XXVII (January 31, 1855), p. 5.

Krauss, Rosalind. "Photography's Discursive Spaces: Landscape/View." *Art Journal*, vol. XLII (Winter 1982), pp. 311–19.

Kusamitsu, Toshio. "British Industrialization and Design before the Great Exhibition." *Textile History*, vol. XII (1981), pp. 77–95.

Lacan, Ernest. "Album des fleurs par M. A. Braun." *La Lumière*, year 8, no. 4 (January 23, 1858), p. 13.

Lacan, Ernest. "Photographie stéréoscopique. M. Adolphe Braun." *La Lumière*, year 8, no. 16 (April 17, 1858), p. 61.

Lacretelle, Henri de. "Beaux-Arts. Salon de 1852." *La Lumière*, year 2, nos. 15 and 21 (April 3 and May 15, 1852), pp. 57 and 81 respectively.

Lagoltière, R. M. "Mulhouse et la conquête photographique des Alpes et du Mont-Blanc." *Annuaire historique de la ville de Mulhouse*, vol. II (1989).

Lagrange, Léon. "Le Salon de 1861." *Gazette des beaux-arts*, year 3, vol. XI (July 1861), pp. 49–73.

Lévy, Robert. *Histoire économique de l'industrie cotonnière en Alsace*. Paris: 1912.

McCauley, Elizabeth Anne. *Industrial Madness: Commercial Photography in Paris, 1848–1871*. New Haven and London: 1994.

McCauley, Elizabeth Anne. *Charles Aubry, photographe*. Paris: 1996.

Mainardi, Patricia. *Art and Politics of the Second Empire: The Universal Expositions of 1855 and 1867*. New Haven and London: 1987.

Mallary, Peter and Frances. *A Redouté Treasury: 468 Watercolors from Les Liliacées*. New York: 1986.

Moltedo, Alida, ed. *La Sistina riprodotta*. Rome: 1991.

Morand, Sylvain. *Charles Winter, photographe: un pionnier strasbourgeois 1821–1904*. Strasbourg: 1985.

Morand, Sylvain. "Les premières expositions de photographie en Alsace." *Cahiers alsaciens d'archéologie, d'art et d'histoire*, vol. XXXI (1988), pp. 205–12.

Musées de Strasbourg. *Olympe Aguado, photographe (1827–1894)*. Strasbourg: 1997.

Nadeau, Luis. *Encyclopedia of Printing, Photographic, and Photomechanical Processes*. Fredericton (New Brunswick): 1994.

Notice historique sur l'établissement de pisciculture à Huningue. Strasbourg: 1862.

Oberlé, Raymond. *L'Enseignement à Mulhouse de 1798 à 1870*. Paris: 1961.

Philadelphia Museum of Art. *The Second Empire, 1852–1870: Art in France under Napoleon III*. Philadelphia: 1978.

Pointon, Marcia. *Naked Authority*. London: 1990.

Redouté, Pierre Joseph. *Fruits and Flowers Comprising Twenty-Four Plates Selected from "Choix des Plus Belles Fleurs et des Plus Beaux Fruits."* Translated by Eva Mannering. New York: 1956.

Réunion des Musées Nationaux. *Delacroix: les dernières années*. Paris: 1998.

Rosenberg, Pierre. *Chardin, 1699–1779*. Paris: 1979.

Rosenblum, Naomi. "Adolphe Braun: A Nineteenth-Century Career in Photography." *History of Photography*, vol. III, no. 4 (October 1979), pp. 357–72.

Rosenblum, Naomi. "Adolphe Braun. Revisited." *Image*, vol. XXXII (June 1989), pp. 1–14.

Rothmuller, Jacques. *Vues pittoresques de chateaux, monumens et sites remarquables de l'Alsace (sic)*. Colmar: 1839.

Roubiliac-Conder, F. "Heliography." *The Art Journal* (London, November 1, 1870), pp. 325–26.

Saunders, Gill. *Picturing Plants*. Berkeley: 1995.

Scharf, Aaron. *Art and Photography*. London and Baltimore: 1968 and 1974 respectively.

Schoeser, Mary, and Kathleen Dejardin. *French Textiles from 1760 to the Present*. London: 1991.

Scott, William Bell. "Michelangelo in the Sistine Chapel (Braun's Photographs)." *The Portfolio*, vol. I (1871), pp. 11–12.

Shaw, Jennifer L. "The Figure of Venus: Rhetoric of the Ideal and the Salon of 1863." *Art History*, vol. XIV (December 1991), pp. 540–70.

Sieberling, Grace, with Carolyn Bloore. *Amateurs, Photography, and the Mid-Victorian Imagination*. Published in association with the International Museum of Photography at George Eastman House. Chicago and London: 1986.

Société Industrielle de Mulhouse. *Histoire documentaire de l'industrie de Mulhouse et de ses environs au XIX siècle*. Mulhouse: 1902.

Solomon-Godeau, Abigail. "Photography and Industrialization: John Ruskin and the Moral Dimensions of Photography." *Exposure*, 21:2 (1983).

Song, Misook. *Art Theories of Charles Blanc: 1813–1882*. Ann Arbor: 1984.

Spalletti, Ettore. "La Documentazione figurativa dell'opera d'arte, la critica e l'editoria nell'epoca moderna (1750–1930)." in Giulio Ballati and Paolo Fassati, eds., *Storia dell'arte italiana*, part I, vol. II. Turin: 1979, pp. 417–82.

Steinberg, Leo. "Who's Who in Michelangelo's *Creation of Adam*: A Chronology of the Picture's Reluctant Self-Revelation." *Art Bulletin*, vol. LXXIV (December 1992), pp. 552–66.

Sturges, Hollister, et al. *Jules Breton and the Rural Tradition*. New York: 1982.

Thoré, Théophile. *Nouvelles tendances dans l'art*. Paris: 1856.

Toussaint, Hélène, ed. *Gustave Courbet (1819–1877)*. Exhibition catalog. Paris and London: 1977 and 1978 respectively.

Turner, A. Richard. "*The Vatican Frescoes of Michelangelo*, photographed by Takashi Okamura. Tokyo and New York: 1980 (review)." *Visual Resources*, vol. I (Fall 1980–Winter 1981), pp. 229–32.

Tyl, Pierre. *Adolphe Braun: photographe mulhousien, 1812–1877*. Dissertation. University of Strasbourg, 1982.

Weisberg, Gabriel, ed. *The European Realist Tradition*. Bloomington: 1982.

Weisberg, Gabriel. *The Realist Tradition: French Painting and Drawing, 1830–1900*. Bloomington: 1980.

Wey, Francis. "Du Naturalisme dans l'art: De Son Principe et de ses conséquences." *La Lumière*, year 1, nos. 8 and 9 (March 30 and April 6, 1851), pp. 31 and 34–35 respectively.

Williams, Raymond. *The Sociology of Culture*. Chicago: 1981.

Yarnall, James L. *Nature Vivante: The Still Lifes of John La Farge*. New York: 1995.

List of Illustrations

Index of Names

List of Lenders

Bibliothèque Nationale de France, Paris

Bibliothèque de la Ville de Colmar

Boston Athenaeum

Bryn Mawr College, Bryn Mawr, Pennsylvania

The Cleveland Museum of Art

The J. Paul Getty Museum, Los Angeles

International Museum of Photography and Film,
 George Eastman House, Rochester, New York

The Metropolitan Museum of Art, New York

Musée de l'Impression sur Étoffes, Mulhouse

Musée d'Orsay, Paris

Musée d'Unterlinden and Société Schongauer, Colmar

Museum of Art, Rhode Island School of Design

Museum of Fine Arts, Boston

Museum of Modern Art, New York

The New York Public Library

Private Collection

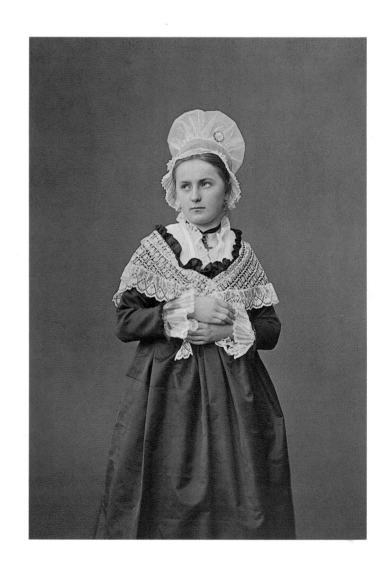